The Deconstructive Impulse

The Deconstructive Impulse Women Artists Reconfigure the Signs of Power, 1973–1991

Edited by
Nancy Princenthal

Essays by
Tom McDonough
Griselda Pollock
Helaine Posner
Nancy Princenthal
Kristine Stiles

Neuberger Museum of Art
Purchase College, State University of New York
Purchase

DelMonico Books · Prestel
Munich Berlin London New York

This publication accompanies the exhibition *The Deconstructive Impulse: Women Artists Reconfigure the Signs of Power, 1973–1991*, curated by Helaine Posner and Nancy Princenthal and organized by the Neuberger Museum of Art, Purchase College, State University of New York, Purchase.

Exhibition Itinerary

Neuberger Museum of Art, Purchase College, State University of New York, Purchase
January 15–April 3, 2011

Nasher Museum of Art at Duke University, Durham, North Carolina
August 25–December 5, 2011

The Deconstructive Impulse is funded in part by the National Endowment for the Arts, Washington, D.C. and the Friends of the Neuberger Museum of Art.

Published by the Neuberger Museum of Art and DelMonico Books, an imprint of Prestel

Prestel, a member of Verlagsgruppe Random House GmbH

Prestel Verlag
Königinstrasse 9
80539 Munich
Germany
tel 49 89 242908 300
fax 49 89 242908 335
prestel.de

Prestel Publishing Ltd.
4 Bloomsbury Place
London WC1A 2QA
United Kingdom
tel 44 20 7323 5004
fax 44 20 7636 8004

Prestel Publishing
900 Broadway, Suite 603
New York, NY 10003
tel 212 995 2720
fax 212 995 2733
sales@prestel-usa.com
prestel.com

© 2011 Neuberger Museum of Art
© 2011 Prestel Verlag, Munich · Berlin · London · New York

"Hot and Cool: Feminist Art in Practice"
© 2011 Helaine Posner

"In Theory: Postmodernism and Polemics"
© 2011 Nancy Princenthal

"Feeling Things: Fetishism and the Sex Appeal of the Inorganic" © 2011 Tom McDonough

"Home Alone: 'Reversal of Positions of Presentation' and the Visual Semantics of Domesticity" © 2011 Kristine Stiles

"What Women Want: Psychoanalysis and Cultural Critique" © 2011 Griselda Pollock

ISBN

978-3-7913-5120-9

Library of Congress Cataloging-in-Publication Data

The deconstructive impulse : women artists reconfigure the signs of power, 1973-1991 / edited by Nancy Princenthal ; essays by Tom McDonough ... [et al.].
 p. cm.
Includes bibliographical references and index.
ISBN 978-3-7913-5120-9 (alk. paper)
1. Women artists. 2. Art, Modern--20th century. 3. Deconstruction. I. Princenthal, Nancy. II. McDonough, Tom, 1969- III. Title: Women artists reconfigure the signs of power, 1973-1991.
N8354.D43 2011
704'.04209047--dc22

2010041142

Designer

Beverly Joel, pulp, ink.

Editor

Nancy Princenthal

Proofreader

Ryan Newbanks

Printed and bound in China

British Library of Cataloguing-in-Publication Data: a catalogue record for this book is available from the British Library; Deutsche National-bibliothek holds a record of this publication in the Deutsche Nationalbibliografie; detailed bibliographical data can be found under: http://dnb.ddb.de.

Lenders to the Exhibition

Anonymous Lenders

Gallery Paule Anglim, San Francisco

Judith Barry and Rosamund Felsen Gallery, Los Angeles

Barbara Bloom and Tracy Williams, Ltd., New York

Melva Bucksbaum and Raymond Learsy

Sarah Charlesworth and Susan Inglett Gallery, New York

Sarah Charlesworth and Margo Leavin Gallery, Los Angeles

Paula Cooper Gallery, New York

Candace Dwan

Electronic Arts Intermix (EAI), New York

Ronald Feldman Fine Arts, New York

Sandi Fellman

Sondra Gilman and Celso Gonzales-Falla

The Carol and Arthur Goldberg Collection

Jay Gorney

Jenny Holzer

Hood Museum of Art, Dartmouth College, Hanover, N.H.

Deborah Kass and Paul Kasmin Gallery, New York

Mary Kelly

Silvia Kolbowski

Louise Lawler and Metro Pictures, New York

Collection Friends of the Neuberger Museum of Art, Purchase College, State University of New York

Peter Norton

Collection of the Adrian Piper Research Archive Foundation, Berlin

P.P.O.W. Gallery, New York

Pamela and Arthur Sanders

Cindy Sherman and Metro Pictures, New York

Laurie Simmons

C. Bradford Smith and Donald Davis

Timothy Taylor Gallery, London

Carrie Mae Weems and Jack Shainman Gallery, New York

The Wieland Collection, Atlanta

Foreword and Acknowledgments

I t is hard to believe that more than three decades have passed since the emergence of a body of artwork that vigorously engaged the "image world" of commercial visual media. With the benefit of hindsight, it becomes possible to see patterns in the development of art called "deconstructive" (or appropriationist, or postmodern) that were obscure at the time. The impetus for this exhibition, and the book that accompanies it, was our belief that the role of women artists has long been scanted in accounts of that work. We determined to bring attention to those artists—and critics—who from the outset clearly articulated the feminist motivations for deconstructivism. Neither the mass media nor the powerful institutions of high culture were gender-neutral in the 1970s and 1980s. (Indeed, inequities and stereotypes continue to plague both fields.) Identifying sexual biases at work in movies, television, advertising, and mainstream journalism, both print and broadcast, as well as in curatorial practices, is a theme running strongly through the admittedly diverse work included in "The Deconstructive Impulse: Women Artists Reconfigure the Signs of Power, 1973–1991." So is the expression of experiences that are distinctive to women.

Our deepest gratitude goes to the artists included in the exhibition. Bringing their work together, and attempting to discern the shapes of its conceptual and historical frameworks, has been tremendously exciting for us, and enormously illuminating. With respect to the challenge of contextualization, we are deeply indebted to the authors who contributed to this book. Tom McDonough has written with great insight and erudition on works by Barbara Kruger and Cindy Sherman that help illuminate a century's worth of thought on the "sex life of

the inorganic." In the process, he traces transformations in the visualization of seduction and desire. Kristine Stiles, who early in her career participated in some of the performance-based activities represented in the exhibition, focuses in her essay on the surprising prevalence of domesticity as a subject in deconstructive art by women. Her text is a potent challenge to the widespread presumption that female postmodernists cast aside concern with what transpires inside the home. Lastly, Griselda Pollock, who was also present at the creation of postmodernism, in her case as an exceptionally alert critic and art historian, reflects on the role played by psychoanalytic theory in its development. Taking a long view, she insists on the urgency, then and now, of admitting cultural theories—even difficult ones—into the visual field. Profound thanks are due to all three.

We are also truly grateful to the galleries, museums, private collectors, and artists for their willingness to lend works from their distinguished collections. A complete list of these generous individuals and organizations appears at the front of this book. Thanks go to our colleagues Sarah Schroth, Nancy Hanks Curator, and Kimerly Rorschach, Mary D. B. T. and James H. Semens Director, of the Nasher Museum of Art at Duke University for their interest in hosting *The Deconstructive Impulse* at their institution. We are delighted to be able to share this exhibition with them. We also wish to thank Mary DelMonico of DelMonico Books Prestel for co-publishing this book with the Neuberger Museum. Her expertise and enthusiasm is very much appreciated. Beverly Joel of pulp, ink. is responsible for the intelligent and handsome design of this book.

At the Neuberger Museum of Art Avis Larson, Assistant Curator, and Pat Magnani, Registrar, handled exhibition loans and shipping arrangements with great efficiency; David Bogosian, Chief Preparator, and Jose Smith, Preparator brought this complex exhibition to life; Tyler Mahowald, Curatorial Assistant, tracked down photographs and reproduction rights with singular focus, and Emily Mello, Curator of Education for Adult and Academic Programs, organized the extensive public programs that accompany this exhibition. Former Neuberger Museum Director Thom Collins provided early and passionate support for this project. Heather Saunders, Purchase College Art Librarian, contributed the valuable bibliography that concludes this book. Their contributions and good will are immeasurable.

Crucial financial support for this exhibition and book has been provided by the National Endowment for the Arts, Washington, D.C. and the Friends of the Neuberger Museum of Art.

<div align="right">Helaine Posner and Nancy Princenthal</div>

Hot and Cool Feminist Art in Practice

Helaine Posner

The mid-1970s saw the emergence of a potent artistic impulse to deconstruct the operations of cultural power, an impulse that is often understood, erroneously, to have been gender blind. The prevailing belief has been that following the identity-based, essentialist work of the late 1960s and early 1970s, progressive women artists put aside their differences with men to help reveal how the mass media and global capitalism control visual culture. A new, deeply theorized art practice dispensed, it has been said, with first-person accounts. It ostensibly exposed authenticity and individuality as obsolete fictions, unsustainable in a media-saturated culture in which advertising, television, and the movies shape visual expression far more powerfully than individual agency. Sexual politics were seen to have submitted to a gender-free critique.

Hindsight helps reveal that this scenario is deeply flawed. Not only was the deconstructive impulse propelled in significant measure by women, but it reflected specifically female and highly individualized experiences of power, and constraint. A chorus of varied voices, of decidedly plural feminisms, rose up from a wide variety of racial, economic, and cultural communities. In fact, the deconstructive impulse helped reveal that gender identity and its representation was far more complicated than had generally been recognized. This exhibition and book attempt to examine the critical ways in which these linked feminist and deconstructive impulses drove the influential media-based conceptual work commonly known as appropriation, focusing on the work of a diverse group of North American women artists who employ the visual languages of the mass media to unveil its codes and reveal embedded gender, sexual, racial, and class-based inequities.

11

Appropriation, quotation, simulation, repetition, and pastiche, the key deconstructive strategies developed by these artists in the 1970s, have pervaded our culture to such an extent that they now go virtually unnoticed. In fact, with the emergence of new technologies and resulting explosion of media networks in recent years, appropriating still and moving images and text has become, paradoxically, the primary way we in which we make sense of our world. In the 1970s, however, the embrace of such material as resources for art marked a radical break with the emphases on originality, authenticity, and master narratives defined by unitary, male subjects, all of which had been touchstones of modern art since the late nineteenth century. Mourned as a loss of influence by some and welcomed as the end of an outmoded, exclusionary, patriarchal worldview by others, including feminists, postmodern art engaged alternative representational strategies and diverse, multiple viewpoints, signifying a major paradigm shift.

The 1970s and 1980s also marked a return to recognizable images after a postwar period dominated by various forms of abstraction. Artists such as Dara Birnbaum, Sarah Charlesworth, Jenny Holzer, Louise Lawler, Mary Kelly, Sherrie Levine, and Barbara Kruger, the so-called "theoretical girls,"[1] critiqued the mass media—advertising, news, commercial film and television—by borrowing the media's own imagery and text. These artists' work was widely considered the antithesis of Neo-Expressionism, a type of large-scale, gestural, figurative painting revived in the 1980s by a group of male painters led by Julian Schnabel and David Salle. The critical, deconstructive approach was seen as the opposite of Neo-Expressionism's visceral messiness. But, as art historian Pepe Karmel recently observed, "It was increasingly apparent that whatever their differences in style, their work was full of similar images of glamour, vanity, alienation, sex, and violence" and, in fact, the work of the women artists was "in its own way, every bit as expressive as the art of the Neo-Expressionists."[2] However, what they chose to say about these essentially American subjects differed greatly from their male peers. The personal and political nature of their imagery, its feminist content, remained largely unexamined.

This oversight surely reflects the same cultural biases that their work sought to address. It also may be due to the fact that the artist's feminist subject matter emerged from a theoretical framework developed mainly by male critics such as French philosophers Jean Baudrillard, Jacques Derrida, Michel Foucault, and Jacques Lacan, and American art critics and historians Douglas Crimp, Hal Foster, and Craig Owens. It was Owens who coined the term "deconstructive impulse" in his landmark 1983 essay "The Discourse of Others: Feminists and Postmodernism," where he focused on "the apparent crossing of the feminist critique of patriarchy and the postmodern critique of representation" and declared, "If I have chosen to

negotiate the treacherous course between postmodernism and feminism, it is in order to introduce the issue of sexual difference into the modernism/postmodernism debate—a debate which has until now been scandalously in-different."[3]

At the same time, a number of feminist theorists working in a variety of disciplines, including psychoanalysis, art history, and media studies, as well as some artists, were examining issues of difference, gender, and their representations in their critical writing.[4] For the artists, their primary mode of communication was, naturally, their work. In practice, they explored a wide range of subject matter, navigating a challenging course between public and private experience through images and text with which other women could readily identify. They applied their rigorous and seemingly cool approach to topics that, in retrospect, were surprisingly hot. A brief review of some the feminist themes and interests that animate their work—melodrama, the power of the stereotype, consumption and commodity culture, women's experience of domestic life, motherhood and sexuality, and, finally, visual pleasure—suggest the passion that fueled their critique.

Melodrama

Perhaps the most highly theorized yet least theoretically inclined artist yielding to the deconstructive impulse is Cindy Sherman. In a remarkably inventive series of black-and-white photographs produced early in her career, the artist nimbly mined popular sources to create what appear to be stills from foreign films and Hollywood B-movies of the 1950s and 1960s. The "Untitled Film Stills" (1977–81) feature the artist in a series of over sixty small, black-and-white photographs in which she dons various guises to evoke, uncannily, a range of heroines from postwar films. Sherman creates her cast of sophisticates, seductresses, librarians, secretaries, housewives, and waifs though precise costuming, gesture, and pose, often placing them in intimate settings that border on the claustrophobic. In each case, her isolated characters respond to some perceived external threat, whether casting an ever-wary glance outside the frame, dissolving into tears, or turning up a collar against the night.

A sense of nostalgia pervades these images of female anxiety, which recall the mood and style of film noir as well the Hollywood melodramas or "women's pictures" of the 1950s. These melodramas typically focus on bourgeois women in crisis, and depend on stereotypical characters and plotlines designed to provide occasions for heightened or exaggerated emotions. Sherman's "Film Stills" borrow much from this often disparaged genre,

portraying an array of female types involved in discrete, emotionally charged scenarios. These compelling fictional women, with multiple, shifting identities, manage to gain our empathy while simultaneously revealing the artifice of their social construction.

Instead of creating multiple personae to construct narratives of women in love and in crisis, Carrie Mae Weems creates just one. Weems's domestic drama features the artist as protagonist in a story of relationships, love, and loss in contemporary society. She tells her tale around the kitchen table in an unfolding sequence of twenty chapters comprised of staged black-and-white photographs and related texts. In form and content, the "Untitled (Kitchen Table Series)," 1990, [see pages 158–61] suggests a serial soap opera rather than stills from a feature film. Weems relays the tale of a strong yet vulnerable black woman who enters into a deepening relationship with a man, and then seeks support from family and friends as it fails. Weems depicts her lead character in her role as a mother and lover and, finally, shows her coping with being alone. Like Sherman, Weems functions as actor in and director (and, in Weems's case, writer) of a fictional narrative that deeply engages the viewer's emotions. In focusing on the trials of a single female protagonist located in the present day and directly confronting our gaze across a kitchen table, Weems challenges us to acknowledge the personal toll exacted when one inherits a social position shaped, in part, by sexual and racial difference.[5]

The Power of the Stereotype

Artists Dara Birnbaum, Silvia Kolbowski, and Barbara Kruger appropriate and manipulate mass media imagery, borrowed from television and advertising, to deconstruct the stereotype as an instrument of cultural control, exposing gender biases that are hidden in plain sight. Birnbaum was one of the first artists to appropriate video footage directly from popular television programs of the day. Her pioneering work, *Technology/Transformation: Wonder Woman* (1978), [see page 89] features a spinning, running, and fighting superheroine dressed in a revealing red, white, and blue spangled costume and adorned with a tiara and bullet-repelling golden bracelets. Solely from her appearance, one might assume that sexuality is the true source of her superpowers. Using the postmodern strategies of quotation, repetition, and fragmentation to critique the action, game show, and soap opera genres, Birnbaum addressed television's objectified representations of women with amazing force. As she explains, "By dislocating the visuals and altering the syntax, these images were cut from the narrative flow and countered with musical texts, plunging the viewer headlong into the very experience of

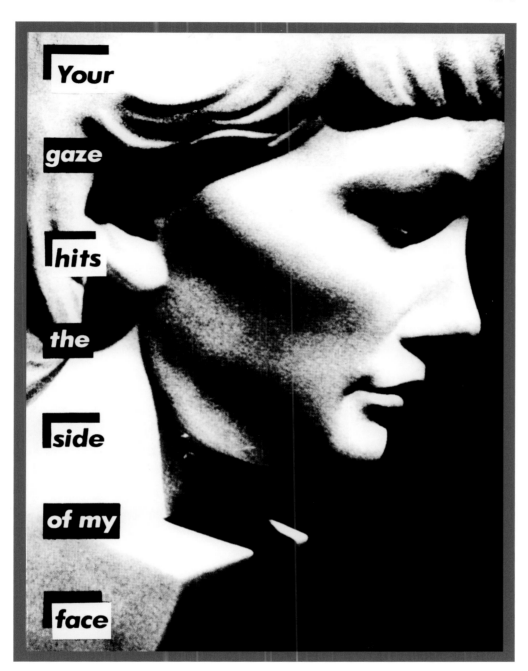

Barbara Kruger

Untitled (Your gaze hits the side of my face), 1981.
Photograph, 55 x 41 in. Courtesy Mary Boone Gallery,
New York

TV—unveiling TV's stereotypical gestures of power and submission, of self-preservation and concealment, of male and female egos."[6]

Lorna Simpson's *Stereo Styles* (1988), [see page 154] a serial grid of ten color Polaroid photographs accompanied by engraved plaques, depicts the backs of various black women's heads, each sporting a different, somewhat outrageous coiffure. The accompanying script supplies descriptive captions such as "Darling," "Long and Silky," "Boyish," and "Country Fresh"— character assessments that rely on the reductive criterion of hairstyle. In a clever critique of gender and racial stereotypes as they appear in advertisements, Simpson draws attention to the importance of hair both as a symbol of female beauty and sexuality, and as the chief and most problematic signifier of racial difference after skin color. In the series "Model Pleasure" (1983), [see pages 120–21] Silvia Kolbowski juxtaposes appropriated images of white fashion models wearing nearly identical make-up and facial expressions to reveal a coercive, stereotypical image of female beauty that is at once highly visible and almost impossible to see.

Barbara Kruger, master manipulator of advertising imagery, employs bold graphic design techniques to create works of art that are virtual icons of appropriation. Her large-scale photomontages superimposing short, clichéd, gender-specific texts over generic black-and-white mass media images have become ubiquitous, much like the stereotypes they skillfully expose and subvert. Kruger tackles the dualist thinking underlying Western patriarchy—culture versus nature, active versus passive, male versus female, observer versus observed—to reveal the fundamental inequity of its terms and their role in promoting and reinforcing cultural stereotypes. Kruger provokes the viewer with such statements as, "Your gaze hits the side of my face," juxtaposed with an image of a classical Greek female bust, and "I am your reservoir of poses," describing a photograph of a fashionably attired woman; underscoring how "your" active male gaze dominates, while "I" remain cool and compliant. As Craig Owens observed, the stereotype is "a gesture executed with the express purpose of intimidating the enemy into submission."[7] For each of these artists, the stereotypes' play in a game of power and constraint is inescapable.

Consumption and Commodity Culture

With considerable wit and irony, Barbara Kruger proclaimed, "I shop therefore I am," revealing how the shopper asserts her gender identity through the products she consumes. Written during the economic boom of the 1980s—the so-called "Reagan Revolution" in which wealth,

glitz, and greed became American hallmarks—the artist's declaration captures the commodity fetishism that defined this period, frequently through items marketed to women. Along with Kruger, artists Judith Barry, Sarah Charlesworth, Martha Rosler, and Louise Lawler examined various aspects of commodity-based culture and the insidious hold it takes on the public and private imagination. In Barry's video, *Casual Shopper* (1981), [see pages 86–87] the camera follows a stylish woman as she strolls through an upscale California shopping mall, casting her gaze on the fashion displays, magazines, and array of luxury items designed to entice her. At the same time, she has a number of elusive, erotic near-encounters with a man who may, or may not, be real, as the social space of the mall becomes the site where female fantasies of desire and consumption are aroused but never truly satisfied. In a sense, Barry's casual shopper represents the quintessential American consumer who, once hooked on the culture's endless supply of goods and services, participates in an endless cycle of manufactured longing.

Like Barry, artist Sarah Charlesworth focuses on the manipulation of desire evident in advertising's attempt to seduce the consumer. In "Objects of Desire" (1983–88), [see pages 98–101] an extensive four-part series of Cibachrome photographs, the artist extracts fragmented images from fashion and pornographic magazines, placing their silhouetted forms against richly colored backgrounds. An evening gown, a chiffon scarf, and a leather harness are among the fetishized items the artist centers on red and black fields meant to connote sexuality and death. It is difficult for us to deny the allure of these images, and our own desires for the things they portray, even as the artist skillfully critiques the restrictive gender roles they represent.

Martha Rosler astutely deconstructs images of romance, glamour, allure, and the promise of "having it all" as she "reads" *Vogue* in a videotaped performance of 1982, [see page 137] breathlessly narrating a fantasy of luxury and beauty likely beyond the reach of the magazine's predominantly female readers. She goes on to use statistics to compare the salaries of highly paid *Vogue* models with the sweatshop earnings of third-world women on whose labor the fashion industry relies. Rosler's video offers an insightful look at a business that sells unattainable dreams, one that objectifies the female subject as it exploits her needs and her aspiration to cross class lines. Artist Louise Lawler explores a world of affluence, asking us to consider the value and meaning of art in sites where culture is often co-opted by capitalism. Lawler's extended series of photographs of contemporary art carefully arranged on the walls of auction houses, private homes, and corporate offices serve as a deadpan but pointed feminist critique of art as the ultimate trophy item, a display of wealth symbolizing class and power. As Barbara Kruger ironically declared, "When I hear the word culture I take out my checkbook."

Women's Domestic Experience

Perhaps the most explicitly female and feminist themes examined by artists deconstructing gender identity and its representation are motherhood and the domestic sphere. Conceptual artists Laurie Simmons, Mary Kelly, and Jenny Holzer, among others, refuse to idealize these time-honored subjects, preferring to look at the pleasures and perils of women's everyday experience both from a critical and deeply felt position. In the late 1970s, Simmons created a series of "Interiors" [see pages 146–51] where she staged and photographed scenes of tiny dolls set in the kitchens, living rooms, and bathrooms of well-appointed dollhouses. These images of miniature housewives—isolated and surrounded by the trappings of home life—cast a nostalgic glance back to the 1950s and recall the affection for playing with dollhouses held by the artist and by many women of her generation. At the same time, these hushed domestic scenes operate as subtle critiques of conventional gender roles, revealing the seemingly benign way they are introduced into the lives of girls, and suggesting the lifelong expectations they establish for women. Simmons's dolls suggest novice *Stepford Wives* and the powerful societal pressures that can overwhelm women, invading their personal lives.

The mother/child relationship is the subject of Mary Kelly's *Post-Partum Document* (1973–79), [see pages 118–19] a radical work of conceptual art examining the first years of her son's life. In this six-part narrative installation, the artist applies the most advanced linguistic, psychoanalytic, and archeological strategies to the study of one of society's most traditional subjects. Kelly charts this intimate relationship through a collection of found objects, texts, diagrams, graphs, drawings, and plaster and resin casts, providing an analytical, yet profoundly personal view of a woman's daily life. In a stunning move, Kelly's extended investigation of early motherhood introduced issues of sexual difference and vulnerability into conceptual art's abstract, dispassionate, and often apolitical discourse.

After creating the breakthrough *Truisms* (1977–79) [see pages 112–13]—strangely impersonal, contradictory statements distributed on posters and T-shirts—artist Jenny Holzer turned her attention to issues of female subjectivity and anxiety in relation to the body. At the end of the 1980s, concerns about the devastating AIDS crisis, combined with deep feelings of protectiveness and fear stirred by new motherhood, took form in two series she called *Laments* (1988–89) and *Mother and Child* (1990). In the latter, the artist employed her signature media-inspired electronic signboards, a very public form of presentation, to display texts that express extremely raw, private emotions. "I am sullen and then frantic when I cannot be wholly within the zone of my infant. I am consumed by her. I am an animal who does

all she should," Holzer confesses. Throughout her work the emotional and social realities of women's experience, as mothers and daughters, as sexual partners and wage earners, and as victims of rape and violence in all its forms, are paramount.

Visual Pleasure

In a recent essay on feminism and art in the 1980s, art historian Johanna Burton suggested that we can "approach anew so many of the artists whose works have been perhaps too quickly (if with the best of intentions) claimed for the side of deconstructive critique without accounting for the possibility that a more complicated scopic pleasure may also be in evidence." Burton noted strict appropriationist Sherrie Levine's statement that the cultural icons she chose to reproduce, such as the photographs of Walker Evans and Edward Weston, are images that she is attracted to, even loves.[8] If we look more closely at the art featured in "The Deconstructive Impulse," for example Cindy Sherman's melodramatic film stills, Laurie Simmons's intimate "Interiors," or Barbara Kruger's nostalgic advertising images, we begin to understand the emotional resonance their imagery holds for artist and viewer alike. In hindsight, it seems an emphasis on conceptual rigor, as exercised by the artists and privileged by theorists of the time, eclipsed the significance of their feminist critique as well as the visual pleasure they took in their selected imagery. That balance has shifted over time.

Helaine Posner is Chief Curator and Deputy Director for Curatorial Affairs at the Neuberger Museum of Art.

1
Quoted in Douglas Eklund, *The Pictures Generation, 1974–1984* (New York: The Metropolitan Museum of Art, and New Haven: Yale University Press, 2009), 144.

2
Pepe Karmel, "Oedipus Wrecks: New York in the 1980s" in Stephanie Barron and Lynn Zelevansky, *Jasper Johns to Jeff Koons: Four Decades of Art from the Broad Collection*, with essays by Thomas Crow, Joanne Heyler, Pepe Karmel, and Sabine Eckmann (Los Angeles: Los Angeles Country Museum of Art, and New York: Harry N. Abrams, 2001).

3
Craig Owens, "The Discourse of Others: Feminists and Postmodernism," in *Beyond Recognition: Representation, Power, and Culture* (Berkeley: University of California Press, 1992), 168–69.

4
Please see Nancy Princenthal's essay "In Theory" in this volume for a full discussion of the importance of theory to the deconstructive impulse.

5
Susan Fisher Sterling, "Signifying: Photographs and Texts in the Work of Carrie Mae Weems" in *Carrie Mae Weems* (Washington, D.C.: National Museum of Women in the Arts, 1993). I thank the author for her insights into the artist's work.

6
Dara Birnbaum quoted on the Electronic Arts Intermix website, http://www.eai.org/artistsBio. htm?id=430

7
Craig Owens, "The Medusa Effect, or, The Specular Ruse," in *Beyond Recognition: Representation, Power, and Culture* (Berkeley: University of California Press, 1992), 194.

8
Johanna Burton, "Fundamental to the Image: Feminism and Art in the 1980s," in *Modern Women: Women Artists at the Museum of Modern Art* (New York: Museum of Modern Art, 2010), 440–42.

In
Theory Postmodernism
and Polemics

I n the later 1960s and early 1970s, feminist art could be characterized loosely (though any such generalization is risky) by its proponents' commitment to physical and emotional exposure. The pioneering women of that generation were dedicated to baring the conditions of inhabiting a female body, and of carrying on one's domestic and professional life in a world dominated by men. If honesty was the salient measure for judging this work, one of its key instruments was nakedness, literal as well as metaphorical. Nudity was also a crucial strategy for derailing the force of imagery seen as exploitative, whether that imagery was produced by twentieth-century mass media or Renaissance masters. The force of these women artists' candor was meant to short-circuit the critical institutions of the art world. Look, these women artists said. This is who we *really* are. We are taking our representation into our own hands.

Soon enough, though, women were putting their clothes back on, and assuming as well the mantle of theories as densely woven as they were elegant. Though this trajectory, too, simplifies the situation of a generation of women artists, it sharply illuminates the origins of the often photo-based work that arose in the middle 1970s and was called, variously, deconstructive, appropriationist, and, most often and most broadly, postmodern. The importance of female experience, and of feminist impulses, to the genesis of this work is the subject of "The Deconstructive Impulse." Provocative but deeply wary of personal disclosure, astute about the operations of power in visual culture, theory-based art turned the focus from first-person perspectives to the social construction of identity and of language, whether visual or

verbal. The position of the viewer was examined as closely as that of the artist. Modes of image delivery—the mediums at an artist's disposal—were just as susceptible to analysis as content. Photography, film, and, in particular, video were favored not just because they established a link to commercial imagery, but also because they participated in the doubling of reality—the masking, the masquerade—that was identified as a signal element of feminine experience. Appropriating such imagery was, no less important, a crucial means of resistance to the power vested in it.

The young writers and theorists who supported—and helped conceptualize—this work included Douglas Crimp, Hal Foster, and Craig Owens. Among them, Owens was the most alert to the importance of gender politics in the development of postmodernism. In 1983, he wrote, in an essay called "The Discourse of Others: Feminists and Postmodernism" (it constituted his contribution to a landmark 1983 collection of essays edited by Foster and titled *The Anti-Aesthetic*), "the [established, modernist] representational systems of the West admit only one vision—that of the constitutive male subject—or, rather, they posit the subject of representation as absolutely centered, unitary, masculine. The postmodernist work attempts to upset the reassuring stability of that mastering position."[1] In *The Anti-Aesthetic*'s introduction, Foster summarizes his colleague's position: "Craig Owens . . . regards postmodernism as a crisis in Western representation, its authority and universal claims—a crisis announced by heretofore marginal or repressed discourses, feminism most significant among them."[2] And in a 1987 interview (the transcripts of which he was unable to correct because of advancing illness; he died of AIDS in 1990), Owens said even more plainly, in response to a question about why "postmodernism" arose "at the precise moment" it did (c. 1975), "There were the feminist activities in the art world, setting up things like the Women's Building in Los Angeles and various feminist collectives: various challenges to how the supposed tolerance in inclusiveness of the art world was in fact including powerful white men from a certain middle class."[3] Foster, too associated the new, as yet unnamed style primarily with women. Writing that under this pioneering work's terms, "the artist becomes a manipulator of signs more than a producer of art objects, and the viewer an active reader of messages rather than a passive contemplator of the aesthetic or consumer of the spectacular," he named as its leading proponents Martha Rosler Sherrie Levine, Dara Birnbaum, Barbara Kruger, Louise Lawler, Allan McCollum, Jenny Holzer, and Krzysztof Wodiczko.[4]

Of course, not all of postmodernism's theorists were men. Some of the women artists were (and are) exceedingly eloquent and forceful theorists themselves, among them Judith Barry, Silvia Kolbowski, Barbara Kruger, and Martha Rosler, though their primary means of communication is through their work. Among early critics of the new deconstructiv-

ism were Abigail Solomon-Godeau and Kate Linker. In 1984, Linker organized an exhibition for the New Museum in New York called "Difference: On Representation and Sexuality" that contributed substantially to an understanding of the gender issues at play in postmodernism; the show's thesis, she wrote in a foreword, was "the continuous production of sexual difference."[5] While literary and psychoanalytic theorists Julia Kristeva, Hélène Cixous, and Luce Irigaray didn't address postmodern art directly, they were touchstones for its artists; the British theorist Jacqueline Rose (who contributed to the catalogue for Linker's show) did write, astutely, about contemporary art by women. Cinema scholar Laura Mulvey's 1975 text "Visual Pleasure and Narrative Cinema," examining how movies framed women as the subjects of the "male gaze," rather than agents of narrative action, was a foundational text for postmodernism; looking back on it in 1991, Mulvey wrote that following the feminism of the 1960s and early 1970s, "A politics of the body led logically to a politics of representation of the body. It was only a small step to include the question of images of women in the debates and campaigns around the body, but it was a step that also moved feminism out of familiar terrains of political action into a terrain of political aesthetics. And this small step . . . opened the way for the influence that semiotics and psychoanalysis have had on feminist theory."[6] And in Owens's 1987 interview, he attributed the origins of postmodernist thought in large part to the art historian Rosalind Krauss: "The only people I knew who were talking about [postmodernism] in the visual arts in the early to mid '70s . . . were people associated with *October*. A lot of it had to do with Rosalind Krauss and her attempt to dissociate herself from [Greenbergian art historian Michael] Fried."[7]

Strikingly, writers of both sexes drew on ideas formulated by a rather fixed roster of European thinkers: the contemporary writers Jacques Derrida, Roland Barthes, Jean Baudrillard, and Michel Foucault, along with the venerable Jacques Lacan and Sigmund Freud. It bears noting that the New York art world—where much of the deconstructivist work in question was first exhibited—was, by the early 1980s, absorbing more European artwork than it had at any point since the heyday of early twentieth-century modernism. Though they arrived more or less simultaneously, the theory being imported from the Continent and the neo-Expressionist painting being shipped from Italy and Germany stood in vigorous opposition.

To the very considerable extent that the artwork itself and the criticism that supported it were mutually dependent—"one of the things [postmodernism] challenges is modernism's rigid opposition of artistic practice and theory,"[8] Owens noted—they also shared paradoxical inclinations. While emphasizing the contingency of identity and the fallacy of linear, progressive models of historical development, the writing tended to take up the reins of artistic progress; it argued forcefully, and often caustically, against retrograde tendencies.

In other words, it was sometimes rather intolerantly prescriptive. Most traditional forms of painting were anathema; expressionism in particular was deplored. Pains were taken to distinguish true postmodernism from "pluralist" pretenders to the title, generally understood to mean painters and, especially, architects who used historical styles indiscriminately and without theoretical defense. In other words, the critics railed against practices that, as they saw it, were called postmodern only because they dispensed with the purities of modernism. Since deconstructivist art proper was deeply involved with popular culture, which provided much of its imagery, its defenders also undertook to distinguish postmodernism from mere populism, and from mere Pop art. It can moreover be claimed, though this argument rests on a slippery slope, that since the reviled Neo-Expressionists and the historical masters they drew upon were mostly male, the postmodern work that opposed it was feminist by default, whether or not its supporters (or producers) said so.

Indeed, the fervor of the argumentation that swirled around deconstructivism now seems its quaintest characteristic. "If *postmodernism* is to have theoretical value, it cannot be used merely as another chronological term; rather it must disclose the particular nature of a breach with modernism," Douglas Crimp proclaimed in a 1979 revision, published in the magazine *October*, of the essay he wrote for the catalogue accompanying the landmark 1977 "Pictures" exhibition he organized for Artists Space in New York.[9] Emerging in a period when the passions, and physical violence, of the 1960s and early 1970s were subsiding—the Vietnam War was over, the Civil Rights struggle had abated, the Left was in disarray, radical politics had gone deep underground—the art and theory of the late 1970s and 1980s undertook to channel intellectual energy often absorbed in political and social struggle into the defense of a particular form of cultural inquiry. If Marx and Freud were still invoked, however guardedly, by the vast majority of ambitious young theorists, the political and cultural regimes that these titans had set in motion were crashing and burning throughout this period. The Berlin Wall came down in 1989, two years after Prozac was introduced in the U.S.; just as Marx was no longer an official guide for any major nation's governance, Freud was no longer an unquestioned authority for treating the most common forms of psychological distress. Their writing was transformed from a call to practical action into a cultural resource, and social struggles were fought on other grounds. And in fact, by the late 1980s the Culture Wars were the hottest form of political combat in the U.S., the right wing having, arguably, taken the bait presented by (among other art forms) the new postmodern work. Perhaps in doing so, conservative ideologues weren't altogether wrong. Despite its cool surfaces and fashion-forward subjects, there were powerful and manifold political energies motivating postmodernism, feminism foremost among them.

Masquerade

One of the primary themes of deconstructivism was its engagement with ideas put forth by Derrida, Barthes, and Baudrillard challenging the singular primacy of the masterful individual artist. In "The Death of the Author" (first published in English 1967), Barthes wrote,

> We know now that a text consists not of a line of words, releasing a single "theological" meaning (the "message" of the Author-God), but of a multi-dimensional space in which are married and contested several writings, none of which is original: the text is a fabric of quotations, resulting from a thousand sources of culture.... [The writer] no longer contains passions, moods, sentiments, impressions, but that immense dictionary from which he draws a writing which will be incessant: life merely imitates the book, and this book itself is but a tissue of signs, endless imitation, infinitely postponed.[10]

In his rather more hyperbolic style, Baudrillard concluded a slim but influential volume titled *Simulations* (published in English in 1983) by proclaiming, "And so art is everywhere, since artifice is at the very heart of reality. And so art is dead, not only because its critical transcendence is gone, but because reality itself, entirely impregnated by an aesthetic which is inseparable from its own structure, has been confused with its own image."[11] It was such ideas, Barthes's in particular, but also Derrida's concerning the "play of the signifier," that Owens drew on to write, "When the postmodernist work speaks of itself, it is no longer to proclaim its autonomy, its self-sufficiency, its transcendence; rather it is to narrate its own contingency, insufficiency, lack of transcendence."[12]

The perceived vitiation of reality took with it, as significant first victims, robust individual bodies and their imperatives. Subjective experience was best understood by examining the patriarchal machinery of language; exposing its operations was necessarily a feminist undertaking, one that had to precede other more personal forms of expression. The means most often chosen was to assume, with deliberate artifice, precisely the kinds of mass-media and pop-cultural identities and poses that women had so long been subjected to involuntarily. To quote Owens again, if "It is precisely at the legislative frontier between what can be represented and what cannot that the postmodernist operation is being staged," then "This prohibitions bears primarily on woman as the subject, and rarely as the object of representation.... In order to speak, to represent herself, a woman assumes a masculine position; perhaps this is

why femininity is frequently associated with masquerade, with false representation, with simulation and seduction."[13] Among the artists engaged in such pursuits, with and without explicit reference to the relevant theorists, were Cindy Sherman, Lynn Hershman, Hannah Wilke, and Adrian Piper.

Sherman is, arguably, the artist who was from the start most firmly identified with the masquerade at the heart of postmodernism (although, famously, she was not included in the "Pictures" exhibition that launched the generation for whom she became a standard bearer). In her hundreds of photographic self-portraits, beginning with the black-and-white "Film Stills" of 1977–81, she has created a seemingly endless series of dramatic characters, many of them instantly recognizable as social types, though never quite normative and sometimes drastically eccentric. Foster, drawing on Baudrillard, wrote of Sherman, "That the self is a construct is the subject of many young artists, Cindy Sherman prominent among them. Her photographs are portraits of the self as it emerges in the field of the other—in types presented by the media *as* women. . . . Oppositions of original and copy, inside and outside, self and society all but collapse: in these 'self' portraits identification is one with alienation."[14]

Owens draws on psychoanalytic theory to account for Sherman's "notion of femininity as a masquerade, that is, as a representation of male desire." In her self-portraits, he writes, "disguise functions as parody . . . in a way that appears to proceed directly from Jacques Lacan's fundamental tenet that the self is an Imaginary construct." Owens proceeds to quote Lacan on this subject: " 'in the labor with which [the subject] undertakes to reconstruct this construct *for another*, he finds again the fundamental alienation which has made him construct it *like another one*, and which has always destined it to be stripped from him *by another*.' "[15] A few years later, Rosalind Krauss drew on Barthes to say, of Sherman's photographs, "There is no free-standing character, so to speak, but only a concatenation of signifiers."[16] Later still, the younger scholar Johanna Burton cited Luce Irigaray: "Any portrayal of a fragmented, dissolute female form . . . necessarily refers to its male counterpart's own deepest fears and/or wishes for self-annihilation." This representation-by-absence of female subjecthood reflects many sources, Burton says. "One need only recall Luce Irigaray's critique of Freud, in which she observes that for him there is only one sex—male—and the not-quite that is female."[17]

One impulse almost never associated with Sherman, curiously enough, is active feminism, an absence noted by Abigail Solomon-Godeau, who observed, of the writing done in connection with a 1987 survey of Sherman's work at the Whitney Museum of American Art, "neither [critic] Peter Schjeldahl nor [curator] Lisa Phillips have a single word to say about feminism."[18] Similarly, Solomon-Godeau noted, critic Arthur Danto chose to elaborate on scenarios he believed Sherman's subjects enact rather than detect in them the artist's own

analytic perspectives. "When confronted with a deconstruction of mythic femininity, these writers must compensate by shoring up or recuperating precisely the fantasies which Sherman's stills attempt to destabilize," Solomon-Godeau concluded.[19] At the same time, it must be admitted that Sherman presents an off-camera identity as hard to pin down, not least with respect to feminism, as the one seen in her self-portraits, making her work a perfect screen onto which observers may project their ideas.

Less often enlisted for critical discourse are the equally radical experiments in masquerade undertaken by Lynn Hershman and Adrian Piper. Roberta Breitmore, an alter ego Hershman created and inhabited part-time from 1974–78 (ultimately with the help of some friends), had her own wardrobe and wig, apartment and job, psychotherapist and weight-watcher's membership—an identity that offered the artist an oblique perspective on her own. Piper's "Mythic Being" was a mustached and exaggeratedly macho black man, whose slightly comic, vaguely sinister identity Piper assumed for performances and various text-and-images works throughout the early 1970s. Addressing racial as well as sexual politics, Piper created a character so challenging to the critical discussions of the time that, tellingly,

Adrian Piper

The Mythic Being: I Embody Everything You Most Hate and Fear, 1975. Altered photograph: oil crayon drawing on photo in plexiglass box, 8 x 10 in. Collection of Thomas Erben, New York

Adrian Piper

The Mythic Being: Cruising White Women, 1975. Three black-and-white photographs, 8 x 10 in. Private collection, USA

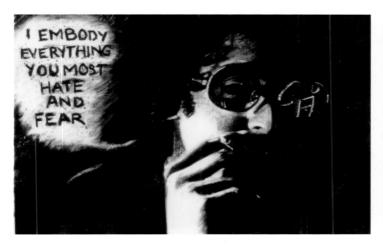

it was seldom included in them. Also kept at arm's length from the postmodern debate, but for very different reasons, were the ways in which Hannah Wilke—who straddled two generations of women artists, both by age and theoretical inclination—addressed conventional, and highly commercialized, sexual fantasies, striking poses defined by fashion photography and erotic display.

Wilke's use of famous male artists' works as props—for instance Duchamp's *Large Glass*, behind which she performed an elaborate striptease in 1976—connects her to women whose masquerade took the form of appropriating work by men. Starting in the early 1960s and working nearly concurrently with then-emerging Pop and Minimalist artists, Elaine Sturtevant (who generally uses only her last name) made exacting copies, by hand, of paintings and sculptures by Andy Warhol, Frank Stella, Jasper Johns, and other contemporaries, as well as by Duchamp. By the beginning of the 1980s, Sherrie Levine was similarly copying modernist masterpieces—working from reproductions in books—by Joan Miró, Stuart Davis, and others; even more provokingly, she re-photographed classic pictures by such masters of the medium as Walker Evans and Edward Weston. Deborah Kass also later took up this theme, making paintings that are composites of works by Warhol, Johns, and others, including such postmodern peers as David Salle. Barbara Bloom further complicates the use of existing photographs by veiling, framing, doubling, and cropping them. Combining these images with objects borrowed from the world of consumer goods and applied design, she creates installations where the distinction between original and copy, history and fiction, are irremediably blurred. Barbara Kruger's photomontages pair old-fashioned black-and-white stock photographs with boldfaced texts that exhort the viewer to pay attention to the operations of power at work in her borrowed imagery. Written in a commanding second person voice that addresses the viewer as "you," Kruger is always the speaker, but never the one spoken; like the supreme authority whose voice she borrows, she is never seen—an ultimate form of masquerade.

In his contribution to a catalogue for the 1986 exhibition "Endgame: Reference and Simulation in Recent Painting and Sculpture" (among the artists shown were Sherrie Levine, Jeff Koons, Peter Halley, and Haim Steinbach), Thomas Crow began with an account of a little-known conceptual exercise undertaken in the early 1970s by the pseudonymous critic Cheryl Bernstein, who championed a fictitious artist for making work that "consisted entirely of exact copies of works by Frank Stella." (This essay was included, without explanation, in Gregory Battcock's 1973 anthology, *Idea Art*.)[20] With more ambivalence though no less acuity than his peers, Crow observed that Bernstein's maneuver solved the problem of content, and noted dryly, "The referent is in theoretical bad odor these days."[21] The subject of the new art,

Crow believed, was almost tautologically reflexive: it examined the conventions by which high art is sorted from low, but had no rationale that was not nearly circular. "In narrowing artistic mimesis to the realm of already existing signs, these artists simply accept, with a serene kind of confidence, the distinction between what the modern cultural economy defines as art and what it doesn't. . . . The sheer, unquestioned difference in coding between art and non-art becomes the primary meaning of this new art," Crow wrote.[22] His argument does not lack force. But it misses, perhaps, the emotional and intellectual urgency experienced, and expressed, by these artists. Challenging a system that had patronized women, at best, when they spoke unabashedly in the first person, these artists found exceptionally inventive, and varied, ways of insinuating themselves into the modes, the media, and the subject matter controlled by men, prodding their weak spots—and, sometimes, their funny bones—from within.

Institutional Critique

A second major area of exploration for deconstructivist artists was the power invested in art-world institutions, and its patterns of circulation. "It is not, after all, by chance that the era of modernism coincides with the era of the museum," Crimp wrote. "So if we now have to look for aesthetic activities in so-called alternative spaces, outside the museum, that is because those activities, those pictures, pose questions that are postmodernist."[23] In the early and middle 1970s, a weak economy and stagnant art market, supplemented by relatively generous public funding, gave artists—and independent art spaces—an unusual degree of freedom to explore uncharted patterns of financial influence, and to plot escape from them. On the other hand, by the middle 1980s the economy was booming, and certain kinds of art, expressionist painting in particular, had become what Peter Schjeldahl memorably called "the sex life of money." Conceptual strategies nurtured in lean years found equally provoking targets amid rampant consumerism, which only exacerbated inequities of gender (and of race and class).

Feminist artists had first militated against exclusion from museums and galleries in the late 1960s; a decade later, and with the benefit of ideas that not only clarified the expressions of patriarchal power in language and visual representation at large but also, more concretely and visibly, in the distribution of museum and gallery exhibitions, women could launch more subtle—and less blatantly personal—critiques. At the same time, gender activism became more fractured. The catastrophic explosion of AIDS in the 1980s contributed

to a radical reorganization of thinking about sexual identity and its aesthetic mandates. The impetus provided by feminists and, increasingly, by gay activists led to new examinations not only of who is seen and heard within presentation venues, but also in academia, and in the publications affiliated with it and with the art world (some of which, naturally, overlap).

At the same time, the rise of theory-based writing and freestanding publications as sources of conceptual content—and, sometimes, as house organs—for postmodernism was itself a phenomenon that called for examination. Owens was among the few to acknowledge the sexism in much Marxist analysis; other points of contention arose from the fact that many academic theorists worked within university literature or philosophy departments, and tended to treat artworks as symptoms rather than causes; that art historians and theorists didn't play well together; and that nobody had much respect for journalism, often used as a term of contempt for the practice pursued by art critics. As the art world grew, exponentially, over the period at issue, the question of who were the real arbiters of taste (and, implicitly, of financial success)—galleries, collectors, curators, famous artists, mainstream critics—grew ever harder to resolve.

Perhaps because these questions bore particular meaning for women, who were badly outnumbered among the ranks of the most visible, widely-collected and highest-earning artists, women featured disproportionately among those working to examine just what the system's mechanisms were. Louise Lawler's in situ photographs of contemporary artworks that had found their ways into private, corporate and museum collections—the up-market paintings, prints, and photos are shown in board rooms and Xerox cubicles, above sofas and in storage—are eloquent, dismaying and, sometimes, very funny, despite their formal elegance. Similarly, Silvia Kolbowski created installations that insinuated suppressed information into, for instance, period rooms at the Metropolitan Museum of Art, as in *Enlarged from the Catalogue* (1987–90). Like Kruger, Jenny Holzer spoke in the various accents of political and cultural authority to categorize its effects, beginning, famously, with the *Truisms* [see pages 112–13] she began plastering on walls in SoHo in 1977. Foster incisively compared the work of Lawler, Kruger, Holzer and others to "a dye in the bloodstream" that "delineate[s] the circulation system of art."[24] Discussing Lawler's "Arrangements of Pictures," [see pages 124–25] Foster contended that she "reframes in photographs the various ways in which different collectors—museums, corporations, the old and new rich—invest art with value by 'sumptuary expenditure,' guarantee this value by reference to an institutional code of proper names... and display it as a marker of taste, hierarchy, prestige or simply investment."[25] About Holzer's *Truisms*, he observed that they demonstrate "that meaning is a rhetorical construction of will more than a Platonic apprehension of an idea—that, however directed toward truth, it is finally

based on power." Foster didn't see this as a simple identification of a problem, but as a part of a dialectical challenge to it. "This is not a nihilistic insight," he wrote, since "it allows for resistance based on truth constructed through contradiction. . . . Only through contradiction can one construct a self that is not entirely subjected."[26]

No one, however, was more focused on the instruments and institutions of cultural power than the anonymous collective known as the Guerrilla Girls, who exploited sophisticated graphic and textual strategies—including a judicious use of humor—in print ads for New York City public buses and for commercial billboards (among other outlets); in no uncertain terms, these ads kept score on just how bad it was for women in the art world, naming museums and galleries that failed to represent them in anything like equal numbers with men, and quantifying the extent of the discrimination.

At the same time, much deconstructive work aimed outside the limited precincts of the art world; the news and fashion industries were particularly rich fields for critique. Lorna Simpson's photographs of African-American women shown from the back paired with words or short phrases are determinedly open-ended considerations of the conventions for seeing and labeling women of color. Sarah Charlesworth's consummately delicate excisions of text or photographs from various major newspapers' front pages reveal unexpected patterns of reader/viewer presumption—and ignorance. Adrian Piper's "Vanilla Nightmares" [see pages 134–35] subvert pages of the *New York Times* with hand-drawn images of decidedly provocative dark-skinned intruders. And the video *Martha Rosler Reads Vogue* (1982) [see page 137] is a perfect deadpan of academic analysis. In fact, the deployment of academic language, in earnest or with varying degrees of irony, was an important way of examining institutionalized power. Perhaps the most telling aspect of Martha Rosler's deadpan video *Semiotics of the Kitchen* (1975) [see page 136]—in which she demonstrates the uses of her thoroughly ordinary cooking utensils (each is shown to be, incidentally, a weapon of war between the sexes)—is not its content but its title.

In these appropriations of news and fashion publications, as in artworks that undertook similar observations of the ways and means of the entertainment industry—Hollywood films and broadcast TV in particular—celebrity was an important subject. Dara Birnbaum's justly renowned video *Technology/Transformation: Wonder Woman* (1978) [see page 89], which finds both transcendent strength and abject absurdity in the heroine's supernatural powers, takes advantages of naturally occurring foolishness in commercial television series, as does Judith Barry's *Casual Shopper* (1981) [see pages 86–87], which joins the regulated rhythms of soap operas to the hidden persuasions of television advertising in a video that links unconsummated love with unfulfilled consumer appetites (and was made, Barry says, with Mulvey's

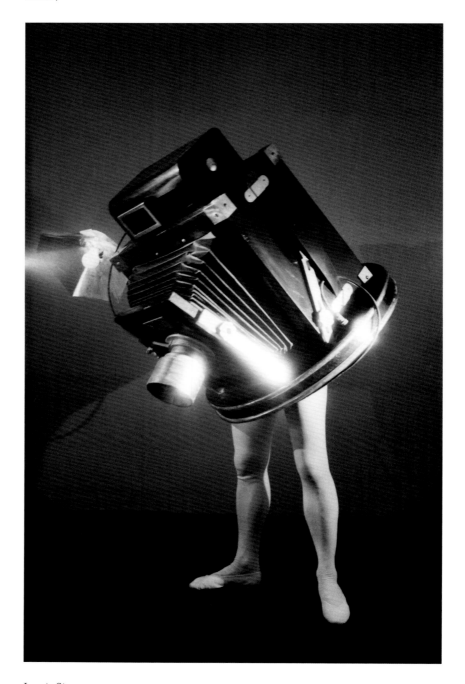

Laurie Simmons

Walking Camera I (Jimmy the Camera), 1987.
Gelatin silver print, 84 x 48 in. Courtesy the artist

"Visual Pleasure and Narrative Cinema" explicitly in mind). As is true of both these works, many deconstructivist videos applied then-new technology to play with linear narrative and temporal progress, using fragmentation, stopped action, reversal, and looping to fudge the differences between still photography and moving pictures—and also to erode boundaries between fine art and popular culture. In some cases, artists went so far as to blur the distinction between camera and body, as in Lynn Hershman's "Phantom Limb" series (1988–90) [see pages 107–9], which joins sexy bodies to video heads, and Laurie Simmons's iconic *Walking Camera* image (1987), a close relative of her "Walking House" photos (1989) [see page 153], hybrids that join women's legs with inanimate—and sometimes overbearingly oppressive—objects.

Of course Cindy Sherman, Sherrie Levine, and others who borrowed postures and pictures from movies, television, and the print media were addressing issues of celebrity and its depredations as well. And although, as Foster wrote, "the line between the exploitive and the critical is fine indeed," and "neither an austere refusal of the mass-cultural nor a dialectical involvement with its imagery and materiality is necessarily critical,"[27] the ethical and cultural judgments impelling the great majority of this work is fairly clear.

Psychoanalysis

It can be observed that among appropriators of mass-cultural imagery, some broad (and necessarily crude) gender-based distinctions are visible. Whereas women inclined toward imagery featuring female subjects, or, implicitly, female viewers, the men just as reliably gravitated toward male imagery and appetites: Marlboro men, pornography (as in, respectively, Richard Prince's photo-appropriations and David Salle's paintings). Indeed much of the women's work involved frank, personal reflection on childbirth and parenting; on distinctively female experiences of sensual pleasure and of sexual violence; and, often, on the way such introspection had been framed by psychoanalytic theory.

As Owens pointed out, Rosalind Krauss's writing, including especially her recourse to theorists unfamiliar to most American readers (including artists), was critical to the development of postmodernism, and psychoanalytic thinking was (and remains) a key element of her intellectual arsenal. This is also where a number of other women theorists enter the picture, as has already been noted (and as Griselda Pollock discusses in her essay for this book). Their cumulative contribution involves a couple of important paradoxes.

First, what they emphasized was the unspeakable—the extra, the liminal, the unsayable—that is the essence of the unconscious, and that can be expressed (and seen) obliquely at best. "It is often forgotten," Jacqueline Rose writes, "that psychoanalysis describes the psychic law to which we are subject, but only in terms of its *failing* [emphasis hers]."[28] Even more notable was their application of psychoanalysis as a way of departing from subjectivity; as understood by the cultural theorists who took it up, psychoanalytic theory was not a tool for plumbing an individual's depths so much as for acknowledging the impossibility of finding the center. As Foster rather bluntly put it, "As a strategy in modern art, extreme subjectivity *was* critical once . . . it is not so now."[29] The eager endorsement of Lacan's abstruse writing, and particularly the extrapolation from it of ideas about the implacable potency of the patriarchy in shaping experience, was, Pepe Karmel has pointed out, fraught with irony. "It seems strange, in retrospect," he writes, "that feminist critics should so enthusiastically have embraced a theory that made the very identity of women hostage to the male imagination."[30] The point could be made even broader by noting the continued importance of Freud (as in the writing of Krauss and others), a man notoriously baffled by female desire.

Ironies and paradoxes notwithstanding, and critical injunctions be damned, a good number of the women associated with deconstructivism looked not only outward, to the structures of constraint, but also inward, to how they felt: to their subjective lives. This was no less true in the late 1970s and 1980s than in the widely (and unfairly) discredited essentialist feminist period that preceded these years. Among the works included in this exhibition, Mary Kelly's analysis of the early days of motherhood is perhaps most explicitly grounded in psychoanalytic theory. But Susan Hiller also reflects an interest in liminality throughout her work, from her exercises in automatic writing to her consideration of the extra-objective sounds and images that might be seen to emanate from mechanical and electronic equipment, including cameras and televisions—a kind of unconscious of inanimate things. Domestic life, including its romantic vicissitudes, is the subject of Carrie Mae Weems's "Kitchen Table Series" (1990) [see pages 158–61], an extended group of photographs all shaped by the tension between the characters depicted and the social norms against which they chafe. Laurie Simmons's prim little photographs of domestic tableaux feature dolls that enact, with propriety both doleful and comic, the lives of housewives in some hazy mid-twentieth-century suburban dreamland just tipping toward nightmare. And although the voice Holzer adopted early on for her laconic texts was, because so incontrovertibly authoritative, also at first notionally male, the subject of her writing became, increasingly, harrowingly explicit about aggression against women, including not just casual misogyny but also sexual violence, whether between partners or as a weapon of war.

Feminism

In claiming that deconstructivism, or postmodernism, is in some significant measure a feminist impulse, it becomes necessary to consider whether the artists enlisted for this argument define themselves as feminists. An easy answer is that all the participants whom we contacted were enthusiastic about this exhibition's theme. But it is important and informative to look back to the period when this work emerged to get a sense of what the feminist stake was in the new theory-driven (or at least theory-friendly) work. In the first of a series of public conferences at the Dia Center for the Arts, in 1987, one evidently tense exchange concerned the relevance of identity politics in redefining the public's engagement with—or access to—the challenging new art. In this context, Martha Rosler said to Thomas Crow, "Tom, I'm shocked by your suggestion that it was somehow groups like women who dragged the discourse away from the pursuit of some imaginary high public." Crow's response included this explanation: "Let me clarify. All these groups—women, Puerto Ricans, whatever others—they're not all the same: there are arguments among women, arguments among urban ethnics, and these arguments are where the politics are. Defining them as audiences strictly in terms of gender, ethnicity or region is precisely the conceptual problem."[31] While perhaps awkwardly phrased to our ears, Crow's point seems inarguable; none of these identities is simple or unitary. In a later session of the same conference, Barbara Kruger said, "The idea of the female is a process of becoming: it is more a verb...than a noun.... There is a multiplicity of feminisms, and a multiplicity of ways to embody the multiplicity. I see feminism as a horizontal site of many positions—which is not to say we are in a 'postfeminist' period."[32] But many women, Rosler among them, saw that occupying the high ground—addressing the "imaginary high public," as she put it—seemed to require giving up one's commitment to engaging artistically with the particularity of being a woman.

In 2008, Douglas Eklund, who organized the "Pictures Generation" exhibition at the Metropolitan Museum of Art, wrote, "[Cindy] Sherman and Laurie Simmons have both commented on the divide between them and the elder generation of explicitly feminist artists. They felt no need to identify themselves as feminist.... To make their art explicitly feminist seemed like allegiance to a cause that did not account for the specificity of individual experience.... For them, gender and sexuality were part of a larger nexus between representation and power." Eklund reports that Jeff Wall "referred jokingly (but with an edge) to Ericka Beckman, Dara Birnbaum, Sarah Charlesworth, Jenny Holzer, Louise Lawler, Sherrie Levine, and Barbara Kruger, among others, as 'the theoretical girls,'"[33] a term that seems plainly dismissive. But even Eklund notes that "in the broader art world at that time, appropriation (and

photography itself as the Ur-form of appropriation) was understood as a female pursuit, in contrast to the explicitly male arena of painting."[34] Occasionally, he is forced, as a result, into such formulations as, in a description of Dara Birnbaum's videos, "The feminist message is so clear as to be almost secondary."[35]

The artist and writer Mira Schor addresses these issues with great clarity, if also understandable anger. "1970s feminism [was] condemned to the essentialist scrap heap of history by certain aspects of postmodernist discourse predominant in the 1980s," she writes. "Those involved in a critique of totalizing systems and essences seemed to display totalizing impulses of their own: to replace Woman with the concept of Human Vehicle for constructed gender signifiers, a shift that continues to leave out the more complex lived experience of interwoven biological and social construction."[36] In other words, theory-based work, guilty of its own simplifications, forced active feminism underground, although its imperatives retained their force and its goals remained unmet. Extending her argument, Schor quotes Jane Elliott: "We sidestep the difficult realization that while intellectual work should be exciting, political work may be dull, that things may stay true longer than they stay interesting."[37] Without doubt, inequities remained in the 1970s and 1980s, despite the attention with which some of the artists in this show were favored—and despite the fact that a great deal of their work can be seen as determined attacks on those injustices, launched from another angle than that taken by their immediate feminist predecessors. Nor can it be doubted, regardless of all that has happened since, that inequities remain today.

Before and After

Just as the ideas that impelled the work in this show can be seen reflected in an enormous range of art made subsequently, postmodernist deconstructivism drew from many sources. As a recent exhibition at the Metropolitan Museum of Art in New York revealed, Victorian women were making elaborate collages with *cartes de visite* featuring photographs, using the late nineteenth century's premier social networking medium to create remarkably sharp critiques of an emerging phenomenon: celebrities famous mostly for being well known. More immediately germane are more obvious and proximate sources: the postmodern generation was, as is often noted, the first brought up on television, which by the 1970s had introduced "reality" programming (*An American Family*, a public television series documenting the life of the Loud family that first aired in 1973) and was already parodying its own successful genres—

variety shows, comedy hours, soap operas—with hits like *Saturday Night Live* (which was launched in 1975), and *Mary Hartman, Mary Hartman* (1976–77). The monopoly on viewers held by the major networks was broken with the explosion of cable TV; one of its most popular new networks was MTV, launched in 1981. Meanwhile, Hollywood movies had grown increasingly spectacular, and new technologies greatly enhanced the dramatic power of advertising, which became ever more widespread.

To be sure, the landscape of popular culture, of commercial television, Hollywood films and consumer advertising had already been surveyed by Pop art in the 1950s and 1960s; it can be glimpsed in Surrealism and Dada as well. (The Whitney Museum's 1990 exhibition "Image World," which surveyed the new photo-based postmodern work, began its story with Rauschenberg, Warhol, and Wesselman.) The theorists of postmodernism were fully aware that the line between Pop and latter-day image appropriationists was not always clean and bright, and some were at pains to clarify the distinction. Krauss, for instance, offered this discrimination: "The gendered body, the specificity of site in relation to its political and institutional dimensions—these forms of resistance to abstract spectatordom have been, and are now, where one looks for whatever is critical, which is to say non-Imaginary, nonspecular, in contemporary production. All the rest, we would have to say, is pure pop."[38] In short, where artists met the established codes of visual representation with vigor, wit, and perseverance—with, perhaps first and foremost, determined awareness of gender—postmodernism happened.

Nancy Princenthal is a New York-based writer and former Senior Editor of Art in America. *Her monograph on Hannah Wilke was published by Prestel in 2010.*

1

Craig Owens, "The Discourse of Others: Feminists and Postmodernism" in *The Anti-Aesthetic: Essays on Postmodern Culture*, edited and with an introduction by Hal Foster (Port Townsend, Wash.: Bay Press, 1983), 58.

2

Hal Foster, "Postmodernism: A Preface," *The Anti-Aesthetic*, xiii.

3

Anders Stephanson, "Interview with Craig Owens," in Craig Owens, *Beyond Recognition: Representation, Power and Culture*, edited by Scott Bryson, Barbara Kruger, Lynne Tillman, and Jane Weinstock (Berkeley and Los Angeles: University of California Press, 1992), 303.

4

Hal Foster, "Subversive Signs," in *Recodings: Art, Spectacle, Cultural Politics* (Seattle: Bay Press, 1985), 100.

5

Kate Linker, "Foreword and Acknowledgments," in Linker, Craig Owens, Lisa Tickner, Jacqueline Rose, Peter Wollen and Jane Weinstock, *Difference: On Representation and Sexuality* (New York: The New Museum of Contemporary Art, 1984), 5.

6

Laura Mulvey, "Cosmetics and Abjection: Cindy Sherman 1977–87," in *October Files 6: Cindy Sherman* (Cambridge, Mass.: MIT Press, 2006), 66–67; this text revised 1996.

7

Stephanson, "Interview with Craig Owens," 299.

8

Owens, "The Discourse of Others," 63.

9

Douglas Crimp, "Pictures," *October* 8 (spring 1979): 87.

10

Roland Barthes, "The Death of the Author," in *The Rustle of Language* (Berkeley and Los Angeles: University of California Press, 1989), 52–53.

11

Jean Baudrillard, *Simulations*, translated by Paul Foss, Paul Patton, and Philip Beitchman (New York: Semiotext(e), 1983), 151–52.

12

Owens, "The Allegorical Impulse: Toward a Theory of Postmodernism, Part 2 (1980)," in *October Files 6*, 21.

13

Owens, "The Discourse of Others," 59.

14

Foster, "The Expressive Fallacy," in *Recodings*, 67.

15

Owens, "The Allegorical Impulse," 19.

16

Rosalind Krauss, "Cindy Sherman: Untitled (1993)," in *October Files 6*, 103.

17

Johanna Burton, "A Body Slate: Cindy Sherman (2004)," in *October Files 6*, 198.

18

Abigail Solomon-Godeau, "Suitable for Framing: The Critical Recasting of Cindy Sherman (1991)," in *October Files 6*, 57.

19

Solomon-Godeau, 58

20

Thomas Crow, "The Return of Hank Herron," in Crow, Yve-Alain Bois, Elisabeth Sussman, David Joselit, Hal Foster, and Bob Riley, *Endgame: Reference and Simulation in Recent Painting and Sculpture* (Cambridge, Mass.: MIT Press and Boston: Institute of Contemporary Art, 1986), 11.

21

Crow, 12.

22

Crow, 20.

23

Crimp, "Pictures," 88.

24

Foster, "Subversive Signs," in *Recodings*, 106.

25

Foster, "Subversive Signs," 104.

26

Foster, "Subversive Signs," 109.

27

Foster, "Against Pluralism," in *Recodings*, 29, and "Between Modernism and the Media," in *Recodings*, 33.

28

Jacqueline Rose, "Sexuality in the Field of Vision," in *Sexuality in the Field of Vision* (New York: Verso, 1986), 232.

29

Foster, "Against Pluralism," in *Recodings*, 17.

30

Karmel, "Oedipus Wrecks: New York in the 1980s," in Stephanie Barron and Lynn Zelevansky, *Jasper Johns to Jeff Koons: Four Decades of Art from the Broad Collection*, with essays by Thomas Crow, Joanne Heyler, Pepe Karmel, and Sabine Eckmann (Los Angeles: Los Angeles County Museum of Art and New York: Harry N. Abrams, 2001), 122.

31

"The Birth and Death of the Viewer: On the Public Function of Art/Discussion" in *Dia Art Foundation Discussions in Contemporary Culture: Number One*, edited by Hal Foster (Seattle: Bay Press, 1987), 26–27.

32

"Strategies of Public Address: Which Media, Which Public/Discussion" in *Dia Art Foundation Discussions*, 49.

33

Douglas Eklund, *The Pictures Generation, 1974–1984* (New York: The Metropolitan Museum of Art and New Haven: Yale University Press, 2009), 143–44.

34

Eklund, 157.

35

Eklund, 171.

36

Mira Schor, "The *ism* that dare not speak its name," in *A Decade of Negative Thinking: Essays on Art, Politics, and Daily Life* (Durham: Duke University Press, 2009), 27.

37

Schor, "Generation 2.5," in *A Decade of Negative Thinking*, 60.

38

Krauss, "Theories of Art after Modernism and Pop," *Dia Art Foundation Discussions*, 64.

Feeling Things

Things Fetishism and the Sex Appeal of the Inorganic

Tom McDonough

> . . . not only an object for the subject, but also a subject for the object.
> — *Karl Marx, "Introduction to a Critique of Political Economy"*

I n an untitled work of 1981, Barbara Kruger frames a stock black-and-white photograph of two empty gloves, entwined as if holding hands—a smooth woman's calfskin and a rougher man's driving glove—with a caption reading, "You are seduced by the sex appeal of the inorganic." The gloves certainly do suggest living bodies: they seem filled with some vital energy and appear truly to grasp one another, with the thumb and forefinger of the light-colored woman's glove suggestively encircling the dark fabric of the man's thumb in a mime of sexual penetration. The whole scene is tightly composed, the two objects forming an inverted V in the center of the photograph, and strongly lit from a low angle, so that they cast a long shadow against the fabric on which they are positioned. But the graphic concision of this image is countered by the text, in white bold letters on bright red ground, distributed in the top corners of the work and along its bottom border. Craig Owens, in an oft-cited analysis, explained Kruger's practice as one that took up "the instant legibility of graphic-design techniques" in order precisely to reveal it as a powerful means of constructing stereotypes. "For that legibility," he noted,

> is engineered to produce an immediate subjection, to imprint . . .
> the image directly on the viewer's imagination, to eliminate the need
> for decoding. Kruger's juxtapositions of images and texts produce
> the opposite effect: they impede circulation, postpone subjection, invite
> us to decode the message.[1]

This was, according to an influential reading, the promise of the critical work on images undertaken by a generation of artists that included Kruger, Jenny Holzer, Cindy Sherman, and others: that the representations circulated within media culture constituted a form of control that might be subverted through appropriation and recontextualization. In Kate Linker's succinct formulation, "the feminist approach to art and media has . . . entailed a broad critique of signification, for all representations position their viewers, allowing for active participation in or," more commonly, "subjection to meaning" as merely passive consumers.[2]

Almost three decades after Kruger's montage, the June 2010 issue of *Vogue Italia* features a different image of "the sex appeal of the inorganic": another stock photograph, this time of a giant, red high-heeled shoe covered in lights and placed, like some kind of advertisement, atop a pole. It illustrates an article entitled "The 'Sex' of Things," which revisits Italian philosopher Mario Perniola's 1994 book, *The Sex Appeal of the Inorganic*. As recounted in *Vogue*, Perniola's central claim is that *"we can't distinguish the clothes from the body anymore*. Skin is a fabric and clothes are a second skin, and it's becoming impossible to tell them apart."[3] Noting the clothing metaphors that might describe intimate contact, noting the very similarities of our sexual organs to fabric and furniture, he writes,

> The fleshy clothing of our bodies, liberated from time and suspended in
> an enchantment without expectation, are the object of an infinite and
> absolute sexual investment that would seem more appropriate to a tailor,
> a seamstress, an upholsterer gone mad than to a philosopher.[4]

The identification of body and thing critiqued by Kruger is here celebrated as a peculiarly postmodern passion; Perniola insists that "the kingdom of things is not so much the triumph of technology and capitalism as much as the empire of a sexuality without orgasm." He is describing a rejection of the realm of organic sexuality, which was based on sexual difference and driven by desire and pleasure, in favor of one that is neutral, inorganic, and artificial.[5] Sexuality breaks from nature, from any vital or procreative drive, and humans—in a world in which they have externalized themselves to an unprecedented degree—have become, in Perniola's term, "feeling things," objects without subjects, things among other things. The fundamental opposition or distinction between objects and human beings that subtends Kruger's project—and by extension, much of her generation's—is, in this view, being transformed as a new conjunction of the two takes shape. "We are witnessing a strange inversion," he writes. "Humans are becoming more similar to things, and equally, the inorganic world, thanks to electronic technology, seems to be taking over the human role in the perception of

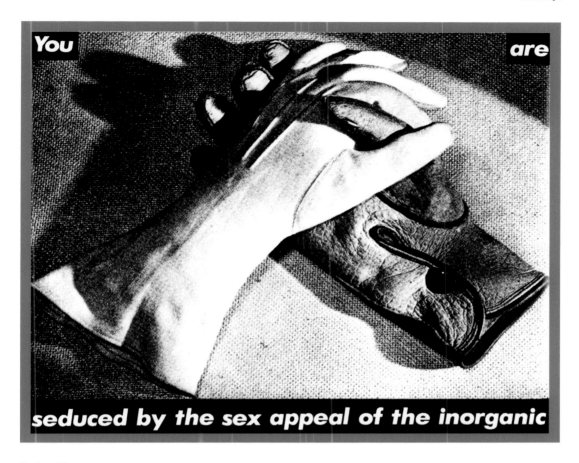

Barbara Kruger

*Untitled (You are seduced by the sex appeal of
the inorganic)*, 1981. Photograph, 38 x 51 in. Courtesy
Mary Boone Gallery, New York

events."[6] In Perniola's view, we are *all* seduced by the sex appeal of the inorganic, but far from the subjection implied in Kruger's work, he understands this collapse of categories to open up new modalities of non-identificatory, de-subjectifying experience.

Let us set aside for the moment the question of why, sixteen years after its first publication, *Vogue* chooses to revisit this text by Perniola, and posit that any attempt to assess

the legacy of the Pictures generation's critique of media culture—and the place of feminism within it—must come to terms with this gap between him and Kruger. One approach may be to look more closely at the phrase they share: "the sex appeal of the inorganic." As has often been remarked, it derives from Walter Benjamin's examination of the place of fashion within capitalist modernity. The nature of fashion, Benjamin wrote,

> resides in its conflict with the organic. It couples the living body to the inorganic world. Against the living it asserts the rights of the corpse. Fetishism, which is subject to the sex appeal of the inorganic, is its vital nerve. The cult of the commodity places it in its service.[7]

The sex appeal of the inorganic is, then, his formulation of the Marxist concept of the commodity fetish, although he shifts the emphasis so that our attention is drawn less to the thing-become-human than to its concomitant, the human-become-thing. The language in this passage is characterized by sexual references, mostly to a fallen state: fashion *couples* —Benjamin uses the verb *verkuppeln*, to procure or prostitute—the body to the inorganic; for Freud, on whom Benjamin drew as much as on Marx, fetishism's motive force is a *subjection* or succumbing (*unterliegen*) to the sexual appeal of the not-living. Our embrace of fashion, then, has long been seen as a necrophilic love for what is dead, a manifestation of *thanatos*. Something of this perspective is contained within the history of the term "sex appeal" itself, which appears in English in Benjamin's text. "Sex appeal" is in fact an Americanism, coined in the early twentieth century and closely linked to the dynamic of modernity. It was first used to describe representations, not individuals: plays and novels that took up the theme of sexual relations had "sex appeal." Only afterward was that quality transferred to persons, particularly of course to women, via the intermediary of the actress.

But from a very early moment, it was tied to the body conceived as a commodity; in his preface to *A Song of Sixpence*, a naturalist drama of 1913, Frederic Arnold Kummer could already ask, "Did not the fact that the vast majority of women devote the bulk of their time and energy to personal adornment argue that they themselves regard sex appeal as their most valuable asset?"[8] Sexual attractiveness came to be seen as a form of property, a personal capital to be carefully nurtured and guarded in a commodity-defined fetishization of self. As Stuart Ewen has remarked, the same period that saw the invention of the term "sex appeal" also imposed a continuous self-interrogation as to whether one's "self," body, and personality were viable in the socio-sexual marketplace. "Women," he writes, "were being educated to look at themselves as things to be created competitively against other women" within the context of

capitalist exchange.[9] If this was an emergent element of pre-1930s American society—already, as we have seen, inflecting its very vocabulary of selfhood—it would become not merely dominant but structurally central to the post-Fordist economy that had developed by the late 1970s. Our current information economy impels us all to mobilize self, body, and personality as productive forces. Self-fetishization has migrated from the morally dubious realm of the theater and film to femininity, before becoming a universal command to late capitalist subjectivity.

This is the terrain that has been explored most thoroughly by Cindy Sherman in various bodies of photographs produced since the mid-1970s. Critical consensus has positioned these works as instruments for demythologizing and deconstructing mass-media representations of the "feminine," and as an undoing of the very assumption of a coherent self as guarantor of individuality. And yet if the early "Film Stills" do have something parodic about them—if Sherman's campy, theatrical reenactments and "starlet veneer" point toward a dissonance between image and reality—this quality becomes less and less evident in subsequent photographs. The "Centerfolds" of 1981, first undertaken as a commission for a *Playboy*-style project in *Artforum*, are instead characterized by a psychological tension between the intimacy of the artist's body, which she positions in close proximity to the camera, and the remoteness of the personae depicted. These photographs, as one critic noted, "ultimately close the viewer off; the women depicted are isolated within the photograph's field of reference," their gazes almost never directed toward the viewer.[10] *Untitled #88* (1981) [see page 46], for example, shows Sherman as a young girl, in sweater, skirt, and socks, crouching with her knees pulled up and encircled by her left arm as she cradles her chin with her right hand. She is lit from below and slightly to the left by a warm, red lamp that seems to mimic a fireplace, and remains enveloped in shadow. While bathed in indeterminate darkness, the setting appears domestic, which is typical of the series—here, there is the suggestion of a quilted blanket or cushion behind Sherman. We look down on her as she stares off into the middle distance, at nothing in particular, apparently lost in thought. It is a construction of pure interiority, the depiction of a subject wrapped upon herself; although she exists only to be seen, the viewer's presence remains irrelevant.

In this and related works, critics glimpsed "vulnerability, suffering, anticipation, desire," crediting Sherman with both exploiting and undermining the conventions of commercial, mass-cultural representations.[11] This was understood to be a paradox, but perhaps by the later twentieth century it would have been more accurate to say that such emotional

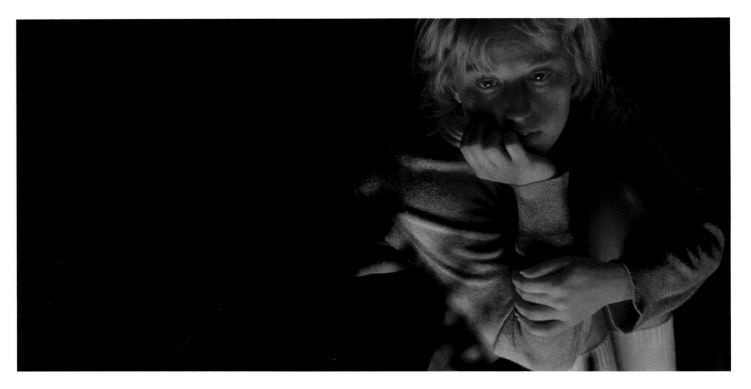

Cindy Sherman

Untitled #88, 1981. Color photograph,
24 x 48 in. Courtesy the artist and Metro
Pictures, New York

states—the signs of interiority—were lived precisely as convention, as representation. To put it in other terms, the gap between image and reality, which a certain critical feminism sought to deconstruct, had already given way to a thoroughgoing collapse of the two. In these photographs, Sherman does not counterpose her projected interiority to the strident exteriority expressed by the typical centerfold pose: smoldering looks directed out to the viewer, frontal display of the body and its sex. The centerfold, as we say, "objectified" women; Sherman's centerfolds seem to "subjectify" them. But this is hardly a liberatory gesture in any straightforward sense. In her mature work, interiority itself has become a commodifiable state.

Fashion, as we have seen, has long been the linchpin conjoining the body and the realm of the inorganic, and so it is far from fortuitous that some of Sherman's most compelling work from the early 1980s was commissioned as magazine advertisements by the modish New York boutique Dianne B. In late 1982 she was asked to produce images using the designer labels carried by the store, and the resulting photographs literalize the dynamic already operative in previous works: we witness Sherman inhabiting the body as a thing. *Untitled #122* (1983) [see page 145] is the most remarkable of the series: the artist stands, at a slight angle and lit harshly from above, in a black jacket and long straight skirt, wearing a disheveled blond wig, one lowering eye peering out at nothing from between her bangs, shoulders hunched, her hands clenched into fists. She is all suppressed rage, filling the over-life-size print—it is more than 6 feet tall—from top to bottom, a menacing column of contained energy. In discussing the process of making these images, however, Sherman discounts any notion of character: "I don't feel that I *am* that person. . . . I don't become her. There's this distance. The image in the mirror [placed before her tripod] becomes her—the image the camera gets on the film."[12] Reflection and image trump subject or, rather, lure the subject into their halls of mirrors to become a thing. Fashion is displayed along with its mechanisms of seduction, and Sherman's figure in this photograph looks more and more like death itself. But death here hardly appears in tragic guise; *Untitled #122* is rather a comic work, almost cartoonish in its sputtering rage. It should hardly surprise us to find that Doris and Charles Saatchi were early owners of an edition of this work (along with eighteen other of Sherman's photos by 1983). The advertising mogul must have recognized, at some level, the devices his own firm deployed in service of the "cult of the commodity."

If one task of this essay has been to come to terms with the contemporary resonance of Benjamin's notion of "the sex appeal of the inorganic" and its ramifications through theoretical and aesthetic practices of the 1980s and later, we might bring one further text into play alongside that of Perniola: the so-called *"théorie de la Jeune-Fille"* developed by the neo-Situationist editorial collective of *Tiqqun*, a short-lived Parisian journal of the late 1990s. The "Young Girl" is by no means intended as a gender-specific term—it does not refer only to women, but is rather a cipher for a fungible post-Fordist subject constructed within a commodified and image-based late capitalist social order. Or, as the group explicates the concept on the final page of their initial description of this figure, in a text that alternates with rows of advertising images of young men and women culled from glossy magazines:

The Young Girl is the most luxurious piece of merchandise circulating in today's perishable-goods market; the principal commodity of the fifth industrial revolution, the one used to sell all the others, from toothbrushes to nuclear power plants; the monstrous yet entirely real dream of the boldest, most fanciful of tradesmen—the autonomous commodity that walks, talks, and imposes silence, *the thing at last living* that no longer understands life but digests it. Three millennia of relentless hard work by billions of fat shopkeepers, generation after generation, finds its magnificent culmination in the Young Girl: she is *the commodity it is forbidden to burn*; the stock that produces itself; inalienable and untransferable property for which one must, however, pay; virtue that is constantly minted. She is the whore that demands respect, death moving by itself, she is the law and the police, all in one.... Who has not, in a lightning flash, glimpsed her absolute and funereal beauty, *the sex appeal of the inorganic?*[13]

Despite the somewhat extravagant rhetoric—*Tiqqun*'s inheritance from Guy Debord, the Situationists' key theorist—this is perhaps the most coherent statement of the centrality of self-fetishization, of the reification of subjectivity itself, within our current regime of immaterial labor. If durable goods (paradigmatically, automobiles) were the star commodities of Fordist production, today we produce selfhood—the sense of "possessing" autonomous agency, youthful beauty, personality. The "Young Girl" epitomizes this condition in its collapse of representation and reality: image and being have become one.

Sherman's work provides the model for one possible response to such a state of affairs. It plays in an exciting *and* troubling fashion with the experience of reification, of becoming a thing. Perniola's injunction for us to become "feeling things" contains in this sense some measure of critical charge, insisting that if we cannot simply return to a prelapsarian state before the commodification of self, we can at least find margins for action within it. This seems to me the point made recently by artist Hito Steyerl when accounting for precisely the linkages between feminist artistic practices of the 1980s and the present. Having cited Perniola, Steyerl writes that "a desire to become this thing . . . is the upshot of the struggle over representation."[14] Practices that have taken up and advanced Sherman's multiplication/undoing of self—such as Bernadette Corporation—suggest that the contours of a new refusal of identity lie in a process of working through reification.[15] It is not a question of asserting some more "authentic" self beyond the image, but of discovering the subversive potential of the Young Girl and the seductiveness of the sex appeal of the inorgnic.

Tom McDonough is Associate Professor of Art History, Binghamton University, State University of New York, where he teaches the history and theory of contemporary art. His most recent book is the anthology The Situationists and the City.

1
Craig Owens, "The Medusa Effect, or, the Specular Ruse," in *Beyond Recognition*, ed. Scott Bryson, Barbara Kruger, Lynne Tillman, and Jane Weinstock (Berkeley: University of California Press, 1992), 195.

2
Kate Linker, *Love for Sale* (New York: Harry N. Abrams, 1990), 63.

3
Edoardo Acotto, "The 'Sex' of Things," *Vogue Italia*, June 2010; accessed June 10, 2010, at http://www.vogue.it/en/people-are-talking-about/that-s-too-much/2010/06/the-sex-of-things.

4
Mario Perniola, *The Sex Appeal of the Inorganic*, trans. Massimo Verdicchio (London and New York: Continuum, 2004), 11.

5
Perniola, *The Sex Appeal of the Inorganic*, 11.

6
Perniola, *Enigmas: The Egyptian Moment in Society and Art*, trans. Christopher Woodall (London and New York: Verso, 1995), viii.

7
Walter Benjamin, "Paris, Capital of the Nineteenth Century," in *Reflections*, ed. Peter Demetz, trans. Edmund Jephcott (New York: Schocken Books, 1986), 153.

8
Frederic Arnold Kummer, "Preface," in *A Song of Sixpence* (New York: Grosset & Dunlap 1913), n.p.

9
Stuart Ewen, *Captains of Consciousness* (New York: McGraw-Hill, 1977), 179–80.

10
Andy Grundberg, "Cindy Sherman: A Playful and Political Post-Modernist," *The New York Times*, November 22, 1981, sec. 2, p. 35.

11
Grundberg, "Cindy Sherman," sec. 2, p. 35.

12
Cindy Sherman, quoted in Gerald Marzorati, "Imitation of Life," *ARTnews* 82, no. 7 (September 1983): 81.

13
"Premiers matériaux pour une théorie de la Jeune-Fille," *Tiqqun* no. 1 (1999): 125.

14
Hito Steyerl, "A Thing Like You and Me," *e-flux journal* no. 15 (April 2010); accessed June 10, 2010, at http://www.e-flux.com/journal/view/134.

15
See Bennett Simpson, "Techniques of Today: Bernadette Corporation," *Artforum* 43, no. 1 (September 2004): 59–61.

Home Alone "Reversal of Positions of Presentation" and the Visual Semantics of Domesticity

Picturing domesticity in a plethora of socially and culturally inflected images, women artists reconfigured the home as a place for critique and alternative experiences from the 1960s to the 1980s. As art historian Kathy O'Dell would observe in 1998, "the body and the domestic world [are] inextricably linked,"[1] taking her lead, in part, from Vito Acconci, who wrote in 1988: "It was as if I had left home too quickly. . . . (Had to begin with my own body, had to begin at home.)"[2] Acconci had, in turn, surely borrowed the subject of home from women artists like Carolee Schneemann, who had made numerous works in and related to home, including *Fuses* (1964–67), an abstract film of her and composer James Tenney (her husband at the time) making love, observed from the vantage point of their cat Kitch sitting in their bedroom window.

While Schneemann attended to the erotic intimacy of domesticity, the home became "a ludic space" in Francesca Woodman's work of the 1970s, according to Carol Armstrong.[3] Writing about Woodman's photographic self-portraits in enigmatic domestic interiors, Armstrong acknowledged the artist's tragic suicide, but significantly separated Woodman's life from an interpretation of her work. Such a critical reading runs counter to the well-rehearsed critique of home as a place of women's oppression, devouring female creativity (among a host of other negative metaphors).[4] Conversely, thinking about home as an enabling refuge and a laboratory for discovery makes it possible to imagine home as a studio of invention, a site of unexpected creativity. While critics and art historians have largely ignored the home in discussions of art of this period, in this essay I propose that many women artists explored

presence, subjectivity, identity, and politics by drawing on the home as a catalyst for engaging and repicturing the world.

Artist Andrea Fraser was a nineteen-year-old student in the Whitney Museum of American Art's Independent Study Program when, in 1985, she applied the term "reversed positions of presentation" to Lawler's photographs, pictures that address the framing devices, sites, structures, and relations of art. Nearly twenty years later, Fraser found Lawler's work to be "performative" for its manner of "*arranging* pictures, *producing* matchbooks, *issuing* gift certificates, *sending out* invitations, and *presenting* art and institutions [Fraser's emphases]."[5] She also deemed Lawler's photographs "subversive and intrusive" for how they visualized the ways in which galleries and museums absorb artists into "collaboration and complicity."[6]

While art institutions might have co-opted experimental art by way of teamwork and collusion, Lawler, too, could orchestrate a "collaborative undertaking" by "alienating no one, conciliating all, and winning over the assistance of many," as art historian Peter Barr observed. Her method, he wrote, was "an artwork in and of itself" in which she "allow[ed] herself to become a vehicle for the ideas [for] a group that includes herself."[7] After having introduced Lawler to the well-known collectors Burton G. Tremaine, Sr. (a philanthropist and industrial executive) and his wife Emily Hall Tremaine (a collector with what architect Philip Johnson called "an original eye"[8]), curator Andrea Miller-Keller commented, "Since Louise is such a gracious, kind person who intends no ill will and is never sneaky or manipulative in how she does the work she does, they interpreted the works through their own lens—as all viewers of her work are invited to do."[9]

Such valuable first-hand observations of Lawler's interaction with the Tremaines, in photographing their New York apartment and Connecticut country home in 1983, counters Fraser's opinion, and that of many critics, that Lawler (like other "postmodern" artists of the 1980s and 1990s) was "intrusive" or even really very "subversive." As it turns out, Lawler's institutional critique matched that of the Tremaines, who were, when she became involved with them, in "ill health," "disillusioned with the art world," and "battling with several museums about what would happen to their collection following their deaths."[10] In addition to sharing an analytic view of art institutions and the practices of the art world, Lawler's ironical approach apparently paralleled that of Emily, whose close attention to aspects of display in her homes included juxtaposing "certain paintings and sculptures in ways that set up a sardonic dialogue [that was] also playful."[11]

In fact, Lawler reported that Emily quipped, after seeing her photograph *Three Women/Three Chairs Arranged by Mr. and Mrs. Burton Trumaine* (1984), in which a Léger painting hangs above three dining room chairs: "You're going to love the thermostat next to the Miro."[12] Obviously, like Lawler, Mrs. Tremaine embraced the mundane juxtapositions entailed by placing art in the home, where it shares space with ordinary objects, furniture, and technology. In other words, the Tremaines' collection was "arranged for living and viewing," the subtitle of Lawler's first exhibition of the Tremaine photographs.[13]

Lawler's first photograph from the series, *Living Room Corner, Arranged by Mr. and Mrs. Burton Tremaine, New York City* (1983) features an array of artworks in a corner of the couple's living room.[14] Several versions of this photograph exist, including one that pictures Stevie Wonder on the television set, prompting a critic to suggest that Lawler's image was an implicit critique of the Tremaines, and that it was a metaphor for how viewers remain "blind" to the odd juxtapositions of objects in the "arranged" home.[15] But Lawler's account of the photograph sharply alters this interpretation. It was she who requested that the television be turned on, and Burton Tremaine, enjoying the ironical effect she sought, immediately did so, even offering to change channels for her.[16]

The tone and photographic results of Lawler's engagement with the Tremaines contradict the idea that she, like other artists practicing "postmodern photography," aimed, as Abigail Solomon-Godeau would write, to "dismantl[e]...reified, idealist conceptions enshrined in modernist aesthetics—issues devolving on presence, subjectivity and aura," even if the effect was to do so.[17] Postmodern photography, Solomon-Godeau continued in her 1989 essay, could be distinguished by "appropriation and pastiche; its systematic assault on modernist orthodoxies of immanence, autonomy, presence, originality, and authorship; its engagement with the simulacral; and its interrogation of the problematics of photographic mass-media representation;"[18] it was, moreover, "supported and valorized for its subversive potential (particularly with respect to its apparent fulfillment of the Barthesian and Foucauldian prescriptions for the death of the author, and by extension, its subversion of the commodity status of the art object)."[19] Such a strategy represented "oppositional modernism," she added, quoting Hal Foster's introduction to *The Anti-Aesthetic* (1983).[20]

Many artists were, in fact, reading everything they could get their hands on related to structuralism and post-structuralism, linguistics and semiotics, and a host of other disciplines. Martha Rosler, for example, remembered getting an astonishing education at the University of California at San Diego by sitting in on classes taught by such thinkers as Fredric Jameson, Jean-François Lyotard, Louis Martin, and Herbert Marcuse, while enrolled as a student of David and Eleanor Antin, among other professors.[21] Judith Barry studied psychoanaly-

sis and semiotics, as well as film theory with Bertrand Augst, at the University of California at Berkeley. Sarah Charlesworth remembered "reading structuralism, anthropology, economics, linguistics, and semiotics."[22]

Lawler, too, was reading postmodern theories, as is evident from a letter she wrote to Miller-Keller in the fall of 1983, promising to "lend" her a copy of *The Anti-Aesthetic*. Lawler described the volume as "one of those books that everybody having anything to do with postmodernism has read," and then she confessed:

> Actually it is about the only one of the books I've read,[23] even though
> I know I should [have read more] and am in the middle of a situation where
> it would be almost spoon fed . . . I'm just somehow resistant. To be
> honest, the last books I read were *Jane Eyre* and *Bouvard and Pucuchet* [sic]
> (Flaubert).[24]

That Lawler's letter indicates resistance to postmodern theories during the period when she photographed the Tremaines is of interest, even though her "situation" and exposure to *The Anti-Aesthetic* obviously had already impressed her thinking. Of more significance is the fact that she was reading Charlotte Brönte's *Jane Eyre* and Gustave Flaubert's *Bouvard and Pécuchet*, two socially critical Victorian novels of domestic life (Flaubert's posthumously published, unfinished novel is tellingly subtitled *A Tragi Comic Novel of Bourgeois Life*). In such books, experience originates in the home and defines one's relationship to the world, and in *Jane Eyre* the story takes place in no less than five different homes whose individual characters determine the qualities of and transitions in the protagonist's life.

Soon after Lawler wrote this letter, she began to plan her first exhibition, "Home/ Museum—Arranged for Living and Viewing," which included her Tremaine photographs and took place in 1984 at the Wadsworth Atheneum, concurrently with "The Tremaine Collection: 20th Century Masters," an exhibition featuring over 150 works from the couple's collection. The wall label that Lawler wrote to accompany her exhibition, "Home/Museum—Arranged for Living and Viewing," read, in part:

> This arrangement of works . . . disregards many of the conventions of
> museum exhibitions. . . . These objects have been arranged with considerations
> that might be used in a *home* [my emphasis], with special attention to the
> outside dimensions and aesthetic effect of the work as well as the content.
> Little effort has been [made to make] their original meaning accessible.[25]

Stripping the works that she photographed of their "original meaning," Lawler had acknowledged art's residence in intimate personal spaces where objects are experienced for private pleasure, and also in institutional spaces, where cultural edification occurs within the domain of canons of visual authority.

Lawler was not the only artist who found compelling subjects in the home. In Silvia Kolbowski's artist's book, *The United States of America: The Metropolitan Museum of Art, New York, 1987* (1988), she interpolated images of domestic interiors from period rooms in the collection of the American Wing of the Metropolitan Museum of Art (celebrated in the 1987 exhibition

Silvia Kolbowski

Enlarged from the Catalogue: The United States of America, 1988
(installation view, Postmasters Gallery, New York 1989). Nine wood
and Plexiglas display vitrines with silkscreens on wood, leather bench,
silkscreen print, books, dimensions variable. Courtesy the artist

"The United States of America") with excerpts from Linda Brent's "Incidents in the Life of a Slave Girl," 1861, reproduced in *The Classic Slave Narratives* (1987), edited by Henry Louis Gates, Jr.[26] Kolbowski boldly inserted the life of Linda Brent, the otherwise invisible slave woman, into the celebrated seventeenth-, eighteenth-, and nineteenth-century homes of white Americans, anticipating by four years Fred Wilson's exhibition, "Mining the Museum" (1992). Both Kolbowski and Wilson explored terrain similar to that which Lawler studied in her Tremaine series.

Many women artists who were engaged in discourses concerning the home availed themselves of imagery taken from the commercial print media. Indeed, as Solomon-Godeau rightly pointed out, "by 1983, plundering the pages of glossy magazines, shooting advertisements from the television set, or 'simulating' photographic tableaux . . . had become as routine an activity in the more sophisticated art schools as slopping paint on canvas."[27] In this regard, Sarah Charlesworth remembered "tearing images out of magazines and books and setting them out around my studio floor."[28] She began to notice that "values were being constructed in mass culture that informed the way we think about the world, our possibilities as human beings, how it is to be a woman, how it is to be a man, how it is to be an American or a white person or whatever. My work took off from that point."[29]

Martha Rosler had been making photomontages culled from pictures in magazines since 1966, "because in the most obvious way," she explained, "a photographic montage disrupts the notion of the real while still employing photographic material, which speaks to people with a great degree of immediacy."[30] Rosler's aim to interrogate "the internalization of repressive codes and norms" followed such writers as Henri Lefebvre, whose *Everyday Life in the Modern World* (1947) she (and many others) found "crushingly true" for its description of "the internalization of the control systems that make us imagine we are free."[31] Situating her oeuvre between the private and the public, Rosler interrelated both in images drawn from "everyday life" and the "ideological superstructures and political, economic and social attitudes" they reflect.[32] Rosler also read E.E. Cummings's war novel *The Enormous Room* (1920), which proposed, as she remembered, that "Society creates a house, an ideological house—an enormous room—that encloses us although we don't know it is there. It takes a certain will to look beyond the imaginary walls and to decide that the door is open." So Rosler "kick[ed] out the jambs," taking up what she considered to be "the artist's business" in two photomontage series, "Body Beautiful, or Beauty Knows No Pain" (1966–72) and "Bringing the War Home: House Beautiful" (1967–72).[33]

In "Body Beautiful," Rosler visualized the interrelationship between the use of pornography and the secrets of the home, revealing an apparently neutral room or domestic

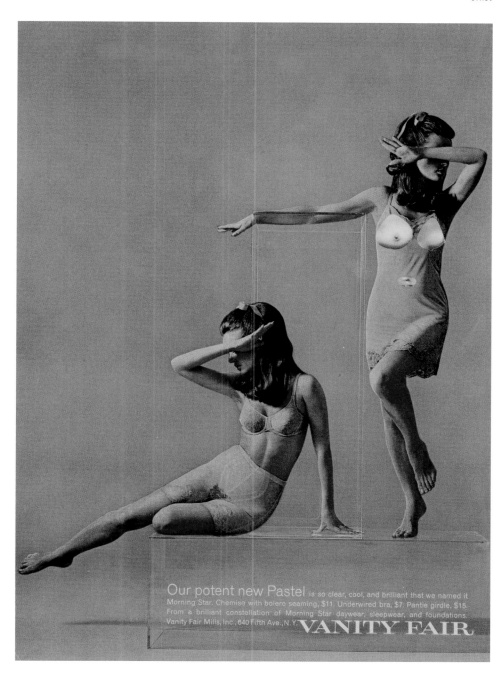

Martha Rosler

Transparent Box, or Vanity Fair, from "Body
Beautiful, or Beauty Knows No Pain," 1966–72.
Photomontage. Courtesy the artist and Mitchell-Innes
& Nash

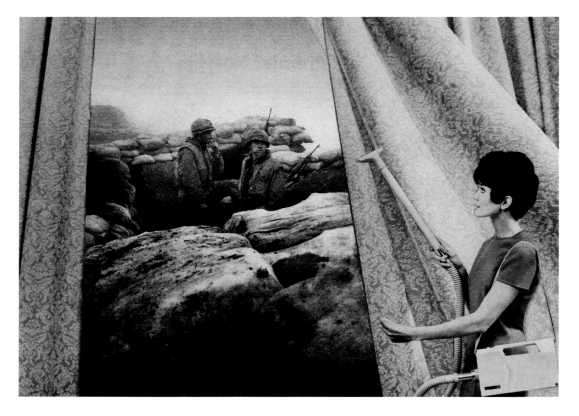

Martha Rosler

Cleaning the Drapes, from "Bringing the War
Home: House Beautiful," 1967–72. Photomontage.
Courtesy the artist and Mitchell-Innes & Nash

object to be oozing with sex. Clipping photographs from magazines like *Playboy*, she montaged
such images as naked women in suggestive poses into the kitchen, bedroom, and bathroom;
placed a couple fornicating in the family car; and combined a gorgeous Bianchi bridal gown
bedecked in lace, pearls, and sequins with explicit photographs of a pair of nubile breasts and
a thick patch of pubic hair, calling to mind the deflowering of the virgin on the wedding night.
In "House Beautiful," a Vietnamese woman, carrying her bloodied and dying child, threatens
to ascend the stairs to the family bedrooms; a Beautyrest mattress supports a mother reading

while father shows his son how a toy airplane bombs and strafes (an image that anticipated Mary Kelly's iconic study of the socialization of children in *Post-Partum Document*, 1973–79); and soldiers are seen scouring the halls outside the kitchen for bombs or Vietcong. In a lavish living room festooned with modern art, Giacometti's emaciated *Walking Man* (1960) pauses at the picture window to observe a scene of carnage, and so on, in photomontages that bring combat violence, blood, and death into the beautiful homes of beautiful owners who live in a country continually waging war.[34]

 Rosler's early videos also situate social and cultural narratives in the home. In *Semiotics of the Kitchen* (1975) [see page 136], she invented a semiotic "system of harnessed subjectivity;"[35] in *Losing: A Conversation with the Parents* (1977), anorexia is examined from the perspective of parents talking about a child who died of self-starvation; in *Domination and the Everyday* (1978), the social expectations of family life are overlaid with international politics and cultural theory; and in *Born to be Sold: Martha Rosler Reads the Strange Case of Baby S-M* (1988), she reveals, through an examination of an early case of surrogacy, the class biases shown by the media and courts in determining who is qualified to rent a womb and raise a child. In *The Bowery: In two inadequate descriptive systems* (1974–75), Rosler pictured "the un-housed," eventually taking up the question of home in *If You Lived Here* (1989), a work further addressing the homeless in the United States and throughout the world.

 While Rosler disclosed the erotic, violent, and political subtext of the home as a center of the social, Lynn Hershman examined the traumatized personae that emerge from the incestuous secrets they sometimes conceal. From 1974–78, Hershman assumed the persona of a fictive self named Roberta Breitmore [see page 106], created as a schizotypal personality whose inner experience ranged from normal dissociative imagination to more extreme states associated with psychosis. Hershman not only performed the role of Roberta, she lived, worked, dated, and attended psychotherapy as Roberta. The theme of a secret, protected by the walls of the home, would run in many guises throughout Hershman's work, including her series of confessional videos, "Electronic Diary," comprised of *Confessions of a Chameleon* (1986), *Binge* (1987), and *First Person Plural* (1989). *CyboRoberta* would reappear in 1998 as a cybernetic doll able to peer into homes through webcam technology, and *Life Squared* (2007) found Roberta in the virtual world of Second Life.

 Judith Barry, too, created a number of works related to the home from the 1970s through the 1990s, and worked on a book in 1979 that was never published "about the open plan [in architecture] and lack of privacy for women in the home," for which she "photographed Hershman and her daughter."[36] Barry's *Receiver to Remote Control: The TV Set* (1990) and *Home icide* (1993) both examine "a semiotics of/about the home," and her performance

Cup/Couch (1977), in which a woman pulls a couch on wheels or tries to pirouette out of a coffee cup, was an ironic view of domestic labor. "In a sense," Barry wrote, "each [of my works] was a typology of certain kinds of possible space produced in the home at certain moments in time and by a number of factors including architecture, discourse, social relations, etc."[37]

By creating and inhabiting situations in the domestic domain, Rosler, Hershman, Barry, and others could be said to have visualized, as well as demonstrated, Simone de Beauvoir's point in *The Second Sex* (1949) that a woman's "body *is* a situation." Not "as a feminine *attribute* [that can be] 'owned'—but . . . *inherent* in any act of self-definition," as Ewa Lajer-Burcharth, following Toril Moi, would put it in 2006.[38] Moi insists that what de Beauvoir meant was "that the body *is* a situation," as well as "that the body is always *in* a situation."[39] This formulation, Moi adds, "rejects both biological determinism and the limiting distinction between sex and gender [and] provides a brilliant starting point for future feminist investigations of the body, agency and freedom."[40]

These artists' works, with their liberating and empowering confrontations with domestic demons and associated psychological experiences, were courageous forerunners of Cindy Sherman's determined procession of constructed personae, many in domestic settings. In *Untitled Film Still #10* (1978) [see page 140], a woman in a mini skirt and a 1960s haircut, with long bangs, picks up groceries that have presumably fallen on the floor. Laurie Simmons, too, situates women in kitchens, as in *Purple Woman Kitchen* (1978), in which a doll-woman in a purple dress stands before a table laid with food awaiting preparation. Simmons's image recalls Rosler's *Semiotics of the Kitchen*, in which the artist is poised behind a table full of kitchen utensils and, at one point, slices the air with a huge knife. But Simmons's anesthetized figure performs her duty robotically, while Sherman's figure looks up, perturbed, from the kitchen floor.

In *Walking House* (1989) [see page 153], Simmons went so far as to replace the head and torso of a woman with a small-scale model home supported on long legs, recalling a similar image by Louise Bougeois, *Femme/Maison—To Carletto* (1947). Simmons presented dolls in uncanny and eerie interiors "to evoke the 1950s idealization of the perfect housewife that you'd find in magazines or on television,"[41] as she put it, while Sherman used herself to explore the full range of female experience, period dress, and psychophysical behavior. Both artists' work call to mind Walter Benjamin's identification of "the phantasmagoria of the interior [and the] imperious need to leave the imprint of . . . private individual existence on the rooms [one] inhabits,"[42] which Diana Fuss describes as a definition of modernity, "simply another name for the reign of interiority, that moment in history where exteriority is driven indoors by the domesticating passions of the bourgeoisie."[43]

Carrie Mae Weems also turned to the kitchen in her "Untitled (Kitchen Table Series)," 1990. Under an overhead lamp at the kitchen table, a visual narrative of heterosexual love unfolds, leaving the woman with a daughter and, finally, playing solitaire—home alone. Weems's work is most frequently said to concern "race and gender," but its setting stages a universal narrative, albeit told in a particular voice. For Weems represents actions that exist behind the closed doors of almost every home and in the interior of almost every life. Hers is a theater of intimate activities, recognizable in and through particular household objects, food, and drink: a make-up mirror, cigarettes, a comb, playing cards, a newspaper; whiskey, wine, beer, and sherry with their accompanying varieties of glasses; unshelled peanuts, lobster, and chocolates. These items contribute to interactive dialogue or soliloquy, reinforced by gestures and expressions that convey the psychic conditions of romance, friendship, and parenthood. Weems simultaneously conveys the interiority of home and of mental sensations, which range from seduction, suspicion, love, boredom, and loss, to loneliness, friendship, comfort, humor, sorrow, and emptiness, and from mothering, work, and play to self-empowerment, satisfaction, and self-reliance. Weems offers a view of an embodied domestic interior where the unfolding emotional theater of life, animated by its objects, *is* what takes place at home, *is* the body *in* and *as* its situation.

"The architectural dwelling is not merely something we inhabit," Fuss writes, "but something that inhabits us . . . interiority itself as a built structure."[44] That habitation also occurs through the internalization of the visual codes inculcated by the media. In October 1979, while watching the CBS show "Live from Television City in Hollywood," Barbara Kruger commented in a journal on the insipid scenario of the game, which "illustrates the production of lack through the promise of a secondary other (objects, goods, machines), then the commercials, which puncture the game (or vice versa), introduce lack as this secondary other's attributes." Kruger closed her observations by noting:

> Johnny announces another prize. "A fuur cooaat!" the audience is screaming
> again. On the screen the model is buried in a huge, black fuzzy thing,
> which looks like an acrylic bathroom rug. She is stroking herself and wrinkling
> her nose. . . . This tiny furry figure adrift in blue and pink fog is someone's
> idea of heaven. The effect is one of comedic aura, but in Springfield, Ohio,
> a thirty-eight-year-old woman pours a second cup of coffee and stares at the
> television screen. She is not laughing.[45]

The woman was Kruger. Ten years later, she would produce *Untitled (Your body is a battleground)* (1989), in which a woman's face, split down the center between positive and

negative images, is the divided situation, one half pursuing the "idea of heaven" promoted by the show (and the woman in the fur coat modeling the game show's prize), the other sitting at home with a cup of coffee in front of the promising, but deceptive, television.

It was not just commercial television and advertising that drew many women artists to consider how identity is formed in relationship to objects in the home. A curiosity about the rich and famous—how, where, and with whom they lived—also provoked investigation. This was the initial appeal of Martha Stewart, whose best-selling book *Entertaining* (1982) was followed by her appointment as spokeswoman for K-Mart, and as the nation's expert homemaker and home decorator. Jacqueline Kennedy Onassis was Martha Stewart's more glamorous antecedent. When Kennedy's estate was presented at auction in 1996, the catalogue illustrated a selection of the art, jewelry, furniture, books, letters, and personal items in her home. Barbara Bloom was fascinated by these objects as a collection, and, especially, by the catalogue's "meticulous depiction of the objects, their separate existence continuing beyond death."[46] The former first lady's domestic things were submitted to Bloom's artistic system of "sifting through objects" to consider "categorization, identification, and description," in an "attempt to find the underlying suppositions" that make such objects meaningful.[47]

Making meaning through the act of sorting and collecting is the provenance of all children, who, when home alone in their rooms, collect and sort their collections as a means to register their choices and preferences and to understand attachment and loss. The result of such activities can contribute to understanding the formation of identity, which may be why the objects in Lorna Simpson's early works (such as *Waterbearer* [1986], *Twenty Questions* [1986], *Five Day Forecast* [1988], and *You're Fine* [1988]) are sometimes perceived as metaphors for factors contributing to what Okwui Enwezor has described as "the American sublime and the racial self . . . rooted in a particular type of violence [and] in methods of subjection and denial."[48] Such "methods" issued from the white home. There the woman in Simpson's images —often wearing a simple white cotton shift—served as maid, cook, mammy, lover, psychological supporter, counselor, and many other tasks to which *Five Day Forecast* (1988) testifies. Her consciousness and will, however negatively affected by "misdescription, misinformation," and by occasions to "misidentify, misdiagnose, misfunction, mistranscribe, misremember, misgauge, misconstrue, mistranslate," nevertheless prevails.

Feeding her mind and spirit, then-twenty-two-year-old Adrian Piper addressed the subject/object phenomenology of consciousness in *Food for the Spirit* (1971).[49] Piper spent that summer in her New York loft reading Emmanuel Kant's *Critique of Pure Reason* (1781) while she maintained a yogic discipline of fasting. As she read and meditated, Piper shot a series of

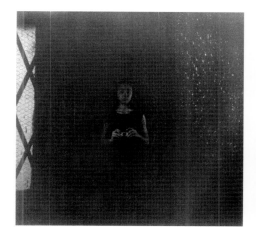 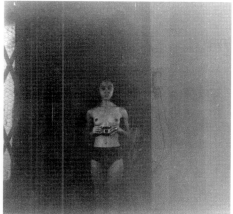 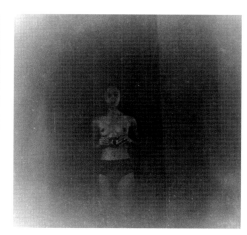

Adrian Piper

Food for the Spirit, 1971. Performance documentation:
#3, #4, and #5 of fourteen black-and-white photographs.
Performance with camera, audio tape, and selected
texts from *The Critique of Pure Reason*. Collection of
Thomas Erben, Whitney Museum of American Art, and
the Museum of Modern Art, New York

fourteen black-and-white self-portraits that recorded her presence, which to her seemed to become a specter disappearing into darkness. "I rigged up a camera and tape recorder next to [a] mirror," she remembered, "so that every time the fear of losing myself overtook me and drove me to the 'reality check' of the mirror, I was able to both record my physical appearance objectively and also record myself on tape repeating the passage in *Critique* that was currently driving me to self-transcendence."[50]

Piper's remarkable unification of Western and Eastern philosophy and practices has been virtually ignored in the scholarship on the artist. But by 1971, Piper had become a *svanistha* (a self-guided yogin who in Vedic tradition directly meditates upon the all-pervading state of ultimate reality), and, in 1985, she was a *brahmacharin* (one who practices celibacy as a yogic discipline).[51] Also in 1985, Piper began teaching the *Upanishads* in an introductory ethics course at Wellesley College, later expanding her course offerings to include "Vedanta Ethics and Epistemology" and "The Philosophy of Yoga." By the end of the millennium, Piper had traveled to India, increased her study of the *Yoga Sutras*, made a serious commitment to

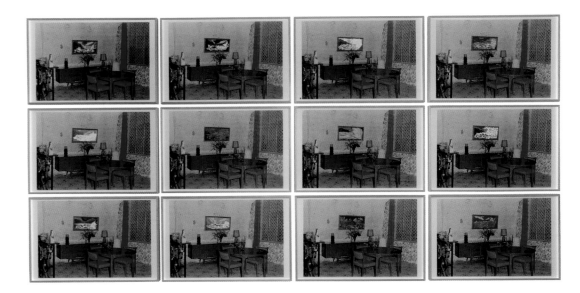

Susan Hiller

Inside a Cave Home, 1983. Twelve photographs,
hand-painted, 20 x 30 in. each. Courtesy Timothy Taylor
Gallery, London

Ashtanga yoga, and applied for a "Persons of Indian Origin" expatriate card on the basis that
her maternal great-grandmother was also Hindu.

For many, traveling far from home results in bringing one home. Susan Hiller
addressed something like this supposition when she created *Inside a Cave Home* (1983). Part
of her series "Rough Seas" (1982–2009), it is comprised of twelve postcards that depict the
living room of a "dugout home" in Coober Pedy, an opal-mining settlement in the South Aus-
tralian Outback. Hiller was drawn to the "poignant" image of a seascape hanging over a side-
board "hundreds of miles from any ocean." Identifying "home" as England, Hiller wrote that
home was the place where she made art:

> Coober Pedy is . . . one of the most inhospitable regions of the Australian
> outback. . . . The combination of symbols in the Coober Pedy postcard—
> desert, cave, and sea—led me to muse on deeper psychological issues, while

the two sorts of "art"—decor and reproduction—suggested other kinds of intriguing relationships. Finally, "it made sense" to bring this postcard home to England and paint studies which return the image to some kind of "original" state, completing the cycle.[52]

In the well-known film *Home Alone* (1990), Kevin, a child of eight, is forgotten when his family leaves in a flurry for a Christmas vacation in Paris. Kevin awakes to find the house empty and relishes the fact that he has made his bullying siblings and dismissive parents "disappear." A sense of freedom to do as he wishes soon fades as he realizes that he needs to shop for food, fend for himself, conquer his fears of being alone, and eventually protect his home against burglars planning to rob the house. In the comedy that ensues, Kevin makes imaginative use of all possible objects and situations to foil the burglars. He eventually triumphs; the police cart away the bumbling thieves; and the family arrives. Kevin emerges with an empowering depth of self-knowledge and self-reliance that few achieve, personal accomplishments that he keeps to himself.

While *Home Alone* is about a boy, his infantilizing, harassing, neglectful treatment may be taken as a trope for most women artists before the 1970s, by and large forgotten at home. Home alone, metaphorically speaking, they forged some of the most inventive, perceptive, and socially insightful art of the period. Individually and collectively, these artists created art using minimal means and inexpensive processes cobbled together from a range of unanticipated sources with unexpected results that remain culturally, socially, and politically enriching. As Laurie Simmons explained, the emotional impact of such work was empowering. Recalling the effect of asking her parents to dress up and dance so that she could photograph them, Simmons remembered

> wishing there was a record of my parents performing this spontaneous, mesmerizing, and tender slow dance in front of me. It wasn't even something I consciously desired to witness but I did, somehow, make it happen, and this made me feel unsettled, like a little kid with too much power at home.[53]

Kristine Stiles, Professor of Art, Art History and Visual Studies, Duke University, specializes in contemporary art and theory, and has particular interest in violence and trauma in art. Her most recent publication is Correspondence Course: An Epistolary History of Carolee Schneemann and Her Circle *(2010).*

1

Kathy O'Dell, *Contract with the Skin: Masochism, Performance Art, and the 1970s* (Minneapolis: University of Minnesota Press, 1998), 57.

2

Vito Acconci, "Projections of Home," *Artforum* 26, no. 7 (March 1988): 127.

3

Carol Armstrong, "Francesca Woodman: A Ghost in the House of the 'Woman Artist,'" in Carol Armstrong and Catherine de Zegher, eds., *Women Artists at the Millennium* (Cambridge, Mass.: MIT Press, 2006), 350.

4

In 2008, the Brooklyn Museum launched a feminist exhibition with the aggressive title, "Burning Down the House." See also, Rosemary Marangoly George, ed., *Burning Down the House: Recycling Domesticity.* (Boulder, Col.: Westview Press), 1998, and Avi Friedman and David Krawitz, *Peeking Through the Keyhole: The Evolution of North American Homes,* (Montreal: McGill-Queens University Press), 2002.

5

Andrea Fraser in George Baker and Andrea Fraser, "Displacement and Condensation: A Conversation on the Work of Louise Lawler," in *Louise Lawler and Others* (Ostfildern-Ruit, Germany: Hatje Cantz Publishers, 2004), 110.

6

Ibid., 107.

7

Peter Barr, "Deconstructing. Louise Lawler at the MFA [Boston]," *Art New England* (December 1990/ January 1991), reprinted in *Excerpts from Some Historical Documents about Louise Lawler, Emily and Burton Tremaine and The Tremaine Collection, Arranged by Andrea Miller-Keller or "You're going to love the thermostat next to the Miro,"* reprinted in *Louise Lawler: The Tremaine Pictures 1984–2007* (Geneva: BFAS Blondeau Fine Art Services, 2007), 73.

8

Kathleen L. Housley, "Emily Hall Tremaine: Collector on the Cusp," in *Woman's Art Journal,* 21, 2 (Autumn 2000–Winter 2001): 16.

9

Email from Andrea Miller-Keller, September 29, 2006, in response to Esther Ruelfs's email of September 5, 2006, reproduced in *Excerpts from Some Historical Documents about Louise Lawler, Emily and Burton Tremaine and The Tremaine Collection*, reprinted in *Louise Lawler,* 79.

10

Letter from Kathleen L. Housley to Esther Ruelfs of the Hochschule fur Bildende Kunste Braunschweig, September 1, 2006, in *Excerpts from Some Historical Documents about Louise Lawler,* reprinted in *Louise Lawler,* 78.

11

Ibid., 77.

12

Email from Louise Lawler to Andrea Miller-Keller, June 27, 2007, quoted in *Excerpts from Some Historical Documents about Louise Lawler,* reprinted in *Louise Lawler,* 79.

13

Bruce Conner made a similar point in a phone conversation when I called (in about 2007) to ask him how he felt about the possibility of my gifting my collection of his work to a museum. "Don't do it," Bruce answered vehemently. "Leave it in your home where people can see it, rather than condemning it to a store room."

14

A Roy Lichtenstein sculpture, *Ceramic Head with Blue Shadow* (1966), sits next to a lamp on a table adjacent to the television, and Robert Delaunay's *First Disk* (1912) hangs above the television next to a Louis XV armchair. The Lichtenstein sculpture looks as if it has been made into a lamp base, but it is the angle from which Lawler took the photograph that made it appear thus. Such tricks of the camera may have been what caused Kathleen L. Housley, Emily Tremaine's biographer, to comment: "Lawler's photographs do not capture a deep truth about the Tremaines. Instead, they capture a deep truth about Lawler." Letter from Kathleen L. Housley to Esther Ruelfs of the Hochschule fur Bildende Kunste Braunschweig, September 1, 2006, *Excerpts from Some Historical Documents about Louise Lawler,* reprinted in *Louise Lawler,* 78.

15

Bruce Hainley, "Louise Lawler: An Arrangement of Pictures," in *Frieze* 56 (January-February 2001): http://www.frieze.com/issue/review/louise_lawler/

16

Louise Lawler in an email exchange with Andrea Miller-Keller, June 27, 2007, in *Excerpts from Some Historical Documents about Louise Lawler,* reprinted in *Louise Lawler,* 79.

17

Abigail Solomon-Godeau, "Living with Contradictions: Critical Practices in the Age of Supply Side Aesthetics," *Social Text* 21 (1989): 193.

18

Ibid.

19

Ibid.

20

Hal Foster, "Postmodernism: A Preface," in *The Anti-Aesthetic: Essays in Postmodern Culture* (Port Townsend, Washington: Bay Press, 1983), ix–xvi.

21

Martha Rosler in "Martha Rosler in Conversation with Molly Nesbit and Hans Ulrich Obrist," in *Martha Rosler: Passionate Signals* (Hannover and Ostfildern-Ruit: Sprengel Museum Hannover and Hatje Cantz, 2005), 8, 10.

22

Sarah Charlesworth, "Sarah Charlesworth, April 12, 1995, Studio, Little Italy," in Judith Olch Richards, ed., *Inside the Studio: Two Decades of Talks with Artists in New York* (New York: Independent Curators International (ICI), 2004), 159.

23

Lawler's emphasis on "the" books refers to a list of publications similar to that which Solomon-Godeau mentioned in her 1989 essay, citing Douglas Crimp, Craig Owens, Buchloh, Krauss, and Foster as "establishing...the conception of postmodernism in the visual arts." See her "Living with Contradictions," footnote no.2, pp. 210–11.

24

Letter from Louise Lawler to Andrea Miller-Keller, no date (circa "Fall 1983"), in *Excerpts from Some Historical Documents about Louise Lawler,* reprinted in *Louise Lawler,* 60.

25

Wall label by Louise Lawler, "From the Collections of the Wadsworth Atheneum, Sol LeWitt, and Louise Lawler, Arranged by Louise Lawler, 1984," in *Excerpts from Some Historical Documents about Louise Lawler,* reprinted in *Louise Lawler,* 65.

26
Silvia Kolbowski, *The United States of America: The Metropolitan Museum of Art, New York, 1987*, artist's book published in New York in 1988 by Postmasters Gallery. For a discussion of nationality as a kind of home, see, also, Silvia Kolbowski and Walid Ra'ad, *Between Artists* (New York: A.R.T. Press, 2006); and Silvia Kolbowski, *Proximity to Power, American Style (2003–2004)* (Chicago: WhiteWalls, Inc., 2008).

27
Abigail Solomon-Godeau, "Living with Contradictions," 198.

28
Sarah Charlesworth, "Sarah Charlesworth, April 12, 1995," 159.

29
Ibid.

30
Martha Rosler in "Martha Rosler in Conversation with Molly Nesbit and Hans Ulrich Obrist," in *Martha Rosler*, 30.

31
Ibid., 34.

32
Juan Vincente Aliaga, "Public and Private: Productive Intersections, some Notes on the Work of Martha Rosler," in Jolanda Romero, ed., *Martha Rosler: La casa, la calle, la cocina— The House, The Street, The Kitchen* (Granada, Spain: Centro José Guerrero, 2009), 75.

33
Martha Rosler in "Martha Rosler in Conversation with Molly Nesbit and Hans Ulrich Obrist," 36.

34
Ibid., 34.

35
Martha Rosler quoted on Video Data Bank's blurb on *Semiotics of the Kitchen:* http://www.vdb.org/smackn.acgi$tapedetail?SEMIOTICSO

36
Judith Barry email to the author, 30 July 2010.

37
Ibid.

38
Ewa Lajer-Burcharth, "Duchess of Nothing: Video Space and The 'Woman Artist,'" in Carol Armstrong and Catherine de Zegher, eds., *Women Artists at the Millennium*, 146.

39
Toril Moi, *What is a Woman* (Oxford: Oxford University Press, 1999), 59.

40
Ibid., 83.

41
Laurie Simmons, "Laurie Simmons, March 7, 1994, Studio, SoHo," in Judith Olch Richards, ed., *Inside the Studio*, 139.

42
Walter Benjamin, "Exposé of 1939," in *The Arcades Project*, trans. Howard Eiland and Kevin McLaughlin (Cambridge, Mass.: The Belknap Press of Harvard University Press, 1999), 220.

43
Diana Fuss, *The Sense of an Interior: Four Writers and the Rooms that Shaped Them* (New York & London: Routledge, 2004), 12.

44
Ibid., 5.

45
Barbara Kruger, *Remote Control: Power, Cultures, and the World of Appearances* (Cambridge, Mass.: The MIT Press, 1993), 96.

46
Antonia von Schoening, "The Collections of Barbara Bloom' at the Martin Gropius Bau Museum," in *Afterall/Online/Journal* (22 January 2009): http://www.afterall.org/online/the.collections.of.barbara.bloom.at.the.martin.gropius.bau.museum
See also, Diane Russell Condon, *Jackie's Treasures: The Fabled Objects from the Auction of the Century.* New York: Clarkson Potter, Publishers, 1996.

47
Publisher's review of *Impossible Objects: The Collections of Barbara Bloom.* Steidl/ICP, 2008.

48
Okwui Enwezor, "Repetition and Differentiation: Lorna Simpson's Iconography of the Racial Sublime," in *Lorna Simpson* (New York: Abrams in Association with the American Federation of Arts, 2006), 113.

49
These paragraphs on Piper are excerpted from my essay "Irregular Ways of Being in Time," in Alexandra Munroe, ed., *The Third Mind: American Artists Contemplate Asia 1860–1989* (New York: Solomon R. Guggenheim Museum, 2009): 333–45.

50
Adrian Piper, "Food for the Spirit," *High Performance* 4, 1 (Spring 1981): 56.

51
Adrian Piper email to the author, 15 May 2008.

52
Susan Hiller commentary on *Inside a Cave Home* on her website: http://www.susanhiller.org/Info/artworks/artworks-cavehome.html

53
Laurie Simmons in "10 Questions James Welling asked Laurie Simmons," in *Laurie Simmons: Color Coordinated Interiors 1983* (New York: Skarstedt Fine Art and Sperone Westwater, 2007), n.p.

What Women Want

Want Psychoanalysis and Cultural Critique

The great question that has never been answered, and which I have not yet been able to answer,
despite my thirty years of research into the feminine soul, is "What does a woman want?"
— *Sigmund Freud to Marie Bonaparte, 1933*

The question of identity—how it is constituted and how it is maintained—is, therefore,
the central issue through which psychoanalysis enters the political field.
— *Jacqueline Rose, 1986*

I write this as a woman, towards women. When I say "woman" I am speaking of woman in
her inevitable struggle against conventional man; and of a universal woman subject who
must bring women to their senses and to their meaning in history. But first it must be said that
in spite of the enormity of the repression that has kept them in the "dark"—the dark which
people have been trying to make them accept as their attribute—there is, at this time,
no general woman, no one typical woman. What they have in common, I will say. But what
strikes me is the infinite richness of their individual constitutions. . . .
— *Hélène Cixous, 1971; translated 1976*

Asking "Who Needs 'Identity'?," cultural theorist Stuart Hall pointed to a paradox. The same moment at which identity became a big topic in the politics of culture, it was "subjected to a searching critique," a critique Hall names *deconstructive*.[1] Rather than replacing what is being critiqued with its "truer" alternative, deconstructive critique puts the concept "under erasure." Not simply displaced and replaced—identity to be worked with—but troubled, problematized. Derrida himself proposed deconstruction as a double-writing because we cannot do without the concepts, in our case of the sexed and gendered self, that we nonetheless must undermine, and from within—within language, within the conceptual field, within the very lived experience the concepts inadequately seek to comprehend and make intelligible to us while all the time getting them all wrong.[2] So we have to think *about* and *with* cultural identities but we have also to undo their effects. We think about masculinity and femininity; we also deconstruct them from within.

Since the 1970s, artists have played a crucial role in finding a novel artistic language for this double-writing that involves simultaneously identification and deconstructive

analysis. Some artists in particular addressed gender and its always-deep imbrications with race, class, and sexualities that are the very terrains of the fictions and lived performances of identity. Let me be clear. Artists were not doing deconstructive theory in art; their art was in itself, as art, indicative of working with the very contradictions that Derrida named philosophically as *Abbau*: deconstruction.

Art is itself the site of a particular kind of thinking. Thinking *with* as well as *about* the image as a critical site for the always-provisional constructions of our imaginative subjectivities, artistic practices from the mid-1960s formed an investigation parallel to the interdisciplinary theoretical revolution in the humanities, which addressed itself to language, subjectivity, and sexual difference in the context of the intensification of image culture and what we might call specular as well as spectacular capitalism.[3]

Constructed by what it ambivalently takes on/in, the subject is never a single, unified, and accomplished identity. Rather, subjectivity is a constant play of *identifications*, some of which the dominant social order seeks to stabilize. It does so through the work of ideology that calls to us, inviting us to recognize ourselves in the representations of gender, race, class, and sexuality which culture offers as the preferred or the abased images of its own hierarchies of power. Thus some of us are positively affirmed by being shaped in the image of white, heteronormative patriarchal culture, while others, differentiated from such privileged subjects, are not affirmed or valued in predominantly racist, sexist, homophobic imagery.

Identity came (c. 1970) and went (c. 1990).[4] At one stage, we always prefaced our remarks with the phrase "As a . . ." The positive dimension of owning up to locatedness "as a . . ." was the challenge offered to the once universal, neutral position of hegemonic utterance by a multiplicity of voices and speaking positions seeking to diversify and democratize culture. We wanted to speak in our own voices, not for others. To write "as a woman" and to call for other women to speak from their own experiences was a radical gesture opening up the half-empty archive of patriarchal cultures to a fuller understanding of plural, inclusive humanity. However, in forming new kinds of collective consciousness around gender or sexuality, for instance, the negative aspect soon became equally apparent. Identities necessarily became hyphenated in the full complexity of social and historical location. The elective affinities that helped to create new collectivities equally hived us off from each other, multiplying lines of division that excluded as much as they embraced.

If the area for the fiction of a true identity became ever smaller, and ultimately generated conflict, we also found the very concept of identity fracturing in our hands. How many momentary positions and fragmenting identities collided in any one person living relations of class, ethnicity, gender, sexuality, ability/disability, or geopolitical location in post-

colonizing, migratory, globalizing, and post-traumatic worlds? How stable were our already shifting identities, evoked and altered by each changing encounter with other people and situations? How soon did the attempt to claim or attribute identity slip from its affirmative acknowledgment of the fundamental plurality of human beings into a war of badge-wearing and ever narrowing fractions?

During the 1970s and 1980s artists not only emerged to explore this tricky territory, they were also creators of, commentators on, as well as pleasured inhabitants of the realm of representation. Their works made us "see" that identity, or rather identities—always plural, unstable, decentered, shifting, historical, and localized—were fabrications of representational systems that offered us images from which we made ourselves up. We composed any sense of self, however shifting and multiple, from the many identifications these regimes of representation offered to us. Thus the issue of identity politics played out on the stage and screen of art was now a *politics of representation*. The artists working in this area, engaged with the profound upheavals of the later twentieth century around gender, sexuality, and cultural and social difference, opened up a new arena for artistic practice that was as formally and aesthetically nuanced and self-conscious as any earlier avant-garde, and equally as engaged with the social effects of the meanings and positions produced in the play of representations.

But the key question was, whose representations? Made from which positions of power or privilege or desire? Whose desires do representations encode or solicit, fabricate or feed? How do representations address us, even draw the shapes of the bodies and appearances into which we seek, in fantasy, to pour our always-becoming selves? What are the constructive effects of the "mirror" of representation, and what is the destructiveness of the power exercised through the images shaping race, class, and gender? In 1984, British feminist cultural analyst Rosalind Coward prefaced her volume of essays on *Female Desire* with the following statement:

> The aim of *Female Desire* is to examine how presumptions about female pleasure and female desire are shot through so many cultural practices, and to look at the way our desire is courted even in our most everyday experiences as women. I do not treat these cultural representations as the forcible imposition of false and limiting stereotypes. Instead I explore the desire presumed by these representations, the desire which touches feminist and non-feminist women alike. But nor do I treat female desire as something universal, unchangeable arising from the female condition. I see the representations of female pleasure as *producing* and

sustaining feminine positions. . . . Feminine positions are produced
as responses to pleasures offered to us; our subjectivity and identity are
formed in the definitions of desire that encircle us.[5]

In the popular imagination, feminists of the 1980s were not interested in pleasure
or desire. They are imagined as kill-joys. Laden with the impenetrable verbiage of high theory,
critical feminist artwork and statements were represented by a later generation as a form of ex-
treme intellectual gymnastics offering as much easy pleasure as atonal music. Coward reminds
us, however, that desire and pleasure were always at the heart of our investigations, which were
as much interrogations of ourselves in all our complexity as of the cultures and representa-
tions through which these lived but also socially authored selves were being produced.[6]

"What do women want?" With the idea of wanting including, playfully, both want
as lack and want as desire, the question is a paraphrase of one Freud posed, with some exas-
peration at his own failure to find an answer to the riddle of femininity and female sexuality,
to Marie Bonaparte in 1933. Freud has been much abused by women for this failure. Jane
Flax, on the other hand, commends Freud for what she calls his daring to ask such a scandal-
ous question at all. Freud was actually acknowledging feminine desire and sexuality, while he
realized that both are as enigmatic to women themselves as they are to men because of the il-
legibility of both to a culture that lacks terms for recognizing the sexual difference of women,
lived from the side of women.[7] The issue is not simply one of a pristine female desire lying in
wait for discovery like the "dark continent" of Freud's admittedly colonial metaphor for femi-
ninity itself. Repressed or censored according to varying theories, feminine subjectivities,
sexualities, and desires are only what can be articulated and represented in a system of repre-
sentations, but they are also what is excessive to what has been articulated and represented in
a culture ruled by the phallus: phallocentric culture.

This sounds clever but so paradoxical as to verge on nonsense. It is precisely the
exploration of this paradox that shaped a major trend in artistic practice during the 1980s,
which is now being assembled under the rubric of "The Deconstructive Impulse." Writing to
defend feminist engagement with psychoanalysis against the pretty considerable initial femi-
nist hostility to Freudianism, Jacqueline Rose stated in 1986:

> Like Marxism, psychoanalysis sees the mechanisms which produce those
> transformations as determinant, but also as leaving something in
> excess. If psychoanalysis can give an account of how women experience the
> path to femininity, it also insists, *through the concept of the unconscious,*

that femininity is neither simply achieved nor is it ever complete. The political
case for psychoanalysis rests on these two insights together—otherwise
it could be indistinguishable from a functionalist account of the internalisation
of norms.[8]

Many people understand the key debate about gender to focus on the opposi-
tion between those for whom woman and women form a self-evident category defined by the
possibilities of biology, anatomy, or psychological essence, and those for whom there is no
essence, only the social construction of norms and images. From a psychoanalytical perspec-
tive, however, essentialist versus social constructionist positions represent two different
kinds of fantasy about the self. The essentialist perspective offers a fixed and secure sense of
what a woman is; but this "woman" can be interpreted itself as a collage of desired attributes
drawn from imagining other women, notably the mother. Hence what is often considered
to be the essence of woman is related to a historically and culturally specific idealization of
the maternal: caring, generative, containing, creative, peace-loving, and so forth. The social
constructionists, disowning any essential attributes of woman, feel liberated from the tie to
the mother through their theorizing of a socially constructed set of conventions that can be
deconstructed. This idea allows the subject-self to rework herself according to a fantasy of
autogenesis. Once the imposed conventions, often transmitted by the idealized mother, have
been identified and questioned, the subject imagines herself to be able to reauthor herself as
who she wants to be. The specificity of psychoanalysis as a contributor to this polarized debate
is that it can interrogate the fantasies that underpin all of our favored positions, and that it
does not offer an either/or position. Rose again:

> The difficulty is to pull psychoanalysis in the direction of both these insights—
> towards the recognition of the fully social constitution of identity and
> norms and then back again to that point of tension between the ego and the
> unconscious where they are endlessly remodelled and endlessly break.[9]

While acknowledging the social construction of identities and norms through cul-
tural practices, laws, politics, and representations, psychoanalysis alone theorizes their fail-
ure. How? The unconscious, a reservoir of repressed wishes and social disavowed impulses,
always exceeds and undoes temporary fixings of the illusions of selfhood typical of the ego,
and thus can be understood as a perpetually deconstructive/renovative force in the psyche. Of
course, it does not undo social identity in order to return us to a pre-social essence, because,

in psychoanalytic thought, there is no nature. There are only the complex processes of the formation of subjectivity and sexuality that are at once socially overdetermined and undermined by both the unconscious and the play of fantasy.

> Thus feminism asks psychoanalysis for an account of how ideologies are imposed on subjects and how female identity is acquired, only to find the concepts of fantasy and the unconscious rule any notion of pure imposition and full acquisition out of bounds.[10]

Fantasy (associated by Lacan with the realm of the Imaginary) and the unconscious (paradoxically identified with the Symbolic and language and also all that both exclude from signification) constitute two key forces that shape us and undo all shaping. We never become an identity once and for all. Yet all socialized subjects participate in socially constructed positions that are endlessly undone by the fundamentally fractured and equivocal nature of subjectivity and sexuality themselves.

Aesthetics and the Spaces of Psychoanalysis

In a reformulation of the foundations of psychoanalysis first published in France in 1987, French psychoanalyst Jean Laplanche proposes that psychoanalytical experience occurs in several sites. Of four sites he identifies, one is "extra-mural psychoanalysis." Laplanche disowns the idea of an *applied* psychoanalysis that implies the clinical site is the only authentic one and that others are external, abstracted applications. "When psychoanalysis moves away from the clinical context, it does not do so as an afterthought, or to take up side issues. It does so in order to encounter *cultural phenomena*."[11] Laplanche reminds us that psychoanalysis itself is a cultural movement, and a broad one at that. It offers a specific definition of human beings as *subjects* whose *subjectivity* can be studied by psychoanalytical methods. But the subjects psychoanalysis studies are, by virtue of the cultural existence of psychoanalysis, "henceforth, culturally marked by psychoanalysis."[12] Having emerged into modern culture, this mode of understanding the human person as a psychological being, divided within by the unconscious, and further shaped by sexualities that are formed rather than innate or "natural," marks us indelibly. In the third domain of psychoanalytically framed experience, *theory*, we discover yet another dimension

disclosed to us by psychoanalysis: "to state that man is a self-theorizing being is, on the other hand, to state that all real theorization is an experiment and an experience which necessarily involves the researcher."[13] The fourth locus of psychoanalytical experience is *history as experience*. Laplanche dismisses the typical historical modes, as exemplified by biographies of Freud and by narratives of the evolution of his theories with their changes of direction. Instead, he reads the way in which the process of thinking about subjectivity echoes the evolution of human subjectivity itself and thus involves the researchers in thinking/theorizing/analyzing how they themselves came to be subjects: understanding formation does not lead us back to an origin, but makes us aware of the constituted dimension of a subjectivity always in process.

In the last quarter of the twentieth century, there was an extraordinary conversation between three of these four sites to which we can add one more, not fully appreciated by Laplanche himself, but fundamental to Freud in his pre-modernist moment and to Lacan in his modernist moment: aesthetics. I want to sweep away any suggestion that after 1970 a number of artists turned away from art to "theory" and imposed its alien intellectuality upon the virgin aesthetic field. Quarantining psychoanalytical experience as "theory" and defending the purity of art from its insights into desire, scopophilia, identification, or fantasy itself are symptoms of a psychoanalytically identifiable human behavior: defensiveness. The defense emerges to protect the cultural subject, as it were, from the very kind of self-knowledge that Laplanche identifies as the mark of the psychoanalytical: self-theorizing, that is, investigating the process of being a self marked by desire, identifications, and fantasy and significantly entrapped in what Jacqueline Rose has named the field of vision.

Furthermore, the engagement, in some cases formally acknowledged and knowledgeable, and in others more symptomatic and indirect, between art and psychoanalytical experience/experience understood psychoanalytically occurred at a specific art historical moment. At the end of the 1950s, painting and sculpture, the master fields of Western visual art, still seemed inevitable choices for ambitious artists. By the early 1970s, this was hardly the case. Within an exceptionally short space of time, significant art had veered away from a four-hundred year history (1450–1950) and embraced what Terry Atkinson named a newly "complex and expanded practice." Happenings, body art, performance, 16mm and 8mm film, installation, the reclamation of the ready-made, the use of expanded resources found in industrial and everyday materials, the minimalist redefinition of objecthood and real space, and the emergence of conceptualism, which often dispensed completely with objects, all emerged in the space of a decade to rewrite the field of artistic production and its institutional sites.

What interests us here specifically is the artistic exploration of photography, film, and video as both media in the modernist sense and as already coded and freighted forms of

popular culture into which artists could intervene with that double consciousness of modernist formalities and cultural semantics. Unlike Pop art, which performed its own (but only apparent) dissolution of the divisions between high and low, elite and popular culture, the "photographic turn" (which includes the engagement with time-based, film-reliant procedures prior to the development of digital equipment) represents a multi-faceted cultural conversation. In her essay on video's "utopian moment," Martha Rosler reminds us that the use of video by artists necessarily operated in relation to the already existing cultural forms of that technology: broadcast television and its celebrity culture. Initial artistic users of video performed social critiques of TV's cultural customs and effects as well as its potential for reflexivity and democratized audiences:

> Artists were responding not only to the positioning of the mass audience but also to the particular silencing or muting of *artists* as producers of living culture in the face of the vast mass-media industries: the culture industry versus the consciousness industry. . . . The early uses of portable video technology represented a critique of the institutions of art in Western culture, regarded as another structure of domination. Thus, video posed a challenge to the sites of art production in society, the forms and "channels" of delivery, and to the passivity of reception built into them.[14]

Artists' engagements with vernacular or popular media, which were already shaping the public as cultural consumers and forming viewers as subjects in the image of what that popular culture was propagating in terms of race, class, gender, nationhood, and sexuality, was in part a reclamation of earlier Surrealist involvement with the everyday and its underlying fantasmatic structure. It was also a post-1968 social project to exploit the potentially democratic dimensions of the medium/technology, allowing it to disseminate more and different kinds of (self-)imaging and to give voice to voiceless minorities.

Photography was formally patented in France in 1839. The moving image, cinema, dates its patented origins to 1895. Co-emerging, therefore, with the major high cultural shifts we name modern art, and clearly embodying modernity's equally defining relation to the machine and technology, photography and photomechanical reproduction changed the art object by recreating it as the reproduced image (note the profound role of photographic reproduction in art history and in this catalogue itself) while competing with the visual arts for the latter's hegemony over the visual field.[15] To my mind, it was inevitable that at some point during the twentieth century, the visual arts as a critical locus of cultural operation and

reflection would have to come to terms with their modernist half-sibling: the photographic in all its cultural forms, from advertisement to the cinematic and now the proliferating forms of the digital image. How long it will take for artists, who are now so widely involved with digital imagery and technologies, to work through this necessary relation or challenge, I cannot foresee. The work in this exhibition belongs art historically to the initial moments of the widespread engagement by *artists* with vernacular and popular cultural practices, mediated by photomechanical reproduction, in which they would use the latter's own media and technologies to perform their investigation into the power, the operations, the effects, and of course the pleasures of the image in later twentieth-century Western capitalist society.

Again, it does not surprise me to note that *psychoanalytical experience* comes into the foreground of cultural discourse at this time. Psychoanalysis offered a critical and, importantly, self-reflexive vocabulary for working on visual culture, terms such as the gaze, the spectator, the image, and identification, to which we can add specific analyses of the visual field striated by desire and fantasy: scopophilia, voyeurism, fetishism. These are not terms imposed intellectually and esoterically on the everyday pleasures of ads and movies, they are merely the means of understanding the processes in the culture of urban industrial capitalism, which configures its subjects in its own image. We have become subjects of the image—imaginary subjects—in ways that previous Western and other cultures have not done. At a certain point artists turned their attention to this phenomenon, and particularly artists interested in the challenges to the image culture that would emerge with feminism.

Difference c. 1984

In one way, the invitation to write for this exhibition catalogue was an invitation to go back. Around 1984, a cluster of events publicly marked a new turn in the field of both Euro-American art practice and cultural theory that was as significant as it now seems remote. I was implicated in that moment and influenced by it in my own thinking about art and about culture. There is, however, no going back. Instead, the time lapse allows us to reflect on what we (re-) encounter anew, here and now. History means difference. The moment that generated much of the art displayed in this exhibition is different from our own, and also different from the often stereotyped accounts that have sedimented in historical narratives about art and its engagement with questions of the image, sexuality and subjectivity in the 1980s. So we need to reconnect with the voices of that moment.

In 1984 the critic Kate Linker, with filmmaker Jane Weinstock, curated a landmark exhibition at the New Museum in New York (founded in 1977 by Marcia Tucker) that focused on art made using photography and film. Titled "Difference: On Representation and Sexuality," the show later moved to the Institute of Contemporary Art in London. Linker was interested in bringing together a body of recent work that explored "the complex terrain triangulated by the terms sexuality, meaning and language." Moreover, if the exhibition "pertains to recent interest in representation, and particularly in the powers inherent in representation," the show diverged from others like it in the "role it accords to theory" and, in particular, "psychoanalytical theory and its account of sexed subjectivity."[16]

Artists included Hans Haacke, Ray Barrie, Mary Kelly, Silvia Kolbowski, Barbara Kruger, Sherrie Levine, Yve Lomax, Jeff Wall, and Marie Yates. There was video work by Judith Barry, Jean-Luc Godard, Theresa Hak Kyung Cha, Dara Birnbaum, and Martha Rosler, as well as a program of feature-length and short films by Yvonne Rainer, Sheila McLaughlin, VALIE EXPORT, Chantal Akerman, Laura Mulvey/Peter Wollen, Sally Potter, and Liz Rhodes. Mold-breaking for combining all of the above areas of practice and media, the exhibition was accompanied by a catalogue that contained essays by Craig Owens, Lisa Tickner, and Jacqueline Rose.

Rose's essay, "Sexuality in the Field of Vision," reminds us that an intersection of the visual and the sexual occurs in the heart of Freud's early thinking, in his reflections on Leonardo da Vinci's drawing of the sexual act, and of women laughing. Freud's writings on sexual differentiation and becoming are notable for his use of scenarios. With the primal scene, or the discovery of sexual difference, Freud imagines the formative moments as staged encounters and visual confrontations with the enigmas of the already differentiated and sexual world of adults. Thus, Rose argues, "The encounter between psychoanalysis and artistic practice is therefore *staged*, but only in so far as that staging *has already taken place*."[17]

Repetition, however, opens up displacement and difference from which arise critical self-knowledge and cultural critique. Beyond the specifically visual domain, Rose reminds us as well that psychoanalytical insights into subjectivity and the unconscious impinge on theories of language and writing, on semiotics and meaning. While the visual image shares the quality of a staged scenario, it is also an organization of signs that have referents and produce meanings that we *read* across its semiotic components in a specific ordering. Modernism in art stressed a quest to purify the signifier, releasing it from reference (the signified). In returning to what could be considered referentiality, postmodernist art refused this quest. But it had also learned deeply from modernism, so that the re-engagement with meaning, the image, ideology, and fantasy is not a simplistic reversal. Rose wrote, "These images require a reading that neither combines them into a false unity, nor struggles to move behind them

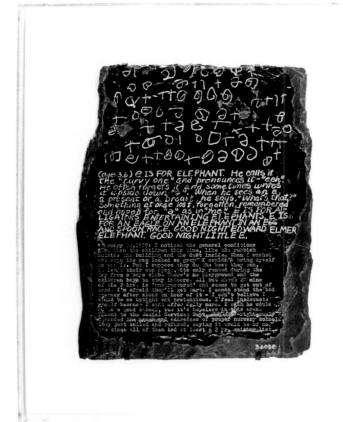

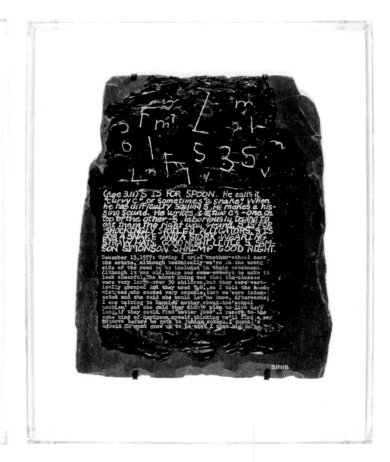

Mary Kelly

Post-Partum Document: Documentation VI:
Pre-Writing Alphabet, Exerque and Diary,
1978–79 (detail). Fifteen slate and resin units and three
diagrams, 14 x 11 in. each. Courtesy the artist

into some realm of truth. The only possible reading is one that repeats their fragmentation of a cultural world they both echo and refuse."[18] Critical postmodernist practice reframes the found image-world of contemporary culture through its investigative formalizing prism, lifting images out of their everyday use to offer them back to us for Brechtian, defamiliarized reconsideration, and thereby discovering the intimacy between sexuality and sexual difference in the image itself. Desire is not separable from the questions of who is desiring, what is the object of desire, and how women negotiate becoming desire's subject rather than merely its object.

Feminist interventions reconfigure this larger cultural impulse with a specific inquiry. Rose points out that it was not self-evident that feminism would have an aesthetic dimension: in holding the image-world responsible for propagating and reproducing fixed gender norms and ideologies of difference, feminism initially scrutinized the image only for its *content*. A specifically artistic interrogation of the relay between cultural image, sexual difference, and sexuality learned from psychoanalysis to attend also to the *form* and what we might call the pleasures within looking: sexuality in the visual field. These pleasures of looking, whose underside is comprised of displeasures that will lead to fetishistic disavowal or sadistic voyeurism, forge a direct link between aesthetics and sexuality. Rose again: "The model is not one of applying psychoanalysis to the work of art.... Psychoanalysis offers a specific account of sexual difference, but its value (and also its difficulty) for feminism lies in the place assigned to woman in that differentiation." This leads to a major statement:

> A feminism concerned with the question of looking can therefore turn this
> theory around, stressing the particular and limiting opposition of male
> and female which any image seen to be flawless serves to hold in place.
> More simply, we know that women are meant to *look* perfect, presenting a
> seamless image to the world so that man, in that confrontation with difference,
> can avoid any apprehension of lack. The position of woman as fantasy thus
> depends on a particular economy of vision (the importance of "images of
> woman" might take on its fullest meaning from this). Perhaps this is also why
> only a project which comes via feminism can demand so unequivocally of
> the image that it renounce all pretensions to a narcissistic perfection of form.[19]

Psychoanalysis encountering feminism on the ironing board of art—to reframe the famous definition of Surrealism—thus produces a specific deconstructive impulse that challenges the place of a heteronormative, racially specific, and ethnically selective image:

"woman" as image, as the pacifyingly beautiful linchpin of a system of meanings and pleasures, races, and sexualities that need to be interrogated and disordered.

Read through this prism, the works collected in this exhibition become performative actions refusing to repeat the fixed positions reinforced by the image world and its dominant ideologies. Some works appropriate popular imagery, seeing pain in the production of beauty, haunting the white world's imaginary with challenges to its disfiguring fantasies of black men and women as bodies of desire or menace, parodying advertisements and rephrasing their messages to expose the politics of gender they typically encode, exploring the act of looking as a sexual unveiling, making the artifice of domestic femininity strange and discomforting, and offering surreal juxtapositions of conflicting imaginings of femininity. Other works disown the image entirely, seeking to find novel forms to trace the emergence of subjectivity in the work of socially circumscribed motherhood in a gendered division of labor. Yet others seek to refuse racializing typologies by creating images of negation, or by finding new languages of desire for the black feminine subject as subject of her own proceedings.

When we now revisit this moment, how will we see these works? How will we catch once again the flavor of that time when artists, returning to the critical deconstructive impulse of Dada and Surrealist avant-gardes, drawing on re-emerging interest in Brechtian cinema and socio-critical montage theory, and learning from anthropology and semiotics, while also making photography both a topic and resource for artistic practice, once again felt engaged with major cultural questions? Can we see, with the artists, this investigation into the image as a cultural site of both psychoanalytical experience—of fantasy, desire, identification, pleasure—and of political action, in which their works could serve at once as inquiry and impulses for change? If deconstructivism is never destructive but pays attention to how we, our worlds and our words are constructed, psychoanalysis as a method and means of cultural critique shares that interest in knowing how we become ourselves and what such becoming entrains. As Cixous suggests, any feminist deconstructive impulse takes infinitely variable forms, as diverse as the singularities of each artist. This exhibition allows us to re-encounter through each work the many different and individualized sentences that collectively add up to an intervention that can be called feminist *in its effects*. The artists represented raise to a level of critical consciousness the deeper structural forces at play in the image, in a culture still struggling to imagine women.

In our present moment of intense over-sexualization of women, amid a celebrity culture based on the iconicity of bodies and looks, underpinned by the widespread actuality of surgical interventions and techniques for producing the flawless image, this re-encounter with an earlier moment of artistic investigation and critique is more than timely. It reminds us that we are still working on the problem.

Griselda Pollock, Professor of the Social and Critical Histories of Art, University of Leeds, is an art historian and cultural commentator known for her extensive writings on visual art as viewed through the lens of feminism and psychoanalytic theory.

1

Stuart Hall, "Who Needs 'Identity'?" in *Questions of Cultural Identity*, edited by Stuart Hall and Paul du Gay (London: Sage Publications, 1996), 1–17.

2

Jacques Derrida, *Positions* (Chicago: Chicago University Press, 1981).

3

It is interesting to note the coincidence in publication date of key catalogues dealing with subjectivity and the image, as I will discuss shortly, and art historian T.J.Clark, for instance, picking up on Situationist theories of the "Society of the Spectacle" for his work on modernist painting in Paris a century earlier. During the 1970s, capitalism was identified as producing a society of the spectacle, and its intensifying commodity-image regime helped make visible the way early Modernist painting in Paris precociously registered initial moments of change in the culture of the image.

4

By the time it "arrived" artistically, for instance in the famous and much contested Whitney Biennial curated by Elisabeth Sussman in 1993, critical theory was disowning the concept.

5

Rosalind Coward, *Female Desire: Women's Sexuality Today* (London: Paladin, 1984), 16.

6

Teresa de Laurentis offers an important formulation of the intersection of socially produced representations of gender offered to us and the ways in which as active processors of signs, the individual subject reproduces what is offered as self-representation. See "Semiotics and Experience" in her *Alice Doesn't: Feminism, Semiotics, Cinema* (Bloomington: Indiana University Press, 1984).

7

Jane Flax, "The Scandal of Desire: Psychoanalysis and the Disruptions of Gender," *Contemporary Psychoanalysis*, 40 (2004): 47–68.

8

Jacqueline Rose, "Feminism and the Psychic" in *Sexuality in the Field of Vision* (London: Verso Books, 1986), 7.

9

Rose, "Feminism and the Psychic," 7.

10

Rose, "Feminism and the Psychic," 15.

11

Jean Laplanche, *New Foundations for Psycho-analysis*, trans. David Macey (Oxford: Basil Blackwell, 1989), 11–12.

12

Laplanche, *New Foundations for Psychoanalysis*, 12.

13

Laplanche, *New Foundations for Psychoanalysis*, 13.

14

Martha Rosler, "Video: Shedding the Utopian Moment," Block 11 (1985/6): 27–28, reprinted in Martha Rosler, *Decoys and Disruptions: Selected Writings* 1970–2001(Cambridge, Mass.: MIT Press, 2004).

15

I cannot go into the ramifications here of Walter Benjamin's theses on the end of the aura of the artwork through reproducibility, nor into André Malraux's theses on the photographic imaginary museum, or even Mary Kelly's important analyses of the way exhibition catalogues produce art as photographic illustration.

16

Kate Linker, "Foreword," *Difference: On Representation and Sexuality* (New York: New Museum of Contemporary Art, 1984), 5.

17

Rose, "Sexuality in the Field of Vision" in *Difference: On Representation and Sexuality* (New York: New Museum of Contemporary Art, 1984), 31.

18

Rose, "Sexuality in the Field of Vision," 32.

19

Rose, "Sexuality in the Field of Vision," 33.

Plates

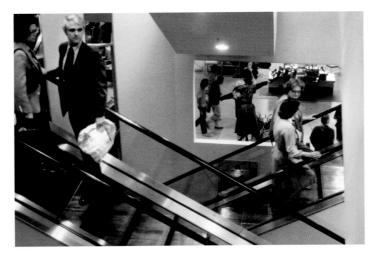

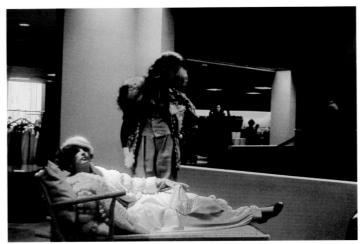

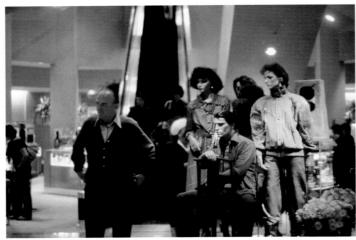

Judith Barry

stills from *Casual Shopper*, 1980–81
Video, color, stereo sound, 28 min.
Courtesy the artist and Rosamund Felsen Gallery,
Los Angeles

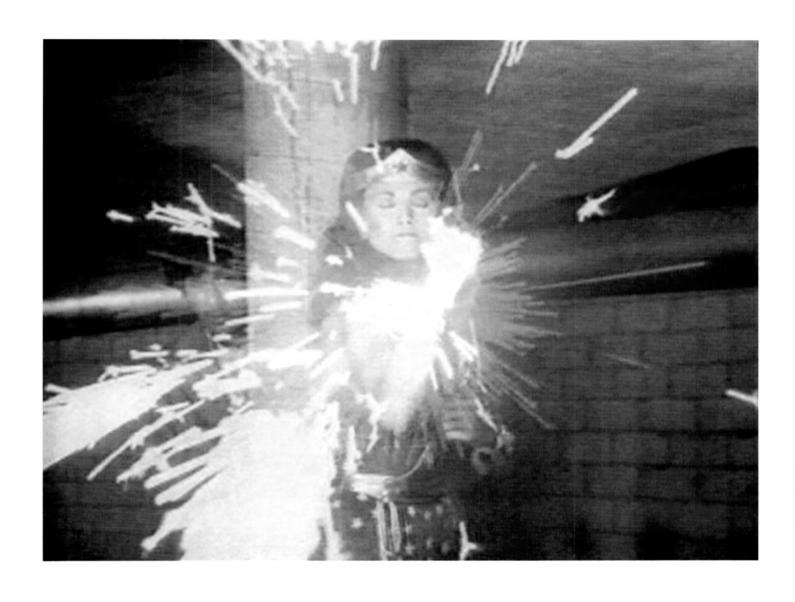

Dara Birnbaum

still from *Technology/Transformation:*
Wonder Woman, 1978–79
Video, color, sound, 5 min., 50 sec.
Courtesy Electronic Arts Intermix (EAI), New York

Dara Birnbaum

still from *Pop-Pop Video: General Hospital/*
Olympic Women Speed Skating, Kojak/Wang, 1980
Video, color, sound, 9 min.
Courtesy Electronic Arts Intermix (EAI), New York

Dara Birnbaum

still from *Artbreak, MTV Networks, Inc.*, 1987
Video, color, sound, 30 sec.
Courtesy Electronic Arts Intermix (EAI), New York

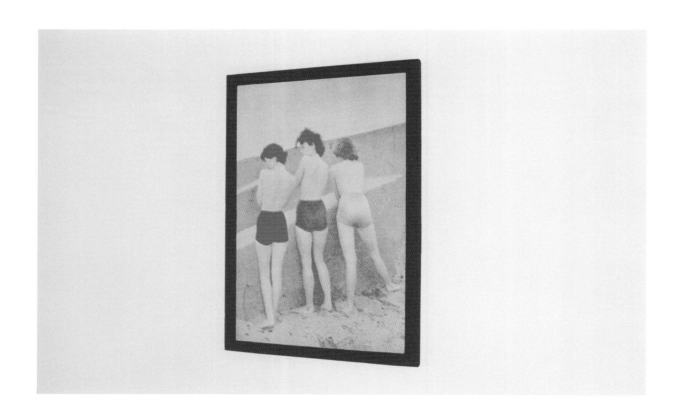

Barbara Bloom

Three Girls from "The Gaze," 1987
Cibachrome print, 40 x 60 in.
Courtesy the artist and Tracy Williams, Ltd.,
New York

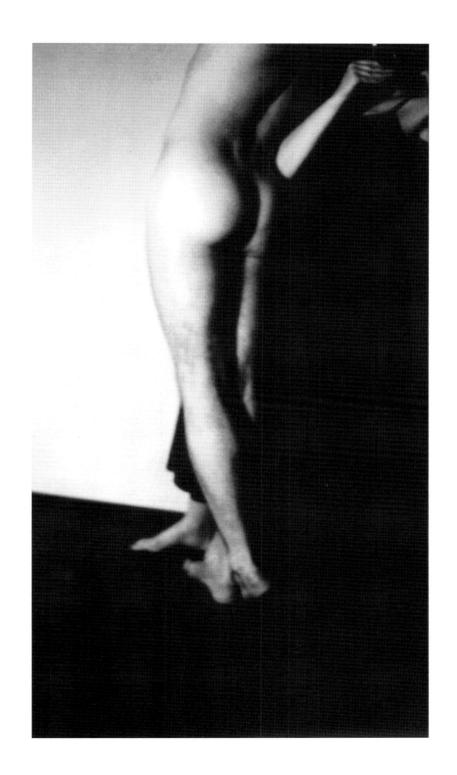

Barbara Bloom

Tango (Male Nude Study) from "The Gaze," 1985
Cibachrome print, 77 x 48 in.
Courtesy the artist and Tracy Williams, Ltd.,
New York

Barbara Bloom

Blue Dahlem Curtain from "The Gaze," 1986
Cibachrome print with white mat, 23 x 34 in.
Courtesy the artist and Tracy Williams, Ltd.,
New York

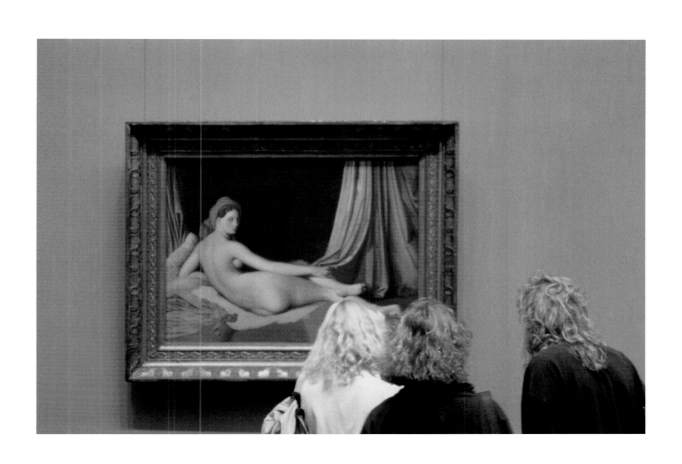

Barbara Bloom

Ingres Girl Viewers from "The Gaze," 1987
Cibachrome print, 24 x 35 in.
Courtesy the artist and Tracy Williams, Ltd.,
New York

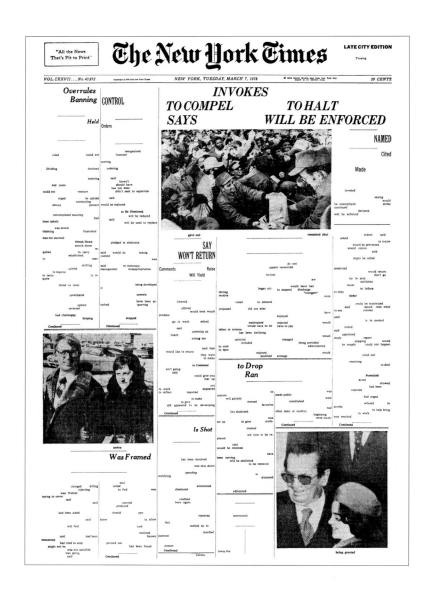

Sarah Charlesworth

Verbs, New York Times, March 7th 1978
from "Modern History," 1978
Fuji Crystal Archive print, 22 1/4 x 13 3/4 in.
Courtesy the artist and Margo Leavin Gallery, Los Angeles

Sarah Charlesworth

Reading Persian from "Modern History," 1979
2 Fuji crystal archive prints, 23 x 16 in. each.
Courtesy the artist and Susan Inglett Gallery, New York

Sarah Charlesworth

Black Mask from "Objects of Desire I," 1983
Cibachrome with lacquered wood frame, 42 x 32 in.
Collection of Jay Gorney.
Courtesy Susan Inglett Gallery, New York

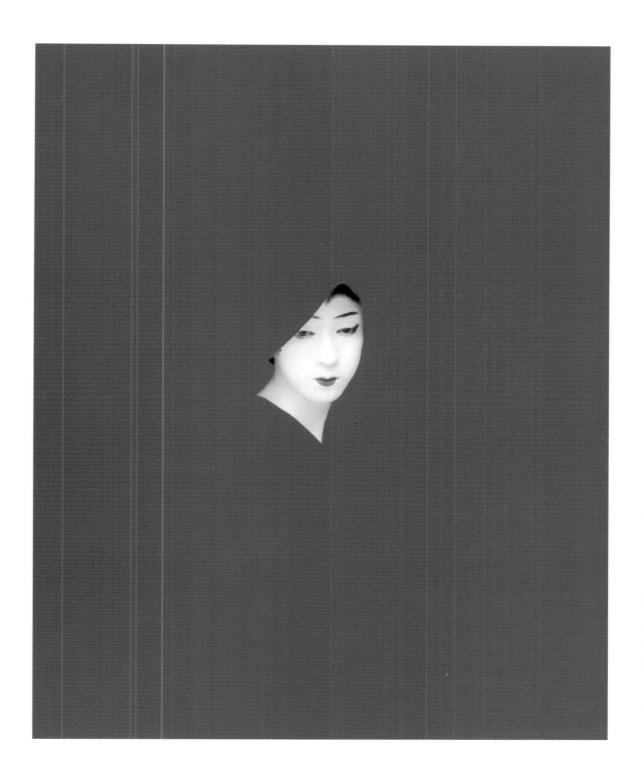

Sarah Charlesworth

Red Mask from "Objects of Desire I," 1983
Cibachrome with lacquered wood frame, 42 x 32 in.
Collection of Sandi Fellman.
Courtesy Susan Inglett Gallery, New York

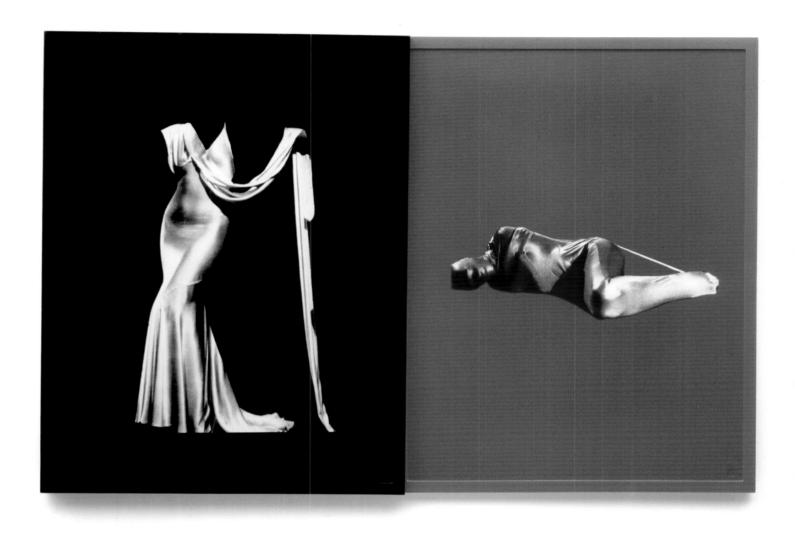

Sarah Charlesworth

Figures from "Objects of Desire I," 1983–84
Cibachrome with lacquered wood frame, 42 x 62 in.
Collection of Sondra Gilman and
Celso Gonzales-Falla

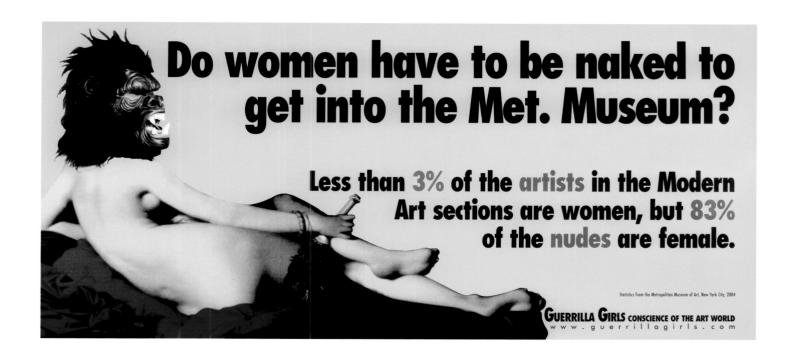

Guerrilla Girls

Do Women Have to be Naked to Get into the Met. Museum?, 1989
Offset print poster, 11 x 24 in.
Collection Friends of the Neuberger Museum of Art,
Purchase College, State University of New York;
Museum purchase with funds provided
by the Friends of the Neuberger Museum of Art

THE ADVANTAGES OF BEING A WOMAN ARTIST:

Working without the pressure of success
Not having to be in shows with men
Having an escape from the art world in your 4 free-lance jobs
Knowing your career might pick up after you're eighty
Being reassured that whatever kind of art you make it will be labeled feminine
Not being stuck in a tenured teaching position
Seeing your ideas live on in the work of others
Having the opportunity to choose between career and motherhood
Not having to choke on those big cigars or paint in Italian suits
Having more time to work when your mate dumps you for someone younger
Being included in revised versions of art history
Not having to undergo the embarrassment of being called a genius
Getting your picture in the art magazines wearing a gorilla suit

A PUBLIC SERVICE MESSAGE FROM **GUERRILLA GIRLS** CONSCIENCE OF THE ART WORLD

Guerrilla Girls

The Advantages of Being a Woman Artist, 1988
Offset print poster, 17 x 22 in.
Collection Friends of the Neuberger Museum of Art,
Purchase College, State University of New York;
Museum purchase with funds provided by the Friends
of the Neuberger Museum of Art

TOP TEN WAYS TO TELL IF YOU'RE AN ART WORLD TOKEN:

10. Your busiest months are February (Black History Month), March (Women's History), April (Asian-American Awareness), June (Stonewall Anniversary) and September (Latino Heritage).

9. At openings and parties, the only other people of color are serving drinks.

8. Everyone knows your race, gender and sexual preference even when they don't know your work.

7. A museum that won't show your work gives you a prominent place in its lecture series.

6. Your last show got a lot of publicity, but no cash.

5. You're a finalist for a non-tenure-track teaching position at every art school on the east coast.

4. No collector ever buys more than one of your pieces.

3. Whenever you open your mouth, it's assumed that you speak for "your people," not just yourself.

2. People are always telling you their interracial and gay sexual fantasies.

1. A curator who never gave you the time of day before calls you right after a Guerrilla Girls demonstration.

A PUBLIC SERVICE MESSAGE FROM **GUERRILLA GIRLS** CONSCIENCE OF THE ARTWORLD
532 LaGUARDIA PLACE, #237 • NY, NY 10012

Guerrilla Girls

Top Ten Signs that You're an Art World Token, 1995
Offset print poster, 17 x 22 in.
Collection Friends of the Neuberger Museum of Art,
Purchase College, State University of New York;
Museum purchase with funds provided by the Friends
of the Neuberger Museum of Art

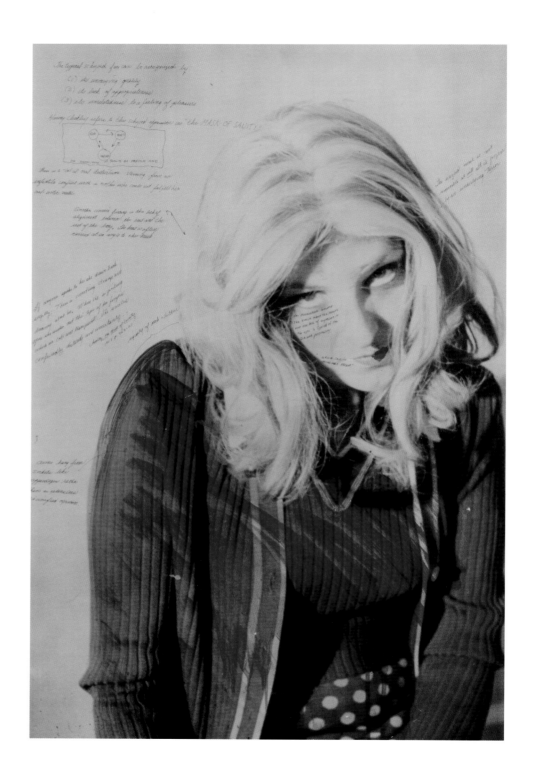

Lynn Hershman

Roberta's Physical Stance from "Roberta
Breitmore Series," 1976
C-print with acrylic and ink, 40 x 30 in.
Courtesy the artist and Gallery Paule Anglim,
San Francisco

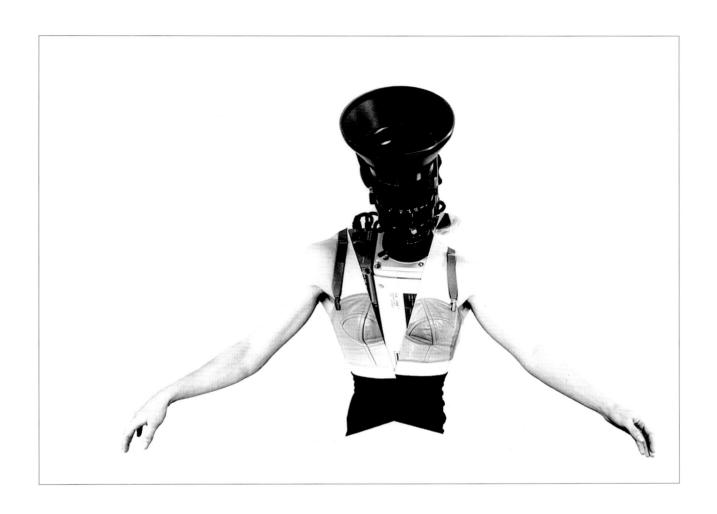

Lynn Hershman

Camerawoman from "Phantom Limb," 1988
Gelatin silver print, 20 x 24 in.
Courtesy the artist and Gallery Paule Anglim,
San Francisco

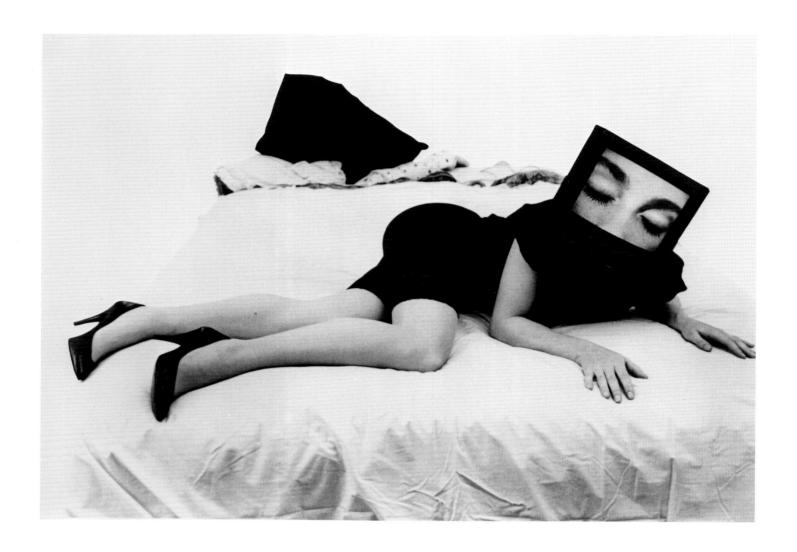

Lynn Hershman

Seduction from "Phantom Limb," 1988
Gelatin silver print, 31 x 41 in.
Courtesy the artist and Gallery Paule Anglim,
San Francisco

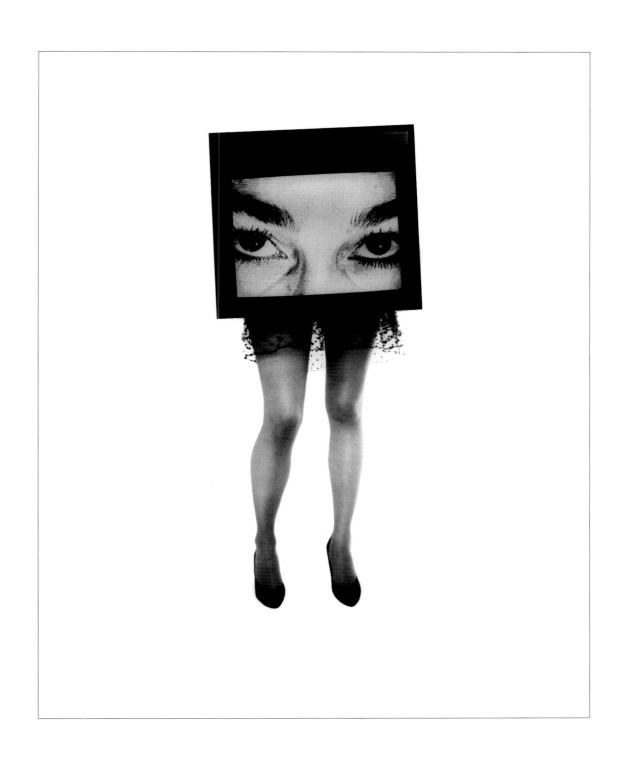

Lynn Hershman

TV Legs from "Phantom Limb," 1990
Gelatin silver print, 24 x 20 in.
Courtesy the artist and Gallery Paule Anglim,
San Francisco

Susan Hiller

Belshazzar's Feast, 1983–84 (installation view,
S.M.A.K, Ghent, Belgium, 2004)
Video, 19 min., 11 sec., installation dimensions variable.
Timothy Taylor Gallery, London

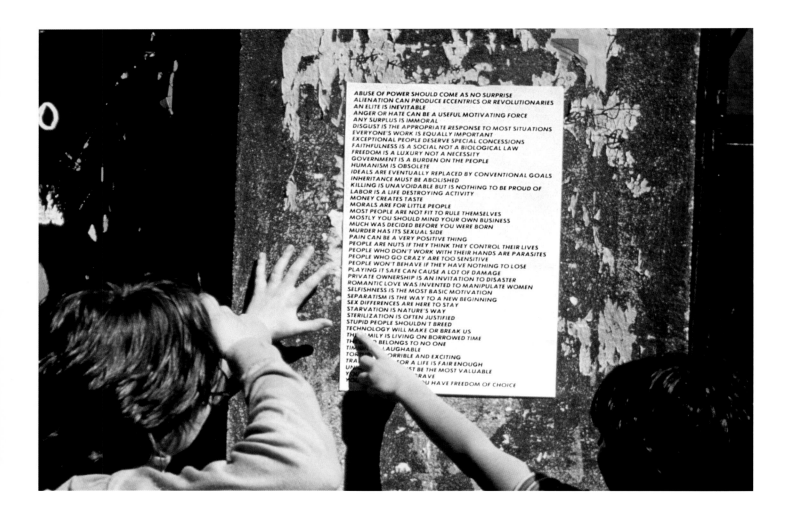

Jenny Holzer

from *Truisms*, 1977–79
(installation view, New York, 1977)
Offset poster, 36 x 24 in.
Courtesy the artist

ABUSE OF POWER SHOULD COME AS NO SURPRISE
ALIENATION CAN PRODUCE ECCENTRICS OR REVOLUTIONAR
AN ELITE IS INEVITABLE
ANGER OR HATE CAN BE A USEFUL MOTIVATING FORCE
ANY SURPLUS IS IMMORAL
DISGUST IS THE APPROPRIATE RESPONSE TO MOST SITUATIO
EVERYONE'S WORK IS EQUALLY IMPORTANT
EXCEPTIONAL PEOPLE DESERVE SPECIAL CONCESSIONS
FAITHFULNESS IS A SOCIAL NOT A BIOLOGICAL LAW
FREEDOM IS A LUXURY NOT A NECESSITY
GOVERNMENT IS A BURDEN ON THE PEOPLE
HUMANISM IS OBSOLETE
IDEALS ARE EVENTUALLY REPLACED BY CONVENTIONAL GOA
INHERITANCE MUST BE ABOLISHED
KILLING IS UNAVOIDABLE BUT IS NOTHING TO BE PROUD OF
LABOR IS A LIFE-DESTROYING ACTIVITY
MONEY CREATES TASTE
MORALS ARE FOR LITTLE PEOPLE
MOST PEOPLE ARE NOT FIT TO RULE THEMSELVES
MOSTLY YOU SHOULD MIND YOUR OWN BUSINESS
MUCH WAS DECIDED BEFORE YOU WERE BORN
MURDER HAS ITS SEXUAL SIDE
PAIN CAN BE A VERY POSITIVE THING
PEOPLE ARE NUTS IF THEY THINK THEY CONTROL THEIR LIVES
PEOPLE WHO DON'T WORK WITH THEIR HANDS ARE PARASITES
PEOPLE WHO GO CRAZY ARE TOO SENSITIVE
PEOPLE WON'T BEHAVE IF THEY HAVE NOTHING TO LOSE
PLAYING IT SAFE CAN CAUSE A LOT OF DAMAGE
PRIVATE OWNERSHIP IS AN INVITATION TO DISASTER
ROMANTIC LOVE WAS INVENTED TO MANIPULATE WOMEN
SELFISHNESS IS THE MOST BASIC MOTIVATION

Jenny Holzer

from *Truisms*, 1977–79 (installation view, Jenny Holzer,
Franklin Furnace, New York, 1978)
Photostats, audio tape, posters (partially destroyed).
Courtesy the artist

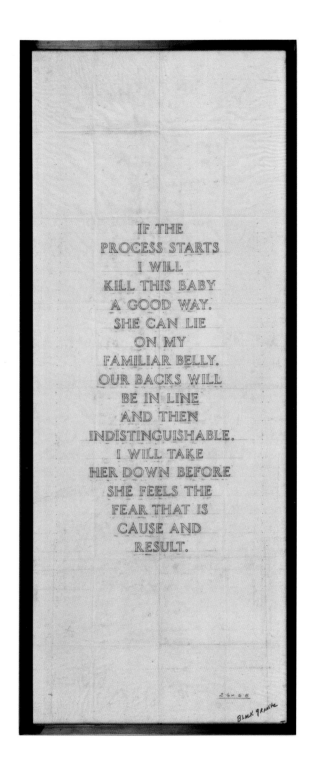

Jenny Holzer

Laments: If the process starts..., 1989
Carbon on tracing paper, 84 x 32 in.
Courtesy the artist

Jenny Holzer

Mother and Child, 1990
Eight electronic mini L.E.D. signboards,
4 x 5 x 1¹/₂ in.
Courtesy the artist

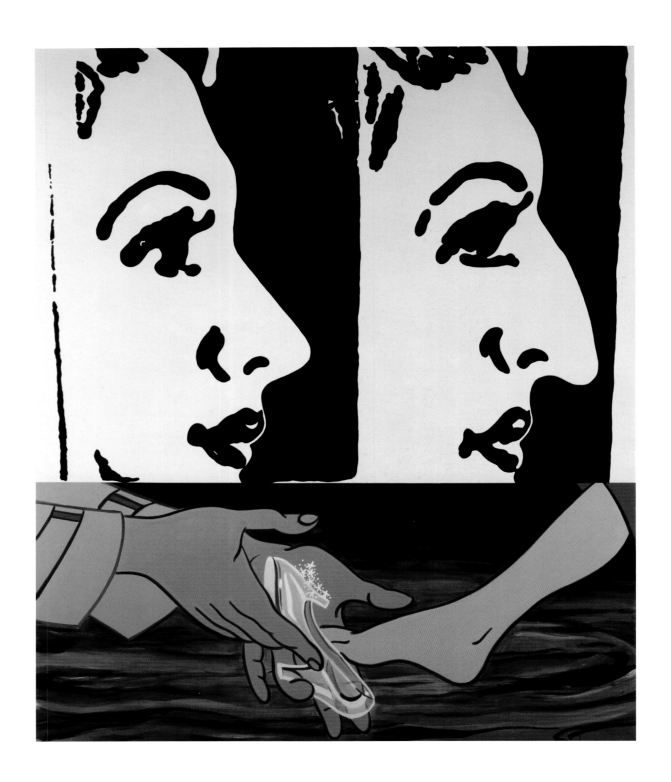

Deborah Kass

Before and Happily Ever After, 1991
Oil and acrylic on canvas, 72 x 60 in.
Courtesy the artist and Paul Kasmin Gallery, New York

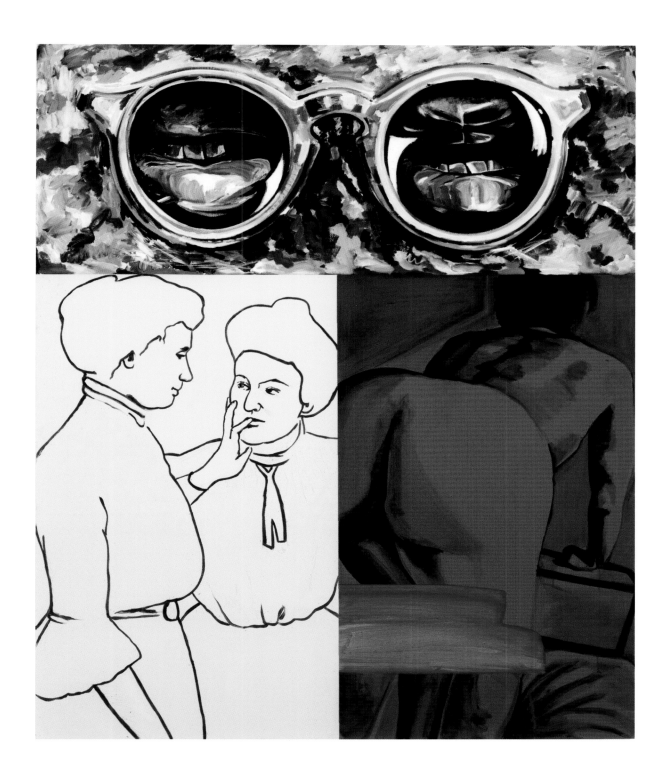

Deborah Kass

Read My Lips, 1990
Oil and acrylic on canvas, 72 x 60 in.
Courtesy the artist and Paul Kasmin Gallery, New York

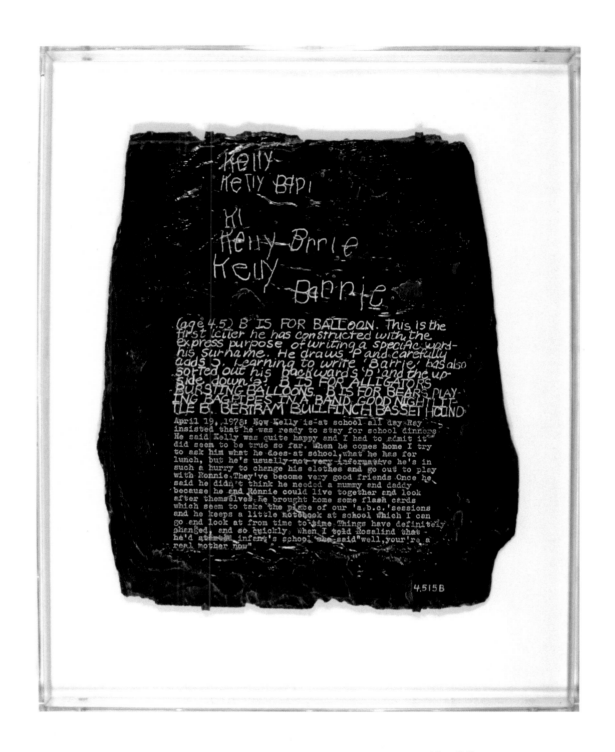

Mary Kelly

Post-Partum Document: Documentation VI:
Pre-Writing Alphabet, Exerque and Diary, 1978–79
(installation view and detail)
Fifteen slate and resin units and three diagrams,
14 x 11 in. each.
Courtesy the artist

Silvia Kolbowski

Model Pleasure III, 1983
Four chromogenic prints and eight gelatin silver
prints, 8 x 10 in. each.
Courtesy the artist

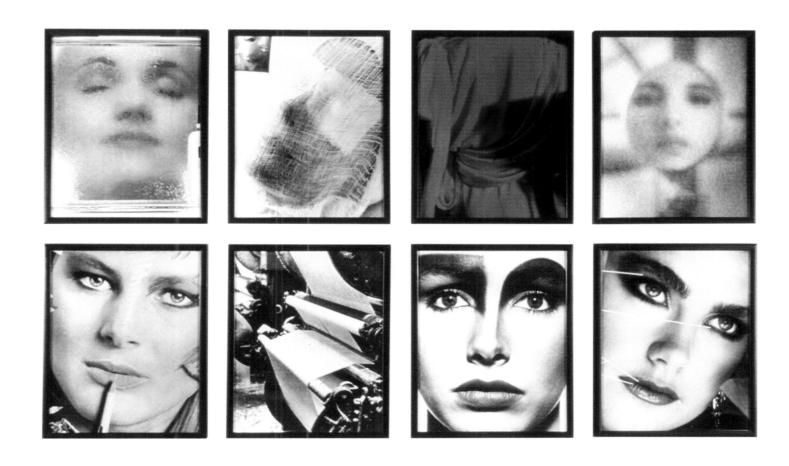

Silvia Kolbowski

Model Pleasure V, 1983
Chromogenic print and seven gelatin silver
prints, 21 1/2 x 36 1/4 x 3/4 in. overall.
Courtesy the artist

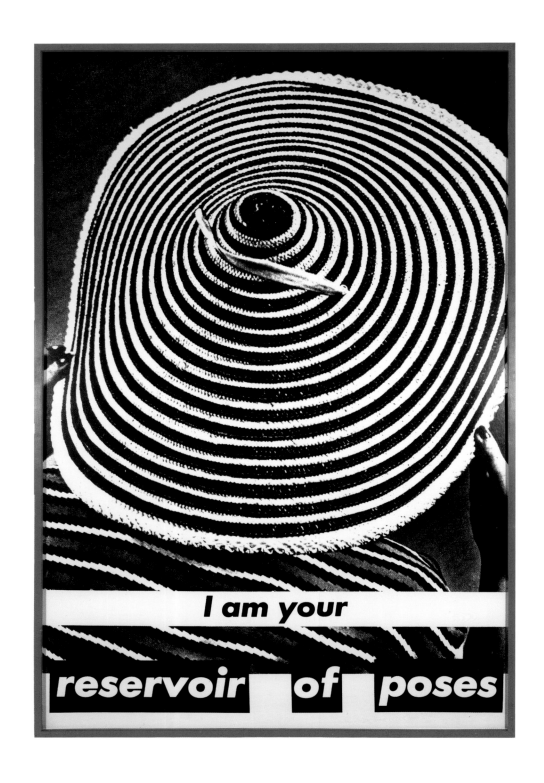

Barbara Kruger

Untitled (I am your reservoir of poses), 1982
Black-and-white photograph, 72 x 48 in.
Private Collection

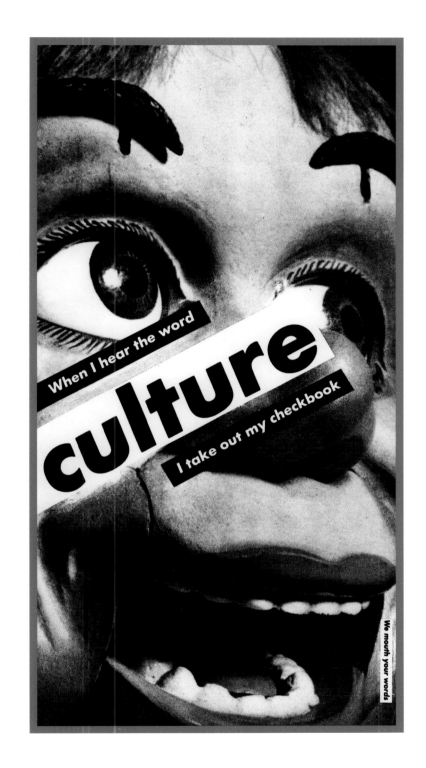

Barbara Kruger

Untitled (When I hear the word culture I take out my checkbook), 1985
Black-and-white photograph, 138 x 60 in.
Collection of Peter Norton

123

Louise Lawler

Arranged by Donald Marron, Susan Brundage,
Cheryl Bishop at Paine Webber Inc., 1982
Black-and-white photograph, 17 ¼ x 23 ¼ in.
Courtesy the artist and Metro Pictures, New York

124

Louise Lawler

Arranged by Donald Marron, Susan Brundage,
Cheryl Bishop at Paine Webber Inc., 1982
Black-and-white photograph, 19 1/2 x 21 3/4 in.
Courtesy the artist and Metro Pictures, New York

125

Louise Lawler

Conditions of Sale, 1988–90
Black-and-white photograph with printed text
on mat, 29 x 32 ³/₄ in.
Courtesy the artist and Metro Pictures, New York

"All property is sold AS IS in accordance with
the section entitled ABSENCE OF OTHER WARRANTIES,
and neither Christie's nor the seller makes any express or
implied warranty or representations as to the condition
of any lot offered for sale, and no statement made at any
time, whether oral or written, shall constitute such
a warranty or representation. Descriptions of condition
are not warranties. The descriptions of the conditions of
articles in this catalogue, including all references to
damage or repairs, are provided as a service to interested
persons and do not negate or modify the section
entitled ABSENCE OF OTHER WARRANTIES."

Louise Lawler

Board of Directors, 1988–89
Black-and-white photograph with printed
text on mat, 16 x 22 ¼ in.
Courtesy the artist and Metro Pictures, New York

"BOARD OF DIRECTORS
L. Guy Hannen, Chairman
Christopher Burge, President and Chief Executive Officer
François Curiel, Stephen S. Lash, Executive Vice-Presidents
J. Brian Cole • Ian G. Kennedy • Karen A.G. Loud
Stephen C. Massey • Anthony M. Phillips, Senior Vice-Presidents
Daniel P. Davison • Geoffrey Elliott"

Sherrie Levine

After Walker Evans, 1981
Gelatin silver print, 6 ¼ x 5 in.
Paula Cooper Gallery, New York

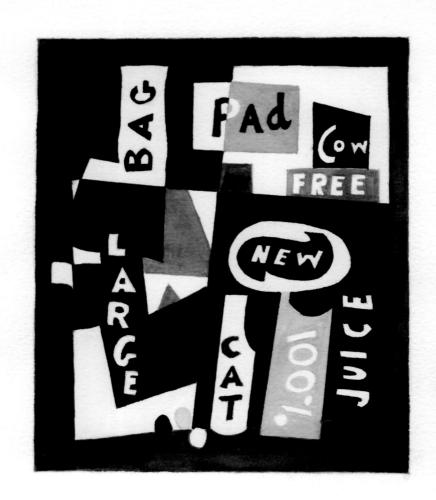

Sherrie Levine

After Stuart Davis, 1983
Watercolor on paper, 14 x 11 in.
Collection of C. Bradford Smith and Donald Davis

Sherrie Levine

After Joan Miro, 1984
Watercolor and graphite on paper, 14 x 10 in.
Paula Cooper Gallery, New York

Sherrie Levine

After Malevich, 1984
Watercolor on paper, 14 x 11 in.
Private Collection, Hamburg

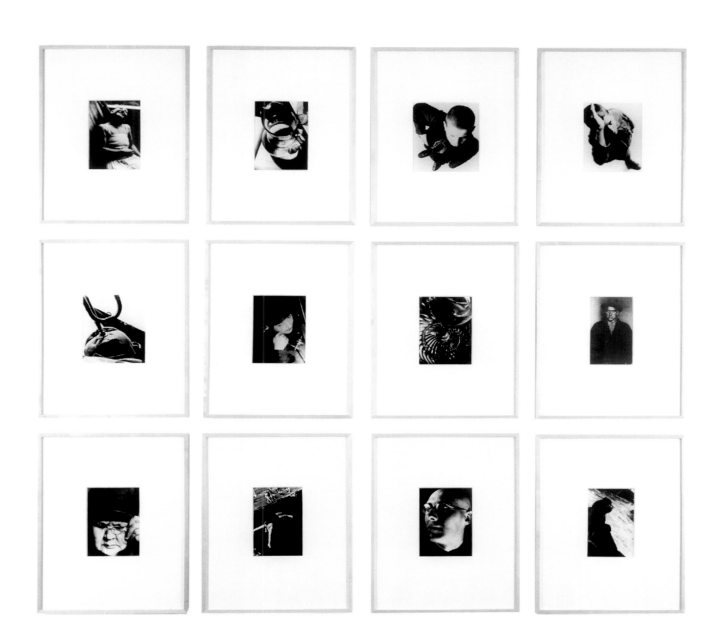

Sherrie Levine

After Rodchenko 1–12, 1987 (printed 1998)
Twelve gelatin silver prints, 8 x 6 in. each.
Collection of Pamela and Arthur Sanders

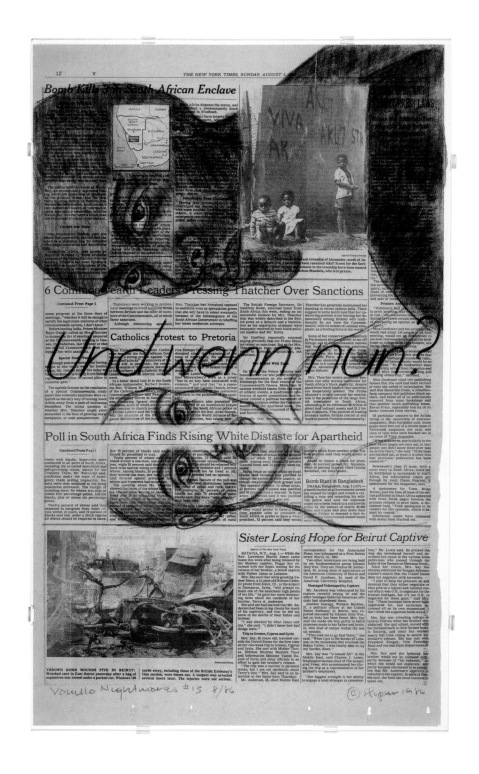

Adrian Piper

Vanilla Nightmares #13, 1986
Charcoal drawing on newspaper, 22 x 13 ¾ in.
Collection of the Adrian Piper Research
Archive Foundation, Berlin

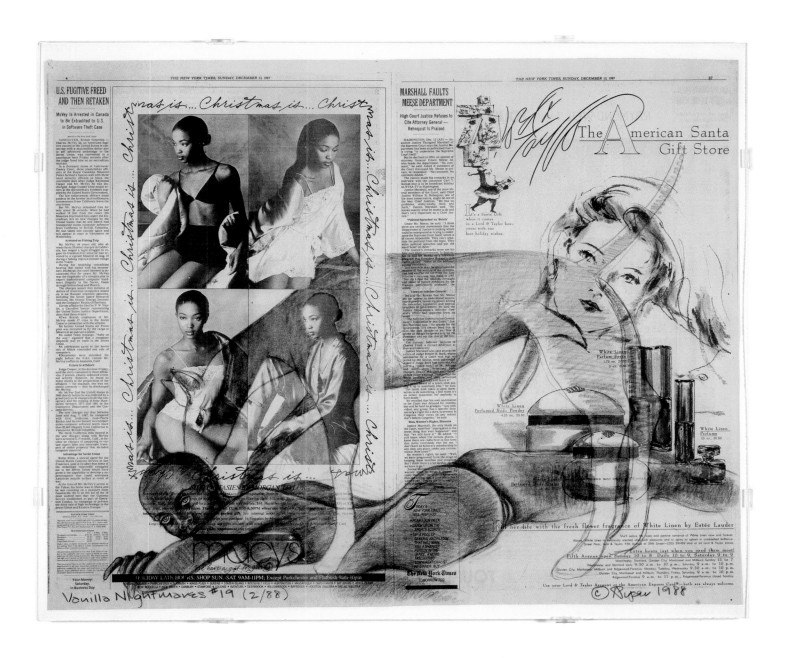

Adrian Piper

Vanilla Nightmares #19, 1988
Charcoal on newspaper, 22 x 27 1/2 in.
Collection of the Adrian Piper Research
Archive Foundation, Berlin

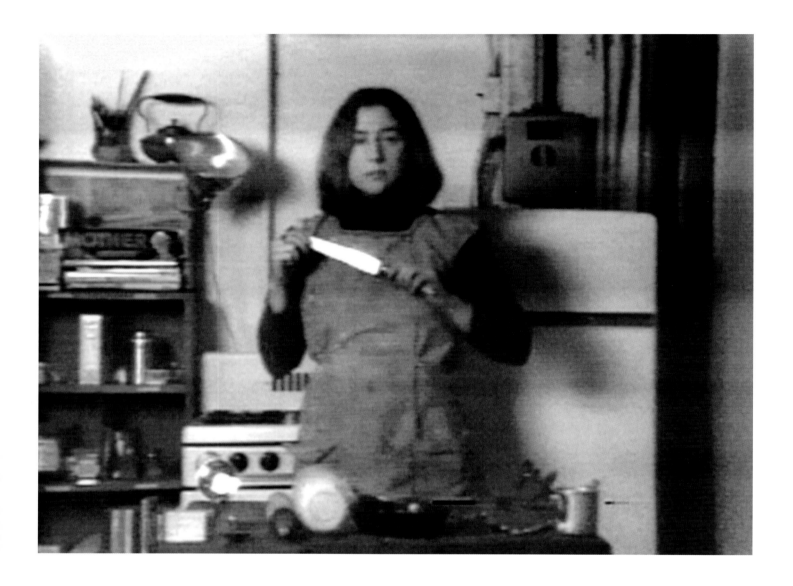

Martha Rosler

still from *Semiotics of the Kitchen*, 1975
Video, black-and-white, sound, 6 min.
Courtesy Electronic Arts Intermix (EAI), New York

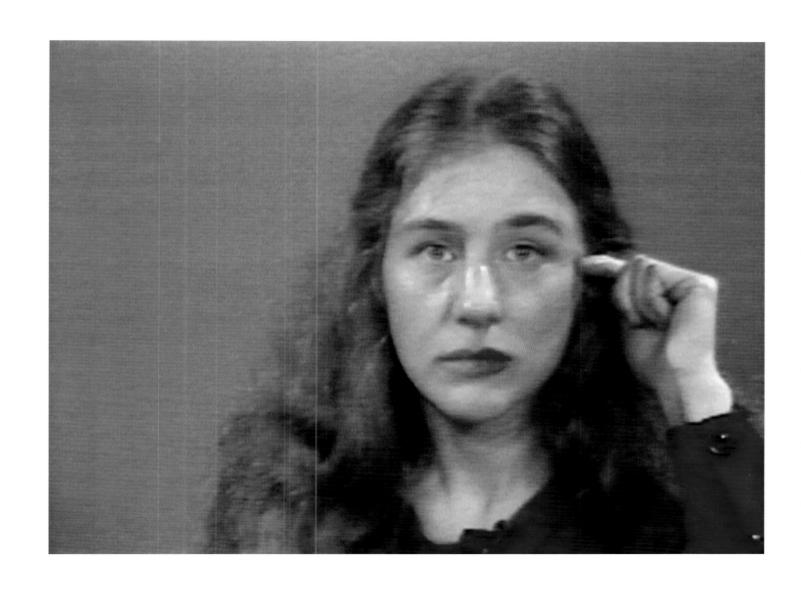

Martha Rosler

still from *Martha Rosler Reads "Vogue,"* 1982
Produced by Paper Tiger Television.
Video, color, sound, 25 min., 45 sec.
Courtesy Electronic Arts Intermix (EAI), New York

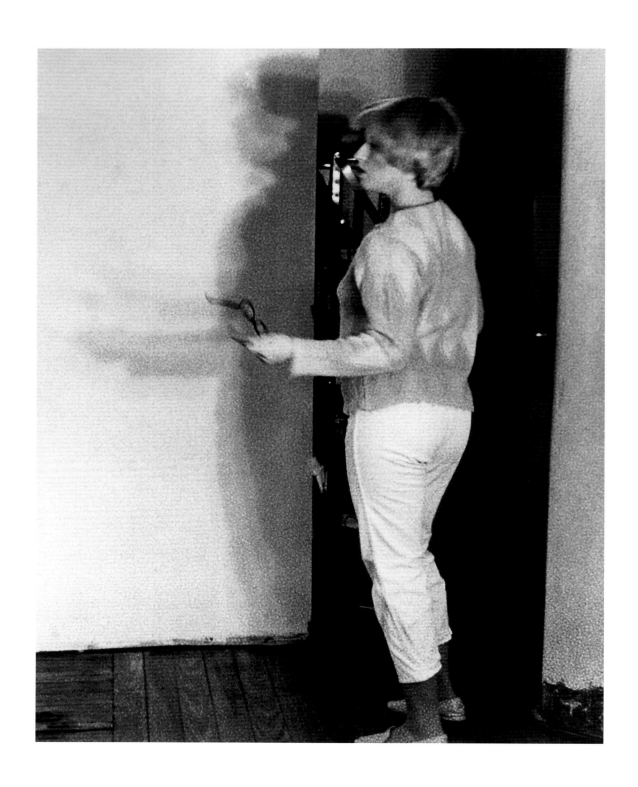

Cindy Sherman

Untitled Film Still # 1, 1977
Gelatin silver print, 10 x 8 in.
Courtesy the artist and Metro Pictures, New York

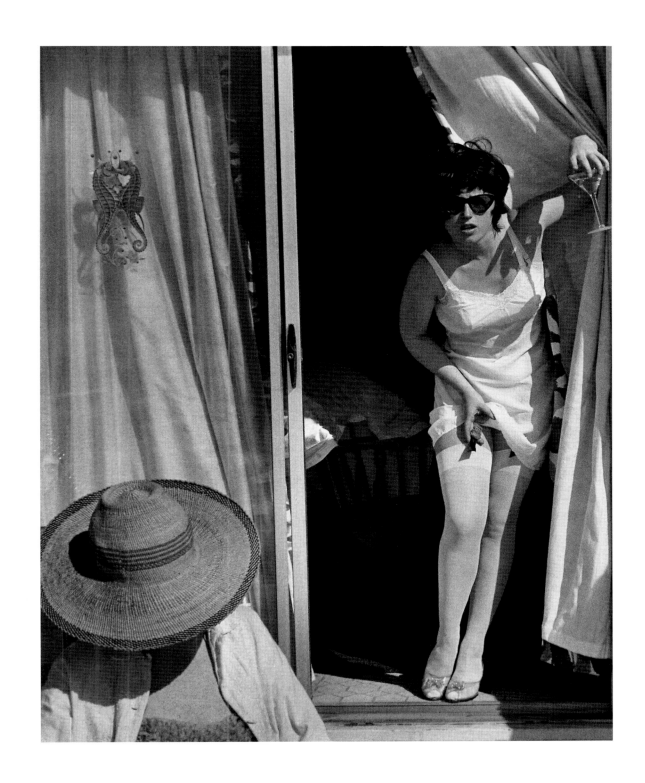

Cindy Sherman

Untitled Film Still #7, 1978
Gelatin silver print, 9 1/2 x 7 9/16 in.
Private Collection, New York

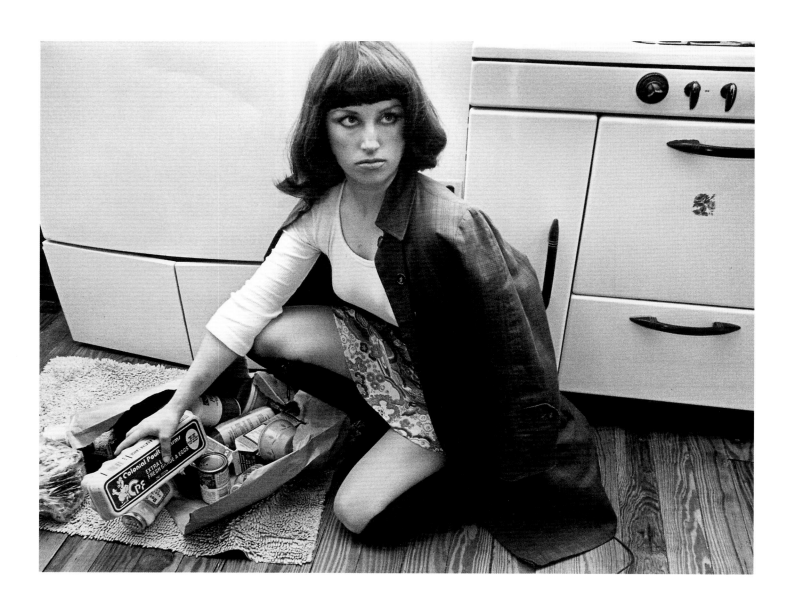

Cindy Sherman

Untitled Film Still # 10, 1978
Gelatin silver print, 8 x 10 in.
Private Collection, New York

Cindy Sherman

Untitled Film Still # 13, 1978
Gelatin silver print, 9 7/16 x 7 1/2 in.
Courtesy the artist and Metro Pictures, New York

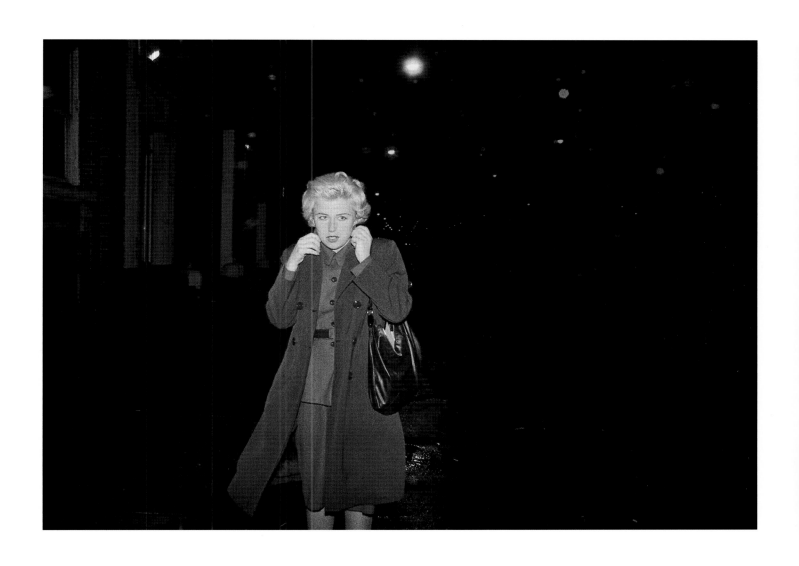

Cindy Sherman

Untitled Film Still # 54, 1980
Gelatin silver print, 6 ¹³/₁₆ x 9 ⁷/₁₆ in.
Courtesy the artist and Metro Pictures, New York

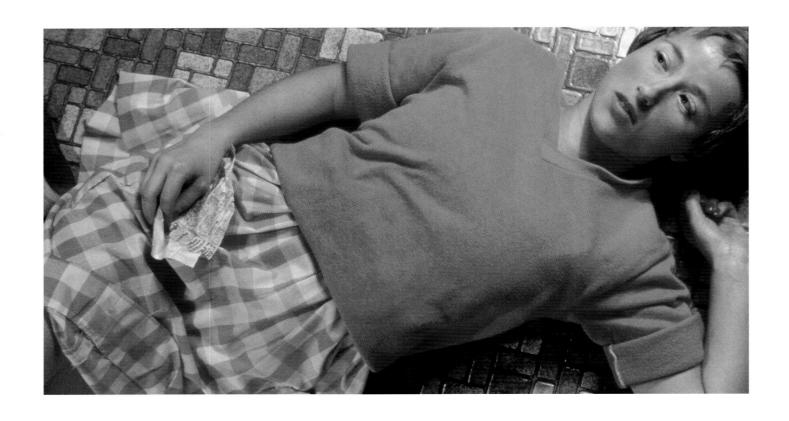

Cindy Sherman

Untitled #96, 1981
Color photograph, 24 x 48 in.
Courtesy the artist and Metro Pictures,
New York

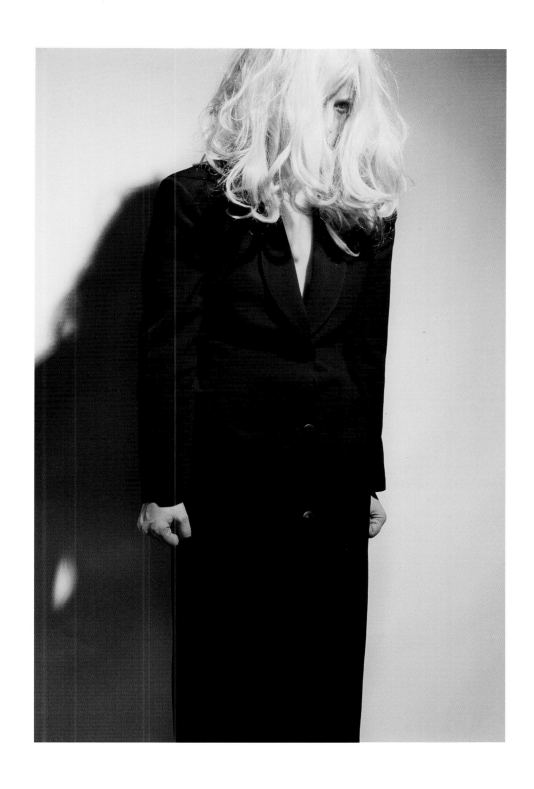

Cindy Sherman

Untitled # 122 , 1983
Color photograph, 35 ¼ x 21 ¼ in.
Collection of Pamela and Arthur Sanders

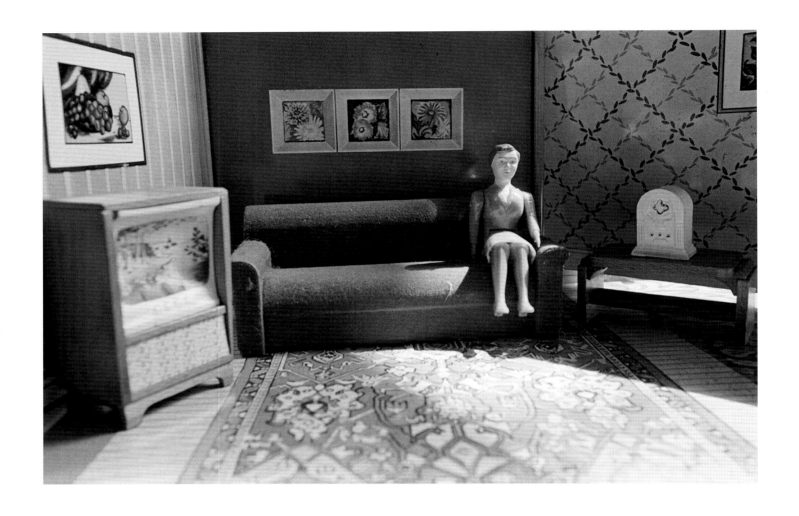

Laurie Simmons

Woman Listening to Radio from "Interiors," 1978
Gelatin silver print, 5¼ x 8
Courtesy the artist

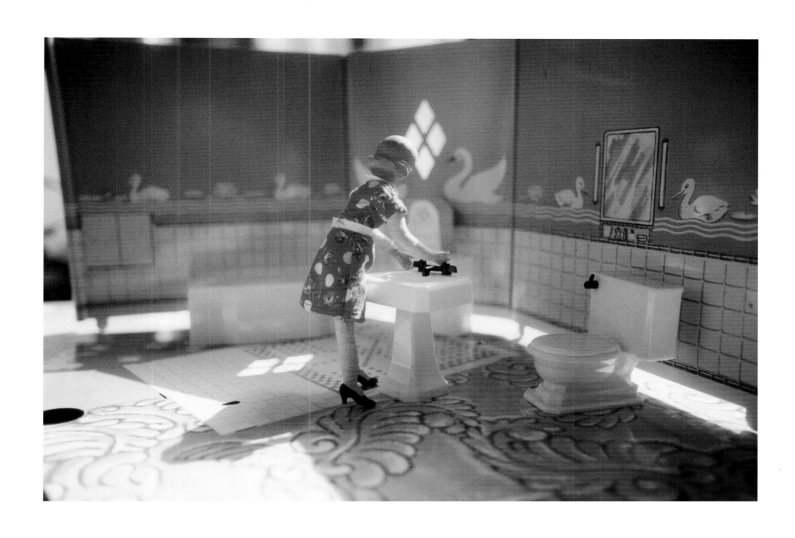

Laurie Simmons

First Bathroom/Woman Standing from
"Interiors," 1978
Cibachrome print, 3 1/2 x 5 in.
Courtesy the artist

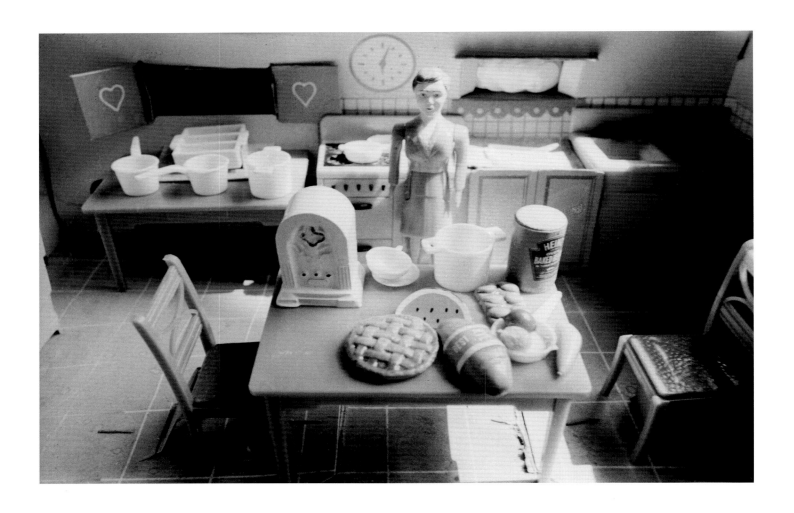

Laurie Simmons

Woman/Purple Dress/Kitchen from "Interiors," 1978
Gelatin silver print, 5¼ x 8 in.
Courtesy the artist

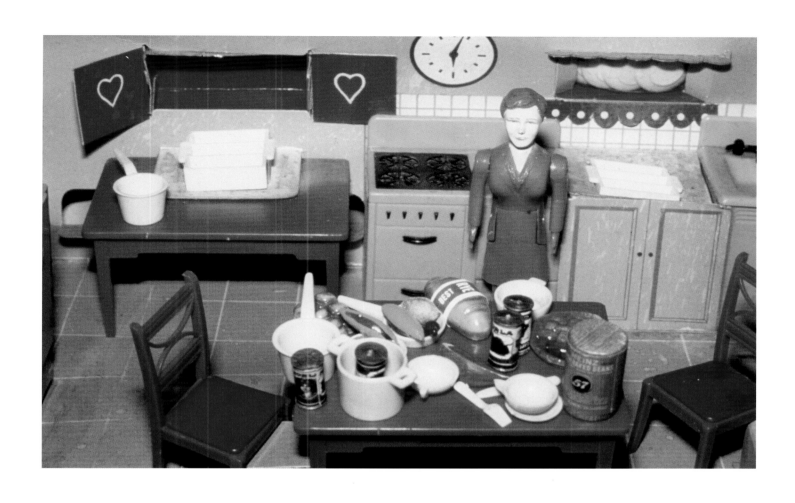

Laurie Simmons

Purple Woman/Kitchen from "Interiors," 1978
Cibachrome print, 3 1/2 x 5 in.
Courtesy the artist

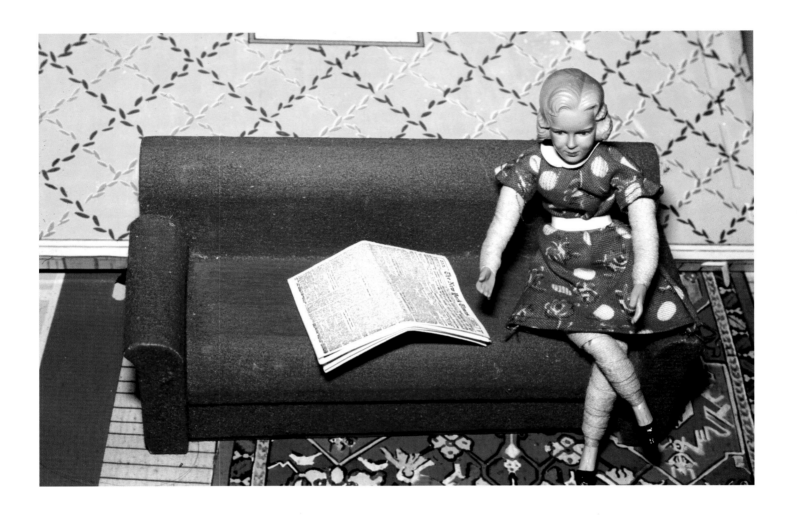

Laurie Simmons

Woman/Red Couch/Newspaper from "Interiors," 1978
Cibachrome print, 3 1/2 x 5 in.
Courtesy the artist

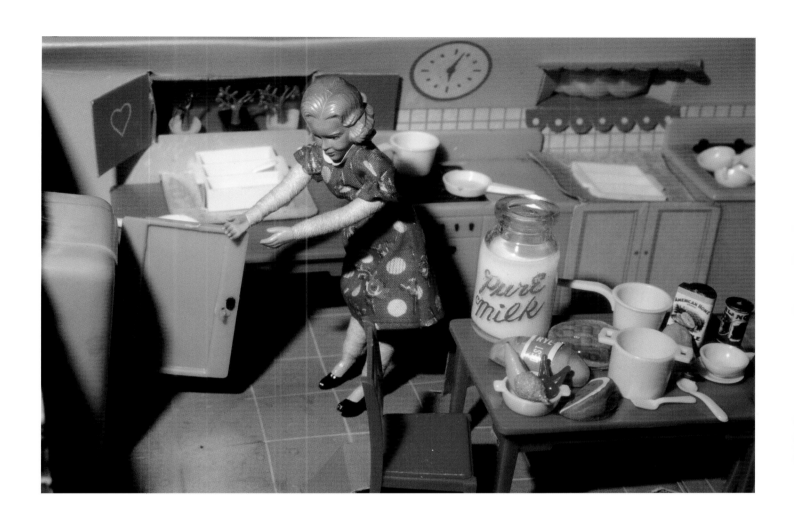

Laurie Simmons

Woman Opening Refrigerator/Milk in the Middle
from "Interiors," 1979
Cibachrome print, 3 1/2 x 5 in.
Courtesy the artist

151

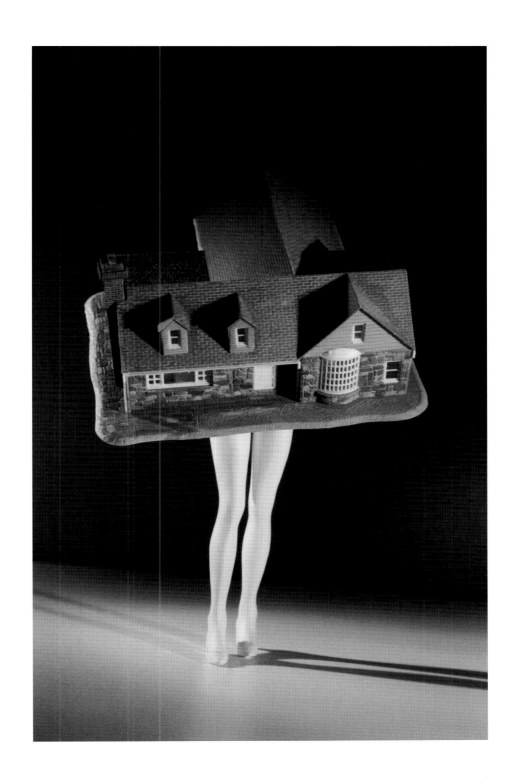

Laurie Simmons

Walking House, 1989
Gelatin silver print, 84 x 48 in.
The Wieland Collection, Atlanta

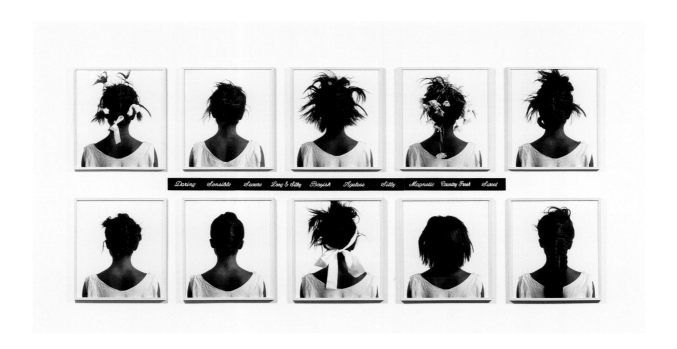

Lorna Simpson

Stereo Styles, 1988
Ten black-and-white Polaroid prints 24 ⁷/₈ x
21 ³/₄ in. each, ten engraved plastic plaques
3 x 8 in. each, 66 x 116 in. overall.
Collection of Melva Bucksbaum and Raymond Learsy

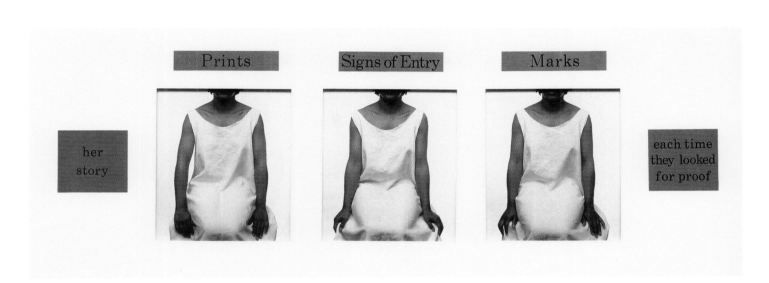

Lorna Simpson

Three Seated Figures, 1989
Three color Polaroid prints, five engraved plastic
plaques, 30 x 97 in. overall.
The Carol and Arthur Goldberg Collection

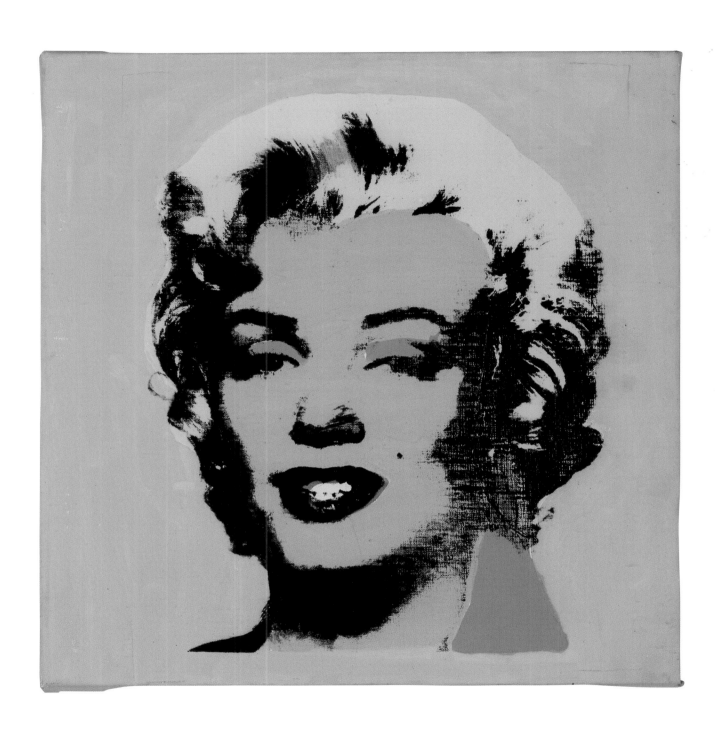

Sturtevant

Warhol Marilyn, 1973
Synthetic polymer silkscreen and acrylic on canvas,
16 ¾ x 15 ¾ in.
Collection Candace Dwan

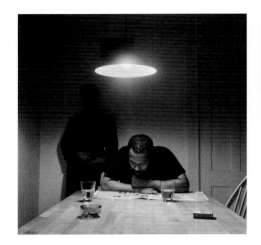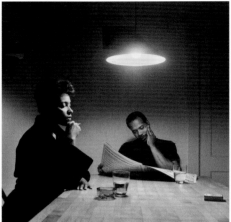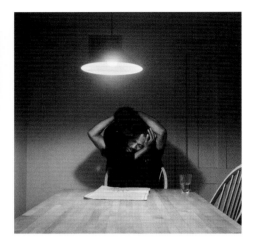

Carrie Mae Weems

Untitled (Man reading newspaper) from
"Untitled (Kitchen Table Series)," 1990
Triptych, three gelatin silver prints,
27 1/4 x 27 1/4 in. each.
Courtesy the artist and Jack Shainman Gallery,
New York

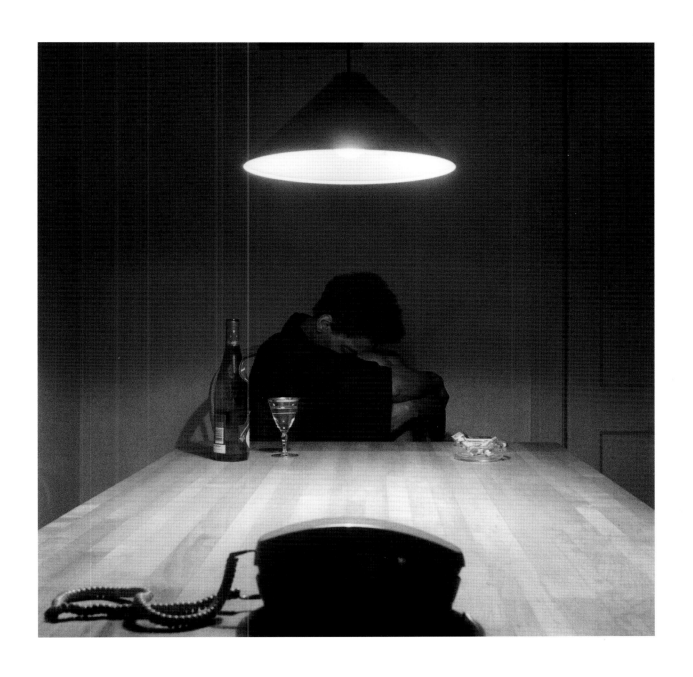

Carrie Mae Weems

Untitled (Woman and phone) from
"Untitled (Kitchen Table Series)," 1990
Gelatin silver print, 28 ¼ x 28 ¼ in.
Courtesy P.P.O.W. Gallery, New York

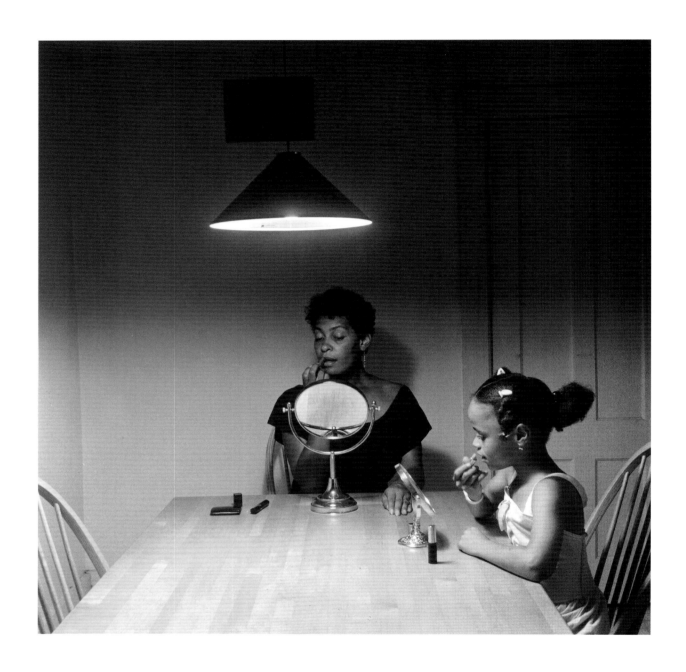

Carrie Mae Weems

Untitled (Woman and daughter with makeup) from
"Untitled (Kitchen Table Series)," 1990
Gelatin silver print, 27¼ x 27¼ in.
Hood Museum of Art, Dartmouth College, Hanover, N.H.;
Purchased through the Harry Shafer Fisher 1966
Memorial Fund

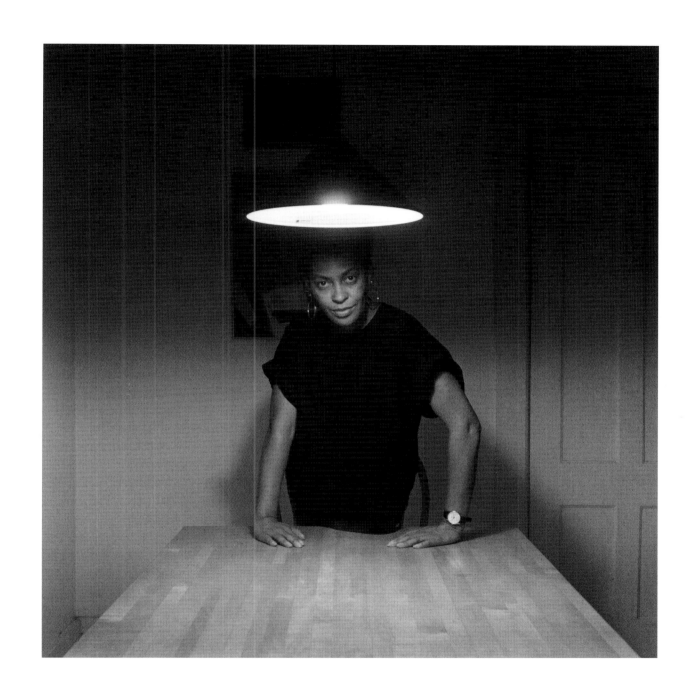

Carrie Mae Weems

Untitled (Woman standing alone) from
"Untitled (Kitchen Table Series)," 1990
Gelatin silver print, 27 ¼ x 27 ¼ in.
Courtesy the artist and Jack Shainman Gallery, New York

161

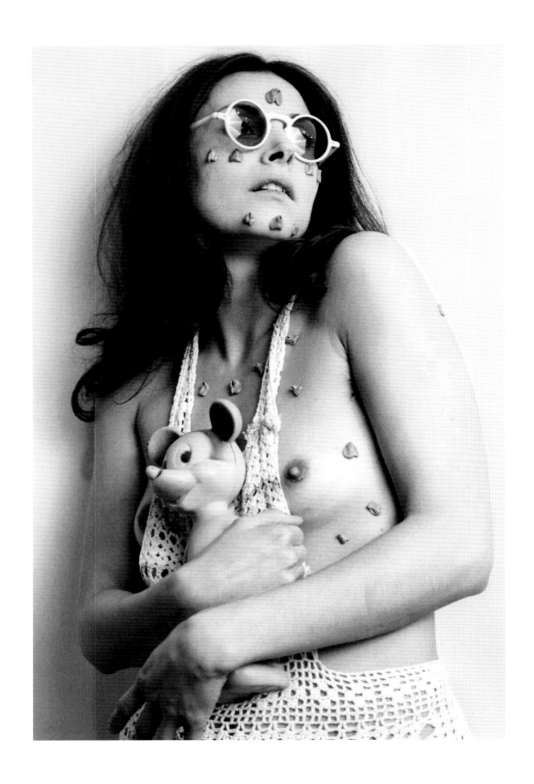

Hannah Wilke

S.O.S. Starification Object Series, 1974
Black-and-white photograph, 40 x 27 in.
Ronald Feldman Fine Arts, New York
© Marsie, Emanuelle, Damon and Andrew Scharlatt/
Licensed by VAGA, New York, NY

162

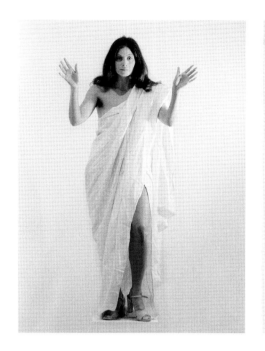 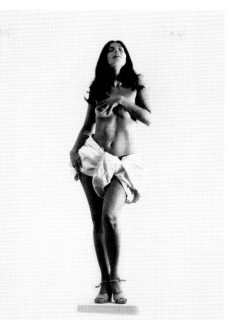 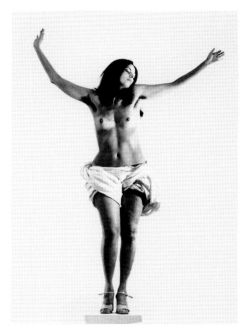

Hannah Wilke

Super-t-Art, 1974
Selection of three gelatin silver prints from a series
of twenty, 10 x 8 in. each.
Ronald Feldman Fine Arts, New York
© Marsie, Emanuelle, Damon and Andrew Scharlatt/
Licensed by VAGA, New York, NY

Works in the Exhibition

Dimensions are in inches;
height precedes width precedes depth.

Judith Barry
Casual Shopper,
1980–81
Video, color, stereo
sound, 28 min.
Courtesy the artist
and Rosamund Felsen
Gallery, Los Angeles
pp. 86–87

Dara Birnbaum
*Technology/
Transformation:
Wonder Woman*,
1978–79
Video, color, sound,
5 min., 50 sec.
Electronic Arts
Intermix (EAI), New
York
p. 89

*Pop-Pop Video: General
Hospital/Olympic
Women Speed Skating,
Kojak/Wang*, 1980
Video, color, sound,
9 min.
Electronic Arts
Intermix (EAI),
New York
p. 90

*Artbreak, MTV
Networks, Inc.*, 1987
Video, color, sound,
30 sec.
Electronic Arts
Intermix (EAI),
New York
p. 91

Barbara Bloom
Three Girls from "The
Gaze," 1987
Cibachrome print,
40 x 60
Courtesy the artist and
Tracy Williams, Ltd.,
New York
p. 92

*Tango (Male Nude
Study)* from "The
Gaze," 1985
Cibachrome print,
77 x 48
Courtesy the artist and
Tracy Williams, Ltd.,
New York
p. 93

Blue Dahlem Curtain
from "The Gaze," 1986
Cibachrome print with
white mat, 23 x 34
Courtesy the artist and
Tracy Williams, Ltd.,
New York
p. 94

Ingres Girl Viewers
from "The Gaze," 1987
Cibachrome print,
24 x 35
Courtesy the artist
and Tracy Williams,
Ltd., New York
p. 95

**Sarah
Charlesworth**
*Verbs, New York Times,
March 7th 1978* from
"Modern History," 1978
Fuji Crystal Archive
print, 22 1/4 x 13 3/4
Courtesy the artist and
Margo Leavin Gallery,
Los Angeles
p. 96

Reading Persian from
"Modern History," 1979
2 Fuji crystal archive
prints, 23 x 16 each
Courtesy the artist and
Susan Inglett Gallery,
New York
p. 97

Black Mask from "Objects of Desire I," 1983
Cibachrome with lacquered wood frame, 42 x 32
Collection of Jay Gorney, courtesy Susan Inglett Gallery, New York
p. 98

Red Mask from "Objects of Desire I," 1983
Cibachrome with lacquered wood frame, 42 x 32
Collection of Sandi Fellman, courtesy Susan Inglett Gallery, New York
p. 99

Figures from "Objects of Desire I," 1983–84
Cibachrome with lacquered wood frame, 42 x 62
Collection of Sondra Gilman and Celso Gonzales-Falla
p. 101

Guerrilla Girls

The Advantages of Being a Woman Artist, 1988
Offset print poster, 17 x 22
Collection Friends of the Neuberger Museum of Art, Purchase College, State University of New York; Museum purchase with funds provided by the Friends of the Neuberger Museum of Art
p. 104

Do Women Have to be Naked to Get into the Met. Museum?, 1989
Offset print poster, 11 x 24
Collection Friends of the Neuberger Museum of Art, Purchase College, State University of New York; Museum purchase with funds provided by the Friends of the Neuberger Museum of Art
p. 103

Top Ten Signs that You're an Art World Token, 1995
Offset print poster, 17 x 22
Collection Friends of the Neuberger Museum of Art, Purchase College, State University of New York; Museum purchase with funds provided by the Friends of the Neuberger Museum of Art
p. 105

Lynn Hershman

Roberta's Physical Stance from "Roberta Breitmore Series," 1976
C-print with acrylic and ink, 40 x 30
Courtesy the artist and Gallery Paule Anglim, San Francisco
p. 106

Camerawoman from "Phantom Limb," 1988
Gelatin silver print, 20 x 24
Courtesy the artist and Gallery Paule Anglim, San Francisco
p. 107

Seduction from "Phantom Limb," 1988
Gelatin silver print, 31 x 41
Courtesy the artist and Gallery Paule Anglim, San Francisco
p. 108

TV Legs from "Phantom Limb," 1990
Gelatin silver print, 24 x 20
Courtesy the artist and Gallery Paule Anglim, San Francisco
p. 109

Susan Hiller

Belshazzar's Feast, 1983–84
Video, 19 min., 11 sec., installation dimensions variable
Timothy Taylor Gallery, London
pp. 110–11

Jenny Holzer

Truisms, 1977–79
Eight offset posters on paper, 34 ¾ x 22 ⅞ each
Courtesy the artist
pp. 112–13

Laments: If the process starts…, 1989
Carbon on tracing paper, 84 x 32
Courtesy the artist
p. 114

Mother and Child, 1990
Eight electronic mini L.E.D. signboards, 4 x 5 x 1 ½
Courtesy the artist
p. 115

Deborah Kass

Before and Happily Ever After, 1991
Oil and acrylic on canvas, 72 x 60
Courtesy the artist and Paul Kasmin Gallery, New York
p. 116

Read My Lips, 1990
Oil and acrylic on canvas, 72 x 60
Courtesy the artist and Paul Kasmin Gallery, New York
p. 117

Mary Kelly

Post-Partum Document: Documentation VI: Pre-Writing Alphabet, Exerque and Diary, 1978–79
Fifteen slate and resin units and three diagrams, 14 x 11 each
Courtesy the artist
pp. 118–19

Silvia Kolbowski

Model Pleasure III, 1983
Four chromogenic prints and eight gelatin silver prints, 8 x 10 each
Courtesy the artist
p. 120

Model Pleasure V, 1983
Chromogenic print and seven gelatin silver prints, 21 ½ x 36 ¼ x ¾ overall
Courtesy the artist
p. 121

Barbara Kruger

Untitled (I am your reservoir of poses), 1982
Black-and-white photograph, 72 x 48
Private Collection
p. 122

Untitled (When I hear the word culture I take out my checkbook), 1985
Black-and-white photograph, 138 x 60
Collection of Peter Norton
p. 123

Louise Lawler

Arranged by Donald Marron, Susan Brundage, Cheryl Bishop at Paine Webber Inc., 1982
Black-and-white photograph, 17 ¼ x 23 ¼
Courtesy the artist and Metro Pictures, New York
p. 124

Arranged by Donald Marron, Susan Brundage, Cheryl Bishop at Paine Webber Inc., 1982
Black-and-white photograph, 19 ½ x 21 ¾
Courtesy the artist and Metro Pictures, New York
p. 125

Conditions of Sale, 1988–90
Black-and-white photograph with printed text on mat, 29 x 32 ¾
Courtesy the artist and Metro Pictures, New York
p. 126

Board of Directors, 1988–89
Black-and-white photograph with printed text on mat, 16 x 22 ¼
Courtesy the artist and Metro Pictures, New York
p. 127

Sherrie Levine

After Walker Evans, 1981
Gelatin silver print, 6 ¼ x 5
Paula Cooper Gallery, New York
p. 129

After Stuart Davis, 1983
Watercolor on paper, 14 x 11
Collection of C. Bradford Smith and Donald Davis
p. 130

After Joan Miro, 1984
Watercolor and graphite on paper, 14 x 10
Paula Cooper Gallery, New York
p. 131

After Malevich, 1984
Watercolor on paper, 14 x 11
Private Collection, Hamburg
p. 132

After Rodchenko 1–12, 1987 (printed 1998)
Twelve gelatin silver prints, 8 x 6 each
Collection of Pamela and Arthur Sanders
p. 133

Adrian Piper

Vanilla Nightmares #13, 1986
Charcoal drawing on newspaper, 22 x 13¾
Collection of the Adrian Piper Research Archive Foundation, Berlin
p. 134

Vanilla Nightmares #14, 1986
Charcoal drawing on newspaper, 22 x 13¾
Collection of the Adrian Piper Research Archive Foundation, Berlin
[not illustrated]

Vanilla Nightmares #19, 1988
Charcoal on newspaper, 22 x 27½
Collection of the Adrian Piper Research Archive Foundation, Berlin
p. 135

Martha Rosler

Semiotics of the Kitchen, 1975
Video, black-and-white, sound, 6 min.
Electronic Arts Intermix (EAI), New York
p. 136

Martha Rosler Reads "Vogue," 1982
Produced by Paper Tiger Television
Video, color, sound, 25 min., 45 sec.
Electronic Arts Intermix (EAI), New York
p. 137

Cindy Sherman

Untitled Film Still #1, 1977
Gelatin silver print, 10 x 8
Courtesy the artist and Metro Pictures, New York
p. 138

Untitled Film Still #7, 1978
Gelatin silver print, 9½ x 7⁹/₁₆
Private Collection, New York
p. 139

Untitled Film Still #10, 1978
Gelatin silver print, 8 x 10
Private Collection, New York
p. 140

Untitled Film Still #13, 1978
Gelatin silver print, 9⁷/₁₆ x 7½
Courtesy the artist and Metro Pictures, New York
p. 141

Untitled Film Still #54, 1980
Gelatin silver print, 6¹³/₁₆ x 9⁷/₁₆
Courtesy the artist and Metro Pictures, New York
p. 143

Untitled #122, 1983
Color photograph, 35¼ x 21¼
Collection of Pamela and Arthur Sanders
p. 145

Laurie Simmons

Woman Listening to Radio from "Interiors," 1978
Gelatin silver print, 5¼ x 8
Courtesy the artist
p. 146

First Bathroom/Woman Standing from "Interiors," 1978
Cibachrome print, 3½ x 5
Courtesy the artist
p. 147

Woman/Purple Dress/Kitchen from "Interiors," 1978
Gelatin silver print, 5¼ x 8
Courtesy the artist
p. 148

Purple Woman/Kitchen from "Interiors," 1978
Cibachrome print, 3½ x 5
Courtesy the artist
p. 149

Woman/Red Couch/Newspaper from "Interiors," 1978
Cibachrome print, 3½ x 5
Courtesy the artist
p. 150

Woman Opening Refrigerator/Milk in the Middle from "Interiors," 1979
Cibachrome print, 3½ x 5
Courtesy the artist
p. 151

Walking House, 1989
Gelatin silver print, 84 x 48
The Wieland Collection, Atlanta
p. 153

Lorna Simpson

Stereo Styles, 1988
Ten black-and-white Polaroid prints, 24⁷/₈ x 21¾ each, ten engraved plastic plaques, 3 x 8 each, 66 x 116 overall
Collection of Melva Bucksbaum and Raymond Learsy
p. 154

Three Seated Figures, 1989
Three color Polaroid prints, five engraved plastic plaques, 30 x 97 overall
The Carol and Arthur Goldberg Collection
p. 155

Sturtevant

Warhol Marilyn, 1973
Synthetic polymer silkscreen and acrylic on canvas, 16¾ x 15¾
Collection Candace Dwan
p. 157

Carrie Mae Weems

Untitled (Man reading newspaper) from "Untitled (Kitchen Table Series)," 1990
Triptych, three gelatin silver prints, 27¼ x 27¼ each
Courtesy the artist and Jack Shainman Gallery, New York
p. 158

Untitled (Woman and phone) from "Untitled (Kitchen Table Series)," 1990
Gelatin silver print, 28¼ x 28¼
P.P.O.W. Gallery, New York
p. 159

Untitled (Woman and daughter with makeup) from "Untitled (Kitchen Table Series)," 1990
Gelatin silver print, 27¼ x 27¼
Collection of Hood Museum of Art, Dartmouth College, Hanover, N.H.; Purchased through Harry Shafer Fisher 1966 Memorial Fund
p. 160

Untitled (Woman standing alone) from "Untitled (Kitchen Table Series)," 1990
Gelatin silver print, 27¼ x 27¼
Courtesy the artist and Jack Shainman Gallery, New York
p. 161

Hannah Wilke

S.O.S. Starification Object Series, 1974
Black-and-white photograph, 40 x 27
Ronald Feldman Fine Arts, New York
p. 162

Super-t-Art, 1974
Selection of three gelatin silver prints from a series of twenty, 10 x 8 each
Ronald Feldman Fine Arts, New York
p. 163

Bibliography

Compiled by Heather Saunders

Nota Bene: This bibliography includes catalogues raisonnés, exhibition catalogues, critical texts, and major monographic books but excludes journal articles.

Judith Barry

Barry, Judith. *Echo/ In the Shadow of the City... Vamp r y*. Exh. cat. Dublin: Douglas Hyde Gallery, 1988.

Barry, Judith. *Study for the Mirror and Garden*. Granada, Spain: Diputación de Granada, 2003.

Brayer, Marie-Ange, and Marí Bartomeu. *Judith Barry: The Work of the Forest: Ouevres récentes, essais critiques*. Exh. cat. Brussels: Fondation Pour L'architecture, 1992.

Dusini, Matthias, and Christoph Keller. *Judith Barry: Friedrich Kiesler Prize*. Exh. cat. Vienna: Friedrich Kiesler Foundation, 2000.

Fisher, Jean. *Judith Barry: Through the Mirror of Seduction: An Essay on the Work of Judith Barry*. Exh. cat. Dublin: Douglas Hyde Gallery, Trinity College, 1988.

Panera, Javier, Helmut Draxler, and Kate Linker. *Body Without Limits*. Exh. cat. Salamanca, Spain: Fundación Salamanca Ciudad de Cultura, 2009.

Sangster, Gary. *Judith Barry*. Exh. cat. Baltimore: Contemporary Museum of Baltimore, 2001.

Van Leuven, Hilde. *Space Invaders or the Failure of the Present*. Exh. cat. Antwerp, Belgium: Internationaal Cultureel Centrum, 1982.

Wallis, Brian. *Judith Barry: Projections: Mise en Abyme*. Exh. cat. Vancouver, B.C.: Presentation House, 1997.

Dara Birnbaum

Birnbaum, Dara. *Dara Birnbaum: IVAM Centre del Carme, Video Instalación*. Exh. cat. Valencia, Spain: Institut Valencià d'Art Modern, 1991.

Birnbaum, Dara. *Dara Birnbaum: The Dark Matter of Media Light*. Exh. cat. New York: D.A.P., 2010.

Birnbaum, Dara. *Every TV Needs a Revolution*. Ghent, Belgium: Imschoot, 1993.

Buchloh, Benjamin H. D., ed. *Rough Edits: Popular Image Video Works 1977–80*. Halifax, N.S.: Press of the Nova Scotia College of Art and Design, 1987.

Demos, T. J. *Technology/Transformation: Wonder Woman*. London: Afterall Books, 2010.

Eleonara, Louis, Toni Stoos, Dot Tuer, Christian Kravanga, Hans U. Obrist, Elli Frank-Grossebner, Brainstorm, Alexander Zigo, and Ingrid Haussteiner. *Dara Birnbaum 1982–1985*. Exh. cat. Vienna: Kunstahalle Wien, 1995.

Gianelli, Ida. *Arte & Arte*. Exh. cat. Milan: Fabbri, 1991.

Huhtamo, Erkki. *Dara Birnbaum: Video*. Exh. cat. Norrtälje, Sweden: Norrtälje Konsthall, 1995.

Malsch, Freiderman. *Dara Birnbaum: Videos seit 1978*. Exh. cat. Köln: Kölnischer Kunstverein, 1992.

Barbara Bloom

Goldmann, Daniela. *Barbara Bloom, Never Odd or Even*. Exh. cat. Pittsburgh: Carnegie Museum of Art, 1992.

Hickey, David, and Susan Tallman. *The Collections of Barbara Bloom. Exh. cat.* New York and Göttingen, Germany: International Center of Photography and Steidl, 2008.

Sarah Charlesworth

Charlesworth, Sarah. *Modern History (Second Reading)*. Exh. cat. Edinburgh: New 57 Gallery, 1979.

Charlesworth, Sarah. *In-photography*. Exh. cat. Buffalo, N.Y.: CEPA Gallery, 1982.

Charlesworth, Sarah. *Sarah Charlesworth: April 21, 1978*. Exh. cat. CMP Bulletin 3, no. 5. Riverside, Calif.: California Museum of Photography, 1984.

Phillips, Lisa, Susan Fisher Sterling, and David Hickey. *Sarah Charlesworth: A Retrospective*. Exh. cat. Sante Fe: Site Santa Fe, 1997.

Guerrilla Girls

Guerilla Girls. *Guerilla Girls Talk Back: The First Five Years: A Retrospective, 1985–1990*. San Rafael, Calif.: Falkirk Cultural Center, 1991.

Guerilla Girls. *Confessions of the Guerrilla Girls*. New York: Harper Collins Publishers, Inc., 1995.

Guerilla Girls. *The Guerrilla Girls' Bedside Companion to the History of Western Art*. New York: Penguin Books, 1998.

Guerrilla Girls. *Bitches, Bimbos and Ballbreakers: The Guerrilla Girls' Illustrated Guide to Female Stereotypes*. New York: Penguin Books, 2003.

Guerrilla Girls. *The Guerrilla Girls' Art Museum Activity Book*. New York: Printed Matter, 2004.

Harrison, Amy. *Guerrillas in Our Midst*. New York: Women Make Movies, 1992.

Lynn Hershman

Cornwell, Regina, and Steve Seid. *Lynn Hershman: Deep Contact /Phantom Limb Photographs /Video Retrospective*. Exh. cat. Davis, Calif.: Richard L. Nelson Gallery and Fine Arts Collection, University of California, 1994.

Hershman, Lynn Lester. *Lynn Hershman: Hero Sandwiches*. Exh. cat. Madison, Wisc.: Madison Art Center, 1987.

Tromble, Meredith, ed. *The Art and Films of Lynn Hershman Leeson: Secret Agents, Private I*. Exh. cat. Berkeley, Calif.: University of California Press, 2005.

Susan Hiller

Brett, Guy, Rebecca Cochran, and Stuart Morgan. *Susan Hiller*. Exh. cat. London: Tate Gallery, 1996.

Einzig, Barbara, ed. *Thinking About Art: Conversations with Susan Hiller*. London and York: Manchester University Press, 1996.

Elliott, David, and Caryn Faure-Walker. *Susan Hiller: Recent Works*. Exh. cat. Cambridge and Oxford: Kettle's Yard and Museum of Modern Art, 1978.

Gallagher, Ann. *Susan Hiller*. Exh. cat. London: Tate Gallery, 2011.

Hiller, Susan. *Rough Sea, 1972–75*. Exh. cat. Gardener Center for the Arts. Brighton: University of Sussex, 1976.

Lingwood, James, ed. *Susan Hiller: Recall: Selected Works 1969–2004*. Exh. cat. Gateshead: Baltic Centre for Contemporary Art, 2004.

Lippard, Lucy, and Andrea Schlieker. *Susan Hiller*. Exh. cat. London: Institute of Contemporary Art, 1986.

Jenny Holzer

Ammann, Jean-Christophe. *Jenny Holzer: Street Work, Installations and Photographs*. Exh. cat. Basel and Villeurbanne, France: Kunstmuseum Basel and Nouveau Musée, 1984.

Auping, Michael. *Jenny Holzer: The Venice Installation*. Exh. cat. Buffalo, N.Y.: Albright-Knox Gallery, 1990.

Auping, Michael. *Jenny Holzer*. New York: Universe Publishing, 1992.

Bernadac, Marie-Laure. *Jenny Holzer: OH*. Exh. cat. Bordeaux: Musée d'art contemporain de Bordeaux (CAPC), 2001.

Cole, Henri, and Angela Schneider. *Jenny Holzer: Neue Nationalgalerie Berlin*. Exh. cat. Berlin: American Academy Berlin and Nationalgalerie Berlin, 2001.

Fernández, Vanesa, and Marco Granados. *Jenny Holzer: Monterrey, 2001*. Exh. cat. Monterrey, Mexico: Museo de Arte Contemporáneo de Monterrey, 2001.

Holzer, Jenny. *Jenny Holzer: Truth Before Power*. Exh. cat. Bregenz, Austria: Kunsthaus Bregenz, 2004.

Joselit, David, Joan Simon, and Renata Salecl. *Jenny Holzer*. London: Phaidon Press Ltd., 1998.

Marincola, Paula. *Jenny Holzer*. Exh. cat. Philadelphia: Institute of Contemporary Art and University of Pennsylvania, 1984.

Pellington, Mark. *Jenny Holzer: Laments*. Exh. cat. New York: Dia Foundation, 1989.

Ruf, Beatrix. *Jenny Holzer, Lustmord*. Exh. cat. Ostfildern-Ruit, Germany: Hatje Cantz, 1996.

Schjeldahl, Peter, Beatrix Ruf, and Joan Simon. *Jenny Holzer: Xenon*. Küsnacht, Switzerland: Inktree Editions, 2001.

Simon, Joan. *Jenny Holzer: Signs*. Exh. cat. Des Moines, Iowa: Des Moines Art Center, 1988.

Smolik, Noemi, ed. *Jenny Holzer: Writing, Schriften*. Stuttgart: Cantz Verlag, 1996.

Waldman, Diane. *Jenny Holzer*. Exh. cat. New York: Solomon R. Guggenheim Museum, 1997.

Deborah Kass

Plante, Michael, ed. *The Warhol Project*. Exh. cat. New Orleans and Los Angeles: Tulane University and Newcomb Art Gallery, 1990.

Self, Dana. *Deborah Kass: My Andy: A Retrospective*. Exh. cat. Kansas City, Mo.: Kemper Museum of Contemporary Art and Design, 1996.

Mary Kelly

Breitweiser, Sabine, ed. *Rereading Post-Partum Document*. Exh. cat. Vienna: Generali Foundation, 1999.

Iversen, Margaret, Douglas Crimp, and Homi K. Bhaba. *Mary Kelly: Contemporary Artists Series*. London: Phaidon Press Limited, 1997.

Kelly, Mary. *Post-Partum Document*. London and Boston: Routledge and Kegan Paul, 1983.

Kelly, Mary. *Imaging Desire*. Cambridge, Mass.: MIT Press, 1996.

Mulvey, Laura. *Mary Kelly: Interim*. Exh. cat. New York: New Museum of Contemporary Art, 1990.

Ottmann, Klaus. *Mary Kelly: Gloria Patri*. Exh. cat. Ithaca, N.Y.: Herbert F. Johnson Museum, Ezra and Cecile Zilkha Gallery, 1992.

Wollen, Peter. *Social Process/Collaborative Action: Mary Kelly 1970–75*. Exh. cat. Vancouver, B.C.: Charles H. Scott Gallery and Emily Carr Institute of Art + Design, 1997.

Silvia Kolbowski

Kolbowski, Silvia. *Silvia Kolbowski: Inadequate… Like…Power*. Exh. cat. Cologne: Walther König, 2004.

Kolbowski, Silvia, and Michèle Thériault. *Silvia Kolbowski: Nothing and Everything*. Exh. cat. Montreal: Galerie Leonard and Bina Ellen Art Gallery, 2009.

Lamoureaux, Johanne, and Lynne Tillman. *Silvia Kolbowski: Projects*. New York: Border Editions, 1992.

Barbara Kruger

Deutsche, Rosalyn, and Ann Goldstein. *Barbara Kruger*. Exh. cat. Cambridge, Mass.: MIT Press, 1999.

Foster, Hal, Miwon Kwon, Martha Gever, and Carol Squires. *Barbara Kruger*. New York: Rizzoli, 2010.

Kruger, Barbara. *No Progress in Pleasure*. Exh. cat. Buffalo, N.Y.: CEPA Gallery, 1983.

Kruger, Barbara. *Remote Control: Power, Culture and the World of Appearances*. Cambridge, Mass.: MIT Press, 1983.

Kruger, Barbara. *We Won't Play Nature to Your Culture*. Exh. cat. London and Basel: Institute of Contemporary Arts and Kunsthalle, 1983.

Linker, Kate. *Love for Sale: The Words and Pictures of Barbara Kruger*. New York: Harry N. Abrams, 1989.

Mayo, Marti. *Barbara Kruger: Striking Poses*. Exh. cat. Houston, Tex.: Contemporary Arts Museum, 1985.

Louise Lawler

Crimp, Douglas. *Louise Lawler: An Arrangement of Pictures*. New York: Assouline, 2000.

Elger, Dietmar, and Thomas Weski. *Louise Lawler: For Sale*. Ostfildern-Ruit, Germany: Hatje Cantz, 1994.

Kaiser, Phillip. *Louise Lawler and Others*, Exh. cat. Ostfildern-Ruit, Germany: Hatje Cantz, 2004.

Lawler, Louise. *A Spot on the Wall*. Exh. cat. Cologne: Oktagon, 1998.

Miller-Keller, Andrea, and Steven Melville. *The Tremaine Pictures 1984–2007*. Exh. cat. Geneva: Blondeau Fine Art Services, 2007.

Molesworth, Helen Anne. *Twice Untitled and Other Pictures (Looking Back)*. Exh. cat. Columbus: Wexner Center for the Arts, 2006.

Sherrie Levine

Caldwell, John. *Sherrie Levine*. Exh. cat. San Francisco: San Francisco Museum of Modern Art, 1991.

Deitcher, David, and Jeanne Siegel. *Sherrie Levine*. Exh. cat. Zurich: Kunsthalle Zürich, 1991.

Krane, Susan, and Phyllis Rosenzweig. *Art at the Edge: Sherrie Levine*. Exh. cat. Atlanta: High Museum of Art, 1988.

Levine, Sherrie. *New Photography*. Exh. cat. Geneva: Musée d'art modern et contemporain, 1996.

Levine, Sherrie. *Abstraction*. Exh. cat. Chicago: Arts Club of Chicago, 2006.

Temkin, Ann. *Sherrie Levine: Newborn*. Exh. cat. Philadelphia and Frankfurt-am-Main: Philadelphia Museum of Art and Portikus, 1993.

Thorp, David. *Sherrie Levine*. Exh. cat. London and New York: Simon Lee Gallery and Nyehaus, 2007.

Adrian Piper

Berger, Maurice, and Dara Meyers-Kingsley. *Adrian Piper: A Retrospective*. Exh. cat. Baltimore: University of Maryland and Baltimore County Press, 1999.

Breitwieser, Sabine. *Adrian Piper seit 1965: Metakunst und Kunstkritik*. Exh. cat. Vienna: Generali Foundation, 2002

Farver, Jane, ed. *Adrian Piper: Reflections 1967-1987*. Exh. cat. New York: The Alternative Museum, 1987.

MacGregor, Elizabeth. *Adrian Piper*. Exh. cat. Birmingham: Ikon Gallery and Cornerhouse, 1991.

Menaker, Deborah, ed. *Adrian Piper: Artworks.* Exh. cat. Williams, Mass.: Williams College Museum of Art, 1990.

Miller-Keller, Andrea, ed. *Matrix 56: Adrian Piper.* Hartford, Conn.: Wadsworth Atheneum,1980.

Piper, Adrian. *Pretend.* Exh. cat. New York: Exit Art, 1990.

Rinder, Lawrence, ed. *Matrix/Berkeley 130: Adrian Piper.* Berkeley, Calif.: University Art Museum, 1989.

Rubin, David, ed. *Adrian Piper: Political Drawings and Installations, 1975–1991.* Exh. cat. Cleveland: Cleveland Center for Contemporary Art, 1991.

Snauwaert, Dirk, ed. *Adrian Piper: Textes d'oeuvres et essays.* Exh. cat. Villeurbanne, France: Institut d'art contemporain, 2003.

Martha Rosler

Chan, Paul, and Martha Rosler. *Between Artists Series.* New York: A.R.T. Press, 2006.

De Zegher, Catherine. *Martha Rosler: Positions in the Life World.* Exh. cat. Cambridge, Mass.: MIT Press for Ikon Gallery and Generali Foundation, 1998.

Rosler, Martha. *Decoys and Disruptions: Selected Writings, 1975–2001.* Cambridge, Mass.: MIT Press, 2004.

Schube, Inka. *Martha Rosler: Passionate Signals.* Exh. cat. Ostfildern, Germany: Hatje Cantz, 2005.

Wagner, Frank, Kasper Konig, and Julia Freidrich. *The Eighth Square: Gender, Life, Desire in the Arts since 1960.* Ostfildern, Germany: Hatje Cantz, 2006.

Cindy Sherman

Basualdo, Carlos. *Cindy Sherman. The Self Which Is Not One.* Exh. cat. Sao Paulo: Museu de Arte Moderna de Sao Paulo, 1995.

Bonami, Francesco, ed., *Cindy Sherman.* Milan: Electa, 2007.

Burton, Johanna. *Cindy Sherman.* Cambridge, Mass.: MIT Press, 2006.

Cowart, Jack. *Cindy Sherman: Unidentified Photographs, 1981–82.* Exh. cat. Saint Louis: Saint Louis Art Museum, 1983.

Cruz, Amanda, Elizabeth A. T. Smith, and Amelia Jones. *Cindy Sherman: Retrospective.* Exh. cat. New York and Los Angeles: Thames & Hudson and Museum of Contemporary Art, 1997.

Danto, Arthur. *Untitled Film Stills Cindy Sherman.* New York: Rizzoli, 1990.

DeAk, Edit. *Cindy Sherman: Specimens.* Kyoto: Kyoto Shoin International, 1991.

Galassi, Peter, and David Frankel. *Cindy Sherman: The Complete Untitled Film Stills.* New York: Museum of Modern Art, 2003.

Görner, Veit, Isabelle Graw, and Maik Schlüter. *Clowns.* Exh. cat. Hannover: Schirmer/Mosel, 2004.

Ha, Paul, and Catherine Morris. *Cindy Sherman: Working Girl. Decade Series.* Exh. cat. Saint Louis: Staint Louis Contemporary Art Museum, 2005.

Kellein, Thomas. *Cindy Sherman.* Exh. cat. Basel: Kunsthalle, 1991.

Knape, Gunilla, ed. *Cindy Sherman.* Exh. cat. Göteborg, Sweden: Hasselblad Center, 2000.

Krauss, Rosalind. *Cindy Sherman, 1975–1993.* New York: Rizzoli, 1993.

Meneguzzo, Marco. *Cindy Sherman.* Exh. cat. Milan: Mazzotta, 1990.

Morris, Catherine. *The Essential Cindy Sherman.* New York: The Wonderland Press and Harry N. Abrams, 1999.

Ozaki, Sachiko. *Cindy Sherman.* Exh. cat. Shiga and Tokyo, Japan: Marugame Genichiro-Inokuma Musuem of Contemporary Art and Museum of Modern Art, 1996.

Rouart, Julie, ed. *Jeu de Paume.* Exh. cat. Flammarion: SA/Éditions, 2006.

Schjeldahl, Peter, and Lisa Phillips. *Cindy Sherman.* Exh. cat. New York: Whitney Museum of American Art, 1987.

Schmidt, Katharina, and Marc Scheps, eds.: *Cindy Sherman.* Exh. cat. Cologne: Museum Ludwig, 1997.

Schneider, Christa. *Cindy Sherman: History Portraits.* Exh. cat. Munich: Schirmer/Mosel, 1995.

Schoon, Talitha, and Karel Schampers. *Cindy Sherman.* Exh. cat. Rotterdam: Museum Boymans-van Beuningen, 1996.

Sherman, Cindy. *Cindy Sherman: A Play of Selves.* Exh. cat. Ostfildern, Germany: Hajte Cantz, 2007.

Sherman, Cindy. *Cindy Sherman.* Exh. cat. New York: Metro Pictures, 2008.

Williams, Edsel. *Early Work of Cindy Sherman.* Exh. cat. New York: Glenn Horowitz Booksellers, 2000.

Zdenek, Felix, Martin Schwander, Elisabeth Bronfen, and Ulf Erdmann Ziegler. *Cindy Sherman. Photoarbeiten 1975–1995.* Exh. cat. Munich: Schirmer/Mosel, 1995.

Laurie Simmons

Charlesworth, Sarah. *Laurie Simmons.* Prescott, Ariz.: A.R.T. Press, 1994.

Howard, Jan. *Laurie Simmons: The Music of Regret.* Exh. cat. Baltimore: Baltimore Museum of Art, 1997.

Linker, Kate. *Laurie Simmons: Walking, Talking, Lying.* New York: Aperture, 2005.

Squiers, Carol. *In and Around the House: Photographs 1976–78.* New York: Carolina Nitsch Editions. Hatje Cantz, 2003.

Lorna Simpson

Enwezor, Okwui, Helaine Posner, and Hilton Als. *Lorna Simpson*. Exh. cat. New York: Harry N. Abrams, 2006.

Fernández-Cid, Miguel, and Marta Gili. *Compostela: Lorna Simpson*. Exh. cat. Santiago de Compostela, Spain: Centro Galego de Arte Contemporánea, 2004.

Golden, Thelma. *Converge*. Exh. cat. Miami: Miami Art Museum, 2000.

Hartman, Saidya V., and Beryl J. Wright. *Lorna Simpson: For the Sake of the Viewer*. Exh. cat. New York and Chicago: Universe Press and Museum of Contemporary Art, 1992.

Jones, Kellie, Thelma Golden, and Chrissie Iles. *Lorna Simpson*. London: Phaidon Press Limited, 2002.

Simpson, Lorna, and Sarah J. Rogers. *Lorna Simpson: Interior/Exterior, Full/Empty*. Exh. cat. Columbus, Ohio: Wexner Center for the Arts and Ohio State University, 1997.

Simpson, Lorna. *Lorna Simpson*. Exh. cat. Salamanca, Spain: Centro de Arte de Salamanca, 2002.

Willis, Deborah. *Lorna Simpson: Untitled 54*. San Francisco: The Friends of Photography, 1992.

Elaine Sturtevant

Dressen, Anne, ed. *Elaine Sturtevant: The Razzle Dazzle of Thinking*. Paris: Paris Musées, 2010.

Kittelmann, Udo, Mario Kramer, and Lena Maculan. *Sturtevant*. Exh. cat. Ostfildern, Germany: Hajte Cantz, 2004.

Sans, Jermone. *Sturtevant*. Exh. cat. Paris: Galerie Thaddaeus Ropac, 1998.

Sturtevant, Elaine. *Sturtevant*. Exh. cat. Munich: Oktagon, 1992.

Sturtevant, Elaine. *Sturtevant: 1,225 Objects à Casino Luxembourg*. Exh. cat. Luxembroug: Casino Luxembourg, 1999.

Carrie Mae Weems

Cahan, Susan, Erik Neil, Susan Cahan, and Pamela R. Metzger. *Carrie Mae Weems: The Louisiana Project*. Exh. cat. New Orleans: Newcomb Art Gallery, 2004.

Kaplan, Cheryl. *The Screen Test: The Films of Carrie Mae Weems*. Exh. cat. Cambridge, Mass.: W. E. B. Du Bois Institute, 2007.

Kirsh, Andrea, and Susan Fisher Sterling. *Carrie Mae Weems*. Exh. cat. Washington, D.C.: National Museum of Women in the Arts, 1994.

Patterson, Vivian. *Carrie Mae Weems: The Hampton Project*. Exh. cat. Williamstown, Mass.: Williams College Museum of Art, 2000.

Piché, Thomas, and Thelma Golden. *Recent Work: Carrie Mae Weems*. Exh. cat. New York: George Braziller Publishing, 2003.

Weems, Carrie Mae. *Carrie Mae Weems: The Kitchen Table Series*. Exh. cat. Houston: Contemporary Arts Museum, 1996.

Weems, Carrie Mae. *Carrie Mae Weems: Constructing History: A Requiem to Mark the Moment*. Exh. cat. Savannah: Savannah College of Art, 2009.

Hannah Wilke

Fitzpatrick, Tracy. *Hannah Wilke: Gestures*. Exh. cat. Purchase, N.Y.: Neuberger Museum of Art, State University of New York, 2009.

Hansen, Elisabeth Delin, and Kirsten Dybbøl. *Hannah Wilke: A Retrospective*. Exh. cat. Copenhagen: Nicolaj Contemporary Art Center, 1998.

Kochheiser, Thomas H., and Joanna Frueh. *Hannah Wilke: A Retrospective*. Exh. cat. Columbia: University of Missouri Press, 1989.

Princenthal, Nancy. *Hannah Wilke*. Munich: Prestel, 2010.

Wilke, Hannah. *Intra-Venus—Hannah Wilke*. Exh. cat. New York: Ronald Feldman Fine Arts, 1995.

Wilke, Hannah. *Hannah Wilke: Selected Work 1960–1992*. Exh. cat. Los Angeles: Solway Jones, 2004.

Exhibition Catalogs/ Critical Texts

Baudrillard, Jean. *Simulations*. New York, Semiotexte, 1983.

Bois, Yve-Alain, Thomas Crow, David Joselit, Elisabeth Sussman, and Bob Riley. *Endgame: Reference and Simulation in Recent Painting and Sculpture*. Boston and Cambridge, Mass.: Institute of Contemporary Art and MIT Press, 1986.

Broude, Norma, and Mary D. Garrard, eds. *Reclaiming Female Agency: Feminist Art History After Postmodernism*. Berkeley, Calif.: University of California Press, 2005.

Brunette, Peter, and David Wills, eds. *Deconstruction and the Visual Arts: Art, Media, Architecture*. New York: Cambridge University Press, 1994.

Crimp, Douglas. *Pictures: An Exhibition of the Work of Troy Brauntuch, Jack Goldstein, Sherrie Levine, Robert Longo, Philip Smith*. Exh. cat. New York: Committee for the Visual Arts, Inc., 1977.

Crimp, Douglas, and Louise Lawler. *On the Museum's Ruins*. Cambridge, Mass.: MIT Press, 1993.

Deepwell, Katy. *New Feminist Art Criticism: Critical Strategies*. Manchester: Manchester University Press, 1995.

Eklund, Douglas. *The Pictures Generation, 1974–1984*. New York: Metropolitan Museum of Art, 2009.

Evans, David. *Appropriation*. Cambridge, Mass.: MIT Press and Whitechapel Gallery, 2009.

Foster, Hal, ed. *The Anti-Aesthetic: Essays on Postmodern Culture*. Port Townsend, Wash., Bay Press: 1983.

Foster, Hal. *Recodings: Art, Spectacle, Cultural Politics*. Port Townsend, Wash.: Bay Press, 1985.

Foster, Hal. *The Return of the Real*. Cambridge, Mass.: MIT Press, 1996.

Gudis, Catherine, ed. *A Forest of Signs: Art in the Crisis of Representation*. Exh. cat. Cambridge, Mass.: MIT Press, 1989.

Hall, Stuart, ed. *Representation: Cultural Representations and Signifying Practices*. London: Sage Publications, 1997.

Heiferman, Marvin, and Lisa Phillips. *Image World: Art and Media Culture*. Exh. cat. New York: Whitney Museum of American Art, 1989.

Isaak, Jo Anna, Jeanne Silverthorne, and Marcia Tucker. *Laughter Ten Years After*. Exh. cat. Geneva, New York: Hobart and William Smith Colleges Press, 1995.

Isaak, Jo Anna. *Feminism and Contemporary Art: The Revolutionary Power of Women's Laughter*. London: Routledge, 1996.

Kalinovska, Milena, and Deirdre Summerbell. *Rhetorical Image*. Exh. cat. New York: New Museum of Contemporary Art, 1991.

Klein, Sheri, *Art & Laughter*. London: I. B. Tauris, 2007.

Lawson, Thomas. *A Fatal Attraction: Art and the Media*. Exh. cat. Chicago: The Renaissance Society at the University of Chicago, 1982.

Linker, Kate. *Difference: On Representation and Sexuality*. Exh. cat. New York: New Museum of Contemporary Art, 1984.

Moxey, Keith. *The Practice of Theory: Poststructuralism, Cultural Politics, and Art History*. Ithaca, N.Y.: Cornell University, 1994.

Owens, Craig. *Beyond Recognition: Representation, Power, and Culture*. Berkeley, Calif.: University of California Press, 1992.

Parker, Rozsika, and Griselda Pollock. *Framing Feminism: Art and the Women's Movement, 1970–85*. London: Pandora Press, 1987.

Pollock, Griselda. *Differencing the Canon: Feminist Desire and the Writing of Art's Histories*. London: Routledge, 1999.

Pollock, Griselda. *Vision and Difference: Feminism, Femininity and the Histories of Art*. London: Routledge, 2003.

Raven, Arlene, Cassandra Langer, and Joanna Frueh, eds. *Feminist Art Criticism: An Anthology*. Ann Arbor, Mich.: UMI Research Press, 1988.

Rice, Shelley. *Deconstruction/Reconstruction: The Transformation of Photographic Information Into Metaphor*. Exh. cat. New York: The New Museum of Contemporary Art, 1980.

Rickitt, Helena, and Peggy Phelan. *Art and Feminism*. London: Phaidon Press, 2001.

Rose, Jacqueline. *Sexuality in the Field of Vision*. London: Verso, 1986.

Stainback, Charles. *Culture Medium*. Exh. cat. New York: International Center of Photography, 1989.

Stiles, Kristine and Peter Selz, eds. *Theories and Documents of Contemporary Art: A Sourcebook of Artists' Writings*. Berkeley, Calif.: University of California Press, 1996.

Wallis, Brian, ed. *Art After Modernism: Rethinking Representation*. New York and Boston: New Museum of Contemporary Art and David R. Godine, 1984.

Wallis, Brian. *Damaged Goods: Desire and the Economy of the Object*. Exh. cat. New York: The New Museum of Contemporary Art, 1986.

Wallis, Brian, ed. *Blasted Allegories: An Anthology of Writings by Contemporary Artists*. Cambridge, Mass.: MIT Press, 1987.

Walters, Suzanna Danuta. *Material Girls: Making Sense of Feminist Cultural Theory*. Berkeley, Calif.: University of California Press, 1995.

Index

Page numbers in color refer to illustrations.

Photograph and Reproduction Credits

Most photographs are reproduced courtesy of the creators and lenders of the material depicted. For some artwork and documentary photographs we have been unable to trace copyright holders. The publishers would appreciate notification of additional credits for acknowledgment in future editions.

Collateral Images

pp. 15, 43 courtesy Mary Boone Gallery, New York; © Barbara Kruger

p. 46 courtesy Cindy Sherman and Metro Pictures, New York; © Cindy Sherman

p. 32 courtesy Laurie Simmons; © Laurie Simmons

pp. 27, 63 courtesy the Adrian Piper Research Foundation, Berlin; © APRA Foundation

p. 64 courtesy Timothy Taylor Gallery, London; © Susan Hiller 2010

pp. 57–58 courtesy Martha Rosler and Mitchell-Innes & Nash, New York; © Martha Rosler

p. 55 courtesy Silvia Kolbowski

p. 79 courtesy Mary Kelly; © 2010 Artists Rights Society (ARS), NY / IVARO, Dublin

Plates Section

pp. 86–87 courtesy Judith Barry and Rosamund Felsen Gallery, Los Angeles; © Judith Barry

pp. 89–91, 136–37 courtesy Electronic Arts Intermix (EAI), New York

pp. 92–95 courtesy Barbara Bloom and Tracy Williams, Ltd., New York; © Barbara Bloom

pp. 96–99, 101 courtesy Sarah Charlesworth and Susan Inglett Gallery, New York; © Sarah Charlesworth

pp. 103–05 courtesy www.guerrillagirls.com © Guerrilla Girls

pp. 106–09 courtesy Lynn Hershman and Gallery Paule Anglim, San Francisco; © Lynn Hershman

pp. 110–11 courtesy Timothy Taylor Gallery, London; © Susan Hiller 2010

pp. 112–13 Courtesy Jenny Holzer. Photograph by Jenny Holzer; © 1977 Jenny Holzer, member Artists Rights Society (ARS), NY

p. 114 courtesy Jenny Holzer; © 1989 Jenny Holzer, member Artists Rights Society (ARS), NY

p. 115 courtesy Jenny Holzer; © 1995 Jenny Holzer, member Artists Rights Society (ARS), NY

pp. 116–17 courtesy Deborah Kass and Paul Kasmin Gallery, New York

pp. 118–19 courtesy Mary Kelly; © 2010 Artists Rights Society (ARS), NY / IVARO, Dublin

pp. 120–21 courtesy Silvia Kolbowski

pp. 122–23 courtesy Mary Boone Gallery, New York; © Barbara Kruger

pp. 124–27 courtesy Louise Lawler and Metro Pictures, New York

pp. 129–33 courtesy Paula Cooper Gallery, New York

pp. 134–35 courtesy Adrian Piper Research Archive Foundation, Berlin; © APRA Foundation

pp. 138–41, 143–45 courtesy Cindy Sherman and Metro Pictures, New York; © Cindy Sherman

pp. 146–51, 153 courtesy Laurie Simmons; © Laurie Simmons

pp. 154–55 courtesy Lorna Simpson and Salon 94, New York

p. 157 photograph by Jim Frank

pp. 158–61 courtesy Carrie Mae Weems and Jack Shainman Gallery, New York; © Carrie Mae Weems

pp. 162–63 courtesy Ronald Feldman Fine Arts, New York; © Marsie, Emanuelle, Damon and Andrew Scharlatt / Licensed by VAGA, New York, NY